WET

WET

On Painting, Feminism, and Art Culture

MIRA SCHOR

DUKE UNIVERSITY PRESS

Durham and London 1997

Third printing, 1999
© 1997 Duke University Press
All rights reserved
Printed in the United States of America on acid-free paper ∞
Typeset in Monotype Garamond by Tseng Information Systems, Inc.
Library of Congress Cataloging-in-Publication Data appear
on the last printed page of this book.

Contents

section of politics and art. That intersection is disrupted by magnetic fields that pull you from side to side. If my overall desire is to work not just at but *in* its edge, it is perhaps truer to say that my essays on painting are informed by a feminist viewpoint, and my essays on gender representation and feminist art history are informed by my love of the art object and the discipline of painting in particular. Some of my writings focus on representations of femininity and masculinity in art by male and by female artists, some focus on painting itself, but are informed by a feminist critique of painting and a feminist reading of other critiques of painting. I always write as a painter and a feminist—or is it as a feminist and a painter? I was once asked to title a slide talk on my work. By the time I arrived at the auditorium, I couldn't remember whether I'd said, "Feminism and Formalism," or, "Formalism and Feminism." I don't want to set one above the other or sacrifice the properties of either, whether it be in my painting or in my critical writing.

My agenda for my work was set by the time I received my M.F.A. from CalArts in 1973, having spent one year in the Feminist Art Program there: I wanted to bring my experience of living inside a female body—with a mind—into high art in as intact a form as possible. The word agenda was not part of my vocabulary in the early seventies; I acquired that kind of strategic language later, in the linguistically oriented eighties, but I knew what my zone of interest was. My writings are the fruit of my feminist education as much as they are the fruit of my earlier training in art history, as an undergraduate at New York University. The recipe could read as follows: mix Hasidic Eastern European ancestors, European artist parents, a French education, New York School of painting family friends, add a splash of H. W. Janson, stir in a shot of Judy Chicago and Miriam Schapiro, a cup of conceptual art, simmer, and, before serving, pepper with critical theory, and you have the ingredients for the essays contained in *Wet!*

These essays represent the survival strategy of a painter during the past decade. In the 1980s, much of the discourse on the visual arts was theory based and the art works that were most admired and critically supported were either based on the work of a few influential theorists or could be easily assimilated into their systems. In order to participate in this theoretical discourse, an artist was well advised to write. Many significant artists who emerged in this period—such as Barbara

Kruger, Peter Halley, David Salle, Mary Kelly, and Sherrie Levine—
have written art criticism or manifestos in art publications and relied
heavily on theoretical texts by Lacan, Derrida, Foucault, Barthes, and
Baudrillard to buttress their visual production and spin its critical re-
ception.

I approach this system of discourse from an oblique angle. A gradu-
ate student once spoke to me of "those of us who have the language,"
unconsciously pointing out to what degree the "language" had been
exclusively arrogated by a self-appointed critical elite that perceived
itself as marginal while it went about policing the ins and outs of pre-
scribed art practice through such institutions as the New Museum,
October, and the DIA Foundation. My effort has been to write from an
intermediary, nondogmatic, albeit polemical, position. I have tried
to bridge the gap between "the language" and those artists who didn't
have it, and also to bridge the gap between the language of critical
theory and the art object. These essays are an intervention, an effort
to interject my voice into the art-theoretical discourse. The choice of
voice over silenced victimization was a personal necessity and had its
roots in my early involvement with feminism as a member of the Cal-
Arts Feminist Art Program. The choice of *voice* also meant providing
a forum for dissenting viewpoints: in 1986 the painter Susan Bee and
I founded the publication $M/E/A/N/I/N/G$ in order to give art-
ists, art historians, poets, and critics a place to challenge the theoreti-
cal and commercial hegemony I have described. $M/E/A/N/I/N/G$
served as a nonjudgmental, noncommodifying forum for artists to
write about issues of special interest to them. Many writings in
$M/E/A/N/I/N/G$ have argued against the dominance of one posi-
tion (or the intellectual "ownership" of the theoretical writings in
question by any one group), and have proposed that theory and ma-
teriality in the practice of art are not mutually exclusive.

The essays in *Wet* are first grouped thematically and then chrono-
logically within each thematic section. The first section of the book is
devoted to male artists' representations of femininity, to a critique of
the sexist contexts of their work, as well as an examination of exist-
ing representations of the male body and masculinity; this section
contains my first published essay, "Appropriated Sexuality," which ex-
amines the depiction of women in the work of David Salle and the
critical reception of these images. Begun in 1984, this essay is unam-

biguous in its critique of the artist's and his apologists' misogyny. I now see "Appropriated Sexuality" as something of a manifesto, given that it was published in 1986 in the first issue of $M/E/A/N/I/N/G,$ at the height of Salle's fame, and given also the art world's considerable financial investment in his work. In fact, it was not possible to get this essay published in a variety of types of art publications, which was one of the factors leading to the founding of $M/E/A/N/I/N/G,$ as a much needed space for dissident points of view. The essay was a declaration of independence from the art world's newly forming hierarchies, a declaration of ideas and values I felt were being discredited. I embraced a criticism of engagement, rather than one of journalistic evenhandedness. It marked as well my entrance into "the language," and in the process of acquiring it my ideas and values shifted balance without radically changing.

Indeed, each section of this book traces an arc from pre-theory, to theory, to post-theory in terms of my acquisition and use of "the language," from early, perhaps slightly grumpy resistance (evident in my focus on theory vocabulary in "Bonnard's Ants"), to full usage, and, at present, gradual simplification. I came to realize that the theoretical vocabulary was necessary to express certain specific concepts. Clearly, my absorption of the vocabulary involved adopting some of the theoretical positions associated with the specific terminologies.

For example, onto the arc of language usage one could overlay a graph of positions associated with the concept of essentialism. I was perhaps coded as an essentialist for focusing on the representation of actual women by actual male artists, as in "Appropriated Sexuality." "Representations of the Penis," in which I turned my lens away from the production of femininity to the production of masculinity in pictorial representation, was considered by some readers to be essentialist because in it I refused to accept the separation between phallus and penis, and I dared to link the gender position "masculinity" to the biologically male body. At the time, representations of the penis were hardly as ubiquitous as they are now, but the basic categories I suggest remain in place. I felt that it was certainly worth taking the risk of "essentialism" by intervening for a brief moment in a six-thousand-year history of representation in order to disturb that hierarchy.

The last essay in the section on masculinity and male artists, " 'The Bitter Tea of General Yen': Paintings by David Diao," is written

at the other end of the arc: it examines Diao's ironic and idiosyncratic involvement with the history of modernism, a complex relationship that combines two opposite positions or strategies—a rather non-Western, non-Oedipal admiration for modernist icons and an ironic and postmodern critique of modernist mechanisms of art-historical and art-career production. The only essentialism implicit here is that of the Western mainstream's essentializing expectations projected onto artists with Third World backgrounds, suggesting that their art should concern itself with questions of ethnicity rather than with the bulwarks of modernism.

The second section of the book contains essays about women artists and artists' collectives. Essentialism is at issue in many of these essays as I examine the intense, but often repressive, debate that transformed the terms of feminist art in the 1980s, in which a polarization existed between those who believed that sexuality and gender are culturally produced at the service of ideology, and those who believed or, more accurately, were *said* to believe in an immutable essence of femininity. In writings on Ana Mendieta, Ida Applebroog, Mary Kelly, and the Guerrilla Girls, I point to similarities in strategies and goals among contemporary women artists that the dominant critical discourse seemed intent on separating. For example, in "Medusa Redux: Ida Applebroog and the Spaces of Postmodernity," Applebroog's work is shown to adhere to the prescriptions for "correct" feminist visual strategies to be found in texts such as Griselda Pollock's *Vision & Difference*, which limited their support to a few artists, most of them not painters. In "The Return of the Same," on Mary Kelly, I confront the stated goals of one such artist's theoretical foundation with the contradictions and discrepancies found in her practice and critical reception.

Although the question of essentialism is central to many of these essays, at the risk of being disingenuous, that this should be the case sometimes has seemed to me almost accidental or circumstantial. I was in a particular place at a particular time—drawn to feminist art and concepts of activism in the United States in the early seventies— which set me on a collision course, eventually, with the antiessentialist discourse that, in the eighties, affected my thought, my work, and, even, at times, my professional opportunities. But I did not choose the terms of this rigorous and bracing, yes, but also often cor-

rosive, battle. Essentialism is a category coined by its opposition. I painted certain images, wrote about others, and found myself sometimes called an essentialist. I felt I had to learn what it meant and deal with it. Like most women artists who were condemned for being essentialists, I did not consider myself as such, once I understood the meaning of the terminology.

It often seemed that, as a feminist artist writing about art, in trying to come to terms with the debate, I was struggling with other people's agendas, granting authority to others. Because even texts that state their desire to disarticulate the discourse and break from the binary limitations of the essentialism/antiessentialism debate become mired in its habitual terminologies, I will not rehearse these here.[1] Yet, while poststructuralist and psycholinguistic theories seemed inimical to my early feminist education and to painting, they helped me better express my ideas through writing, and my enhanced awareness of social constructions of femininity and masculinity enriched my visual image bank. I had the goals and the values, now I had the tools and a valuable critical distance from my earlier beliefs. In a sense, "eighties" feminism helped make me a complete "seventies" feminist, that is to say, an activist, through public writing and more focused artwork about gender representation. The definitional usefulness of the decades fades before the reality of hybrids like myself. If I were to be asked point-blank, "are you now or have you ever been an essentialist?" I would bristle at the accusation that was always inherent to that question. My answer would have to be, "yes and no, depending on the historical moment, the visual art at hand, and on the position of my reader or viewer." My first published artist's statement, in the catalogue for the 1972 *Womanhouse* project, when I was twenty-one years old, was a rapturous paean to my body, nature, and the moon. I blush at its innocence, at—gasp—its essentialism.[2] But at the time, the assertion of one's personal experience of a female identity as a valid subject for art was a revolutionary act. On the other hand, my most recent writing on feminist art, the chapter "Backlash and Appropriation" in *The Power of Feminist Art*,[3] reaped praise from some reviewers for being the only voice to take to task some early-seventies American feminist artists for essentialist simplifications,[4] as well as anguished tongue-lashings by women from both ends of the theoretical spectrum dismayed by my analysis of their work. I'm likely to get it from both

"sides" and have, and that's the way I like it. A maverick position is sometimes harder to commodify than a dogmatic party line, but it can be inclusive and usefully speculative, an important refractive lens on received ideas. The important issue for me is feminism, understood as political analysis of inequalities and injustices perpetrated on women, as well as activism to redress those whenever and however possible, no matter the risk. Political interventions are by their very nature provisional and often flawed, but silence and apathy are the greater flaws, especially when enlightened by sophisticated theoretical arguments.

If the essentialism question is central to many of these writings, it is only part of my broader engagement with visual art. One of the weaknesses of feminist art texts that rehearse antiessentialist discourse is their frequent marginalization of their purported subject, visual artworks, especially contemporary artworks. Rather than theory emerging from a close analysis of the artwork, often the theoretical discourse comes first, followed by brief listing of pertinent works.[5] I always try to include extended, close descriptions of artworks, attending not only to their iconography but also to the details of their articulation in the visual languages of painting and sculpture; similarly, we did not publish reproductions in $M/E/A/N/I/N/G$, at first for financial reasons, but later because this caused the writer and the reader to focus on the capacity of visual artworks to generate meaning, including theoretical meaning. It is particularly crucial that this capacity be accorded to works by women artists: historically, these have been undertheorized or perceived as secondary or lacking in relation to mainstream, universal (male) art movements and theories.

The section on women artists is bracketed by two essays on the formation of feminist art history, which again reflect the development of my theoretical position. In "From Liberation to Lack," written in 1987, I attempt to reread works by artists, such as Cindy Sherman, favored by "postfeminists" through texts often discredited as "essentialist," such as Sandra Gilbert and Susan Gubar's The Madwoman in the Attic. "From Liberation to Lack" is written from an engaged sympathy with the body and a sense of feminist and female identity. "Patrilineage," written in 1991, is more dispassionate and factual: it examines a mechanism of career and canon formation that remains operative to this day, whereby art-historical validation is most frequently accorded through incorporation into a patrilineage, even

ample, points to the gendered subtext of the language of those cri-
tiques, intersecting certain modernists' disgust at the fluidity of paint
with Luce Irigaray's and Klaus Theweleit's analyses of fluidity as a
female trope and threat. "Course Proposal" suggests some simple
procedures for improving painting literacy in the generation of art
critics and painters educated during the 1980s. "Painting as Manual"
picks up the "defense" of painting at the moment "after theory," ex-
amining the challenge to painting from installation art and from new
computer-imaging technologies. It suggests possibilities for painting
through a revival of ancient painting manuals and a revision of Green-
bergian modernist tenets.

My involvement with modernism preceded my involvement with
feminism. No other choice was possible for any woman, indeed for
anyone interested in art before 1970. As I often tell students, believe
it or not, there actually was a time when even women artists were not
aware of Frida Kahlo's work. Art was what you saw in galleries and
museums, and these were works by men, backed by aesthetic philoso-
phies infiltrated by unspoken, universalized, gendered prejudices. An
instinctive search for "femininity," if that was your tropism, had to
take place within a field of male artists: early on, while I admired many
artists, I found encouragement in the works of Paul Klee and Joseph
Cornell, in early Italian Renaissance paintings, surrealist and Rajput
painting. Such small-scale and narrative works provided some sense
of commonality of purpose and visual strategy that other mainstream
art did not provide. This phenomenon continues to be true today, be-
cause feminism (along with many other contemporary isms) remains
marginalized in much standard art instruction. My current interest in
modernism is hard won, because although this aesthetic dominated
my early art awareness, when I began to make art I felt that what I
wished to express and how I wished to express it formally were con-
sidered beyond its pale. It was only once I had fully developed my
own work within feminism that I could confront modernism not only
on its terms but on mine.

I do not advocate painting as the last refuge for lazy, escapist sen-
sualists, but as a still vital site for conceptual art within a field of visual
interest (I use *interest* here rather than *pleasure,* which is after all subjec-
tive). These essays show a progressive movement toward an embrace
of history and of appropriation as a useful visual strategy that I have

incorporated into my own painting. In recent encounters with art students, I have been amused (in light of the charges of essentialism I had encountered previously from students or from other factions) to find myself attacked for embracing the public domain of art history, language, and theory—seen as masculinist—over private concerns and practices—seen as the more suitable domain of the feminine, and, now, apparently, of the twentysomething generation. Second-wave feminism's desire to bring the private and personal into the public has been beset by several backlashes: first the Reagan-era backlash against feminism, then theoretical, or "academic," feminism's critique of essentialism, and, most recently, a return to an untheorized and apolitical ideal of self-expression. Theoretical language's dominance over visual art faces a related antitheoretical backlash. These changes in the zeitgeist are a subtext of the later essays in each section of this book. Here again, I take a bridge or maverick position. I felt it was necessary and useful to attend to and learn from significant critics of painting. I regret that they have sometimes seemed to lack the intellectual curiosity to look beyond a very limited group of artists in order to expand their own discourse.

The last previously published essay in this book, "You Can't Leave Home without It," is not part of a titled section. About the concept of home, it is, appropriately, homeless. It exhibits some of the concerns evident in many of my other essays in a slightly different context—the analysis of a single thematic subject, the idea and image of "Home." It is one of the few essays in this collection in which the topic was assigned to me, in this case by Ida Panicelli, at that time the editor of *ArtForum,* yet it is as dear to me as any of the essays I've written of my own accord, because some of the roots of my worldview and art positions may be found at the very end of the essay, when my relation to irony, love, desire, and representation are traced to my own family's "hearth."

"Afterword: Painting and Language/ Painting Language" is a mirror text to this preface: in it, I write about the experience of being an artist who writes about art—from a historical, an experiential, and, finally, a personal and a painterly point of view. But even as I write the last word, I know that there is no "last word" on painting or on feminism, or on being an artist who writes about both. If I try to remember what I thought about art and feminism in 1972, whether in

the framework of the essentialism debate or of the heritage of modernism within postmodernism, I realize that my memories are merely reconstructions; my views now are surely the same and yet totally different. That will be the case again in the future, so the last word is only one word in the continuum of one's thought.

It is a privilege to be able to collect writings that, published in art journals or given as talks, would otherwise be "lost in the turbulence of daily life."[6] It is also a potentially dangerous exercise for a writer to bring together disparate texts, as certain recurring themes may begin to seem like unhealthy obsessions, and unwholesome tricks of the trade are revealed, such as the wholesale pillaging of one's own words from one text to the next! Does one choose to rewrite everything from the point of view of the present? Does one leave the original writings intact as historical artifacts? I have chosen to do the latter, although some alterations have been necessitated by later developments. In some cases, differing published versions of one piece are combined into a final one.

I have also chosen to leave in certain repetitions, of subjects, bits of texts, and even of certain quotations. For example, my education at CalArts was doubly formative, marking me generationally and politically. It is relevant to some of the artists and themes I write about, so references to that experience occur in several essays, such as "Appropriated Sexuality," "Patrilineage," and "Authority and Learning." Also, certain texts have had a notable impact on my views, books such as *Speculum of the Other Woman* by Luce Irigaray and *Vision & Difference* by Griselda Pollock, and a few quotes from such texts appear more than once. However, each reappearance is essential to the particular piece it occurs in, illuminating the specific context in a way that could not be replicated by elision and referencing.

There are many people I would like to thank for their help in writing these essays. Many friends have listened to me think out loud, often bouncing around inchoate fragments of an idea for a year at a time: I thank Susanna Heller, Whitney Chadwick, Maureen Connor, Nancy Bowen, Tom Knechtel, among many others, for their somewhat puzzled patience. Tom Knechtel gets a special thanks for helping me think up the title for this book. Carrie Moyer helped find the correct "home" for a homeless essay. I have been inspired to write by my interactions with my students: of these, Ingrid Calame appears on

more than one occasion in the important role of the questioner. I have also been inspired by people who have challenged my basic values: it is perhaps not customary to acknowledge someone whom one has critiqued in print, however there is such a thing as being lucky in the quality of one's "opponents": Benjamin Buchloh's conversations and writings spurred the clarification and growth of my ideas.

My sister, Naomi Schor, watched with bemusement as I struggled with theoretical texts she had incorporated into her critical writings years before I got to them. She explains, elucidates, and encourages, at all times. My mother Resia Schor's respect for the written word was a motivating force, and I am happy to be able to add this book to her *naches* pile. Charles Bernstein's early willingness to take my writing seriously was very encouraging (and he has kept me on speaking terms with my computer with commendable patience). I thank Jan Heller Levi and Ida Panicelli for giving me the rare opportunity to write about important women artists for *ArtForum*.

Above all, I thank Susan Bee, who has been my most trusted editor from the beginning of my public career as a writer. In addition to helping me find an audience for my writing by coproducing and publishing the alternative art journal *M/E/A/N/I/N/G*, she taught me how to edit myself and others, providing a standard for quality of text, for degree of personal tone in a critical essay, and for appropriate editorial intervention.

A grant from the Faculty Development Fund from the New School for Social Research helped in the production of this book. Chris Busa, Jeff Hull, Magnus Essunger, and Rebecca Nordhaus provided greatly needed assistance.

Finally, I would like to thank Ken Wissoker for welcoming and nurturing this project and for prodding me into developing a clear overall presentation of the material—into saying *more* about what I had already said in disparate texts.

MASCULINITY

Appropriated Sexuality

Whoever despises the clitoris despises the penis
Whoever despises the penis despises the cunt
Whoever despises the cunt despises the life of the child.
—Muriel Rukeyser [1]

Rapists make better artists.
—Carolyn Donahue/David Salle/Joan Wallace [2]

A woman lies on her back, holding her knees to her stomach. She has no face, she is only a cunt, buttocks, and a foot, toes tensed as if to indicate pain, or sexual excitement, or both. A patterned cloth shape is superimposed over her, and paint-tipped pegs protrude from the wooden picture plane above her. Thus, she is dominated by phallic representations.

This image of woman in David Salle's *The Disappearance of the Booming Voice* (1984) may be appropriated from mass-media pornography, but more immediately it is based on a photograph taken by Salle himself. Salle has said that "what's compelling about pornography is knowing that someone did it. It's not just seeing what you're presented with but knowing that someone set it up for you to see," [3] and that "the great thing about pornography is that something has been

photographed."[4] Salle has even suggested that photography was invented for the enhancement of pornography.

But, cries Robert Pincus-Witten, "clearly your works must be liberated from the false charges of pornography."[5] This sentiment permeates almost all of the vast critical literature on Salle. The issue of pornography is forever raised and laid to rest. But the issue of misogyny is left untouched. Yet, it is the pervasive misogyny of Salle's depiction of woman that is so persistently refuted and excused in favor of a "wider possibility of discussion,"[6] for "in literature of twentieth-century art the sexist bias, itself unmentionable, is covered up and approved by the insistence on . . . other meanings."[7] Salle's depiction of woman is discussed in terms of the deconstruction of the meaning of imagery, and in terms of art-historical references to chiaroscuro, Leonardo, modernism, postmodernism, poststructuralism, Goya and Jasper Johns, Derrida and Lacan—you name it, anything but the obvious. The explicit misogyny of Salle's images of woman is matched by the implicit misogyny of its acceptance by many critics. This complicity is clearly stated by Pincus-Witten: "We're commodifying the object and we're mythifying the makers. . . . I've certainly participated in that mechanism because I believe in the mechanism."[8]

The "mechanism" and Pincus-Witten's belief in it are evident in his earliest interviews with Salle, "up close and personal." He visits Salle's studio in 1979 and meets "a dark 26 year old, impatient and perplexing."[9] "The real content of Salle's painting is irony, or paradox, or parody."[10] *Flesh into Word* (1979), reproduced alongside this text, contains several images of women. The painting is framed on the left by a kneeling nude, seen from behind, near a telephone, and on the right by a headless, upside-down nude. A central, more heavily drawn female contains within her a pleasing, bosomy, sketched-in nude. The central figure is scowling and smoking; a small plane flies into her brain. Thus, the private plane (canvas plane/paintbrush/penis) of the male artist zeros in on the only female in his painting who seems to be trying to think and to question his authority.

Pincus-Witten returns months later, now apparently writing for Harlequin romances. "Complex David Salle—lean of face, tense, dark hair on a sharp cartilaginous profile—the unflinching gaze of the contact-lensed. A cigar-smoker (by way of affectation?) and a just audible William Buckley–like speech pattern."[11] The macho position-

ing is completed by the specification of locale: "the Salle studio is in that row of buildings in which Stanford White—shot by Harry Thaw—died."[12] Thus, the vicarious glamour of a notorious murder committed over the naked body of a woman is rubbed onto Salle (and perhaps onto his hopeful accomplice, Pincus-Witten).

Pincus-Witten offhandedly describes the left half of *Autopsy* (1981), Salle's notorious photo of a naked woman sitting, cross-legged, sad and stiff, on a rumpled bed, a dunce cap on her head and smaller ones on her breasts. In *Autopsy,* the naked woman is juxtaposed with an abstract pattern of blue, black, and white blocks.* This type of juxtaposition of representation with abstraction, as well as any juxtaposition of "appropriated" images, seems to be enough to allow for the deflection of scrutiny away from the sexual content to other, apparently more intellectually valid, concerns, specifically "the uncertain status of imagery, the problems of representation that infect every art."[13]

Challenged in public forums to explain the meaning of *Autopsy* and other like images, Salle has stated tersely that it is about "irony." Indeed, his work is seen by his supporters as an eloquent representation of the nihilistic relativism that can result from an ironic stance and that is one of the hallmarks of current "avant-garde" art.

For Thomas Lawson, who does see Salle's representations of woman as "at best . . . cursory and off-hand; at worst they are brutal and disfigured,"[14] Salle represents nevertheless one of the hopes for the survival of painting, painting as the "last exit" before the despair of "an age of skepticism" in which "the practice of art is inevitably crippled by suspension of belief."[15]

This school of art accepts and revels in the loss of belief in painting except as a strategic device. The images of painting are representations of representations, not of a suspect "reality." Belief in any meaning for an image in this age of reproduction is dismissed as naive.

However, if all images are equivalent, as indicated by the constant juxtaposition of female nudes with abstract marks, bits of furniture, and characters from Disney cartoons in Salle's work, then why are male nudes not given equivalent treatment, not just drawn occasion-

*A reproduction of *Autopsy* was requested by the author. According to a representative of the Gagosian Gallery, N.Y.C., " 'The David Salle Studio' [was] not interested in contributing to this project."

ally from the back, but literally drawn and quartered as female nudes are? If images have been rendered essentially meaningless from endless repetition in the mass media, what is the motivation for the one choice that Salle clearly has made, which is to mistreat only the female nude? Salle does not mistreat the male nude; therefore, he is sensitive to the meaning of some imagery.

Much is made by critics of the refusal of the paintings to render their meaning. Lawson writes that the "obscurity of the work is its source of strength." "Meaning is intimated, but finally withheld."[16] Donald Kuspit writes of a "strangely dry coitus of visual clichés."[17] In withholding their meaning, the paintings are like Woman, the mysterious Other. In withholding his meaning, the artist is an impotent sadist.

The source of this anger is to be found in the intertwined associations among painting, woman, meaning, and death, which form the core of Salle's work. These are clearly expressed in his 1979 manifesto, "The Paintings Are Dead": "The Paintings are dead in the sense that to intuit the meaning of something incompletely, but with an idea of what it might mean or involve to know completely, is a kind of premonition. The paintings in their opacity, signal an ultimate clarification. Death is 'tragic' because it closes off possibilities of further meaning; art is similarly tragic because it prefigures itself an ended event of meaning. The paintings do this by appearing to participate in meaninglessness."[18] For "the Paintings" and "art" one can read "woman," who can only seem to be "known," then returns to the self-enclosed "opacity" of her sex. The meaning "intuited" is that, in the words of Simone de Beauvoir, "to have been conceived and then born an infant is the curse that hangs over [man's] destiny, the impurity that contaminates his being. And, too, it is the announcement of his death."[19] The opacity of the Mother, the calm enclosure of the promise of his own death seems to incite man to fantasies of the rape of woman, and of art.

It is significant that the illustration to Salle's manifesto is an installation shot of the dunce cap pictures. It is also significant that in response to the seemingly obvious offensive nature of this image (*Autopsy*), Kuspit writes that "to put dunce caps on the breasts as well as the head of a woman, and to paint her with a mechanically rendered pattern . . . is to stimulate, not critically provoke—to muse, not re-

veal."[20] This brings to mind *Cane* (1983), in which a woman, hung upside down in one of the traditional poses of Christian martyrdom, is impaled by a real rubber-tipped cane resting in a glass of water on a ledge. The cane represents the phallus of the artist, as well as being an art-historical notation, as the painting and the woman are screwed; as befits a "strangely dry coitus" she may die of peritonitis but she won't get pregnant.

Salle uses woman as a metaphor for death; woman has become a vehicle for the difficulty of painting. Painting, with the potential sensuality implicit in its medium, has become a metaphor for woman, and, also, a vehicle for the subjugation of woman/death. In *Face in the Column* (1983) a naked woman is pressed down by a hand that cannot be her own, by a slice of orange, and by a black band of shadow that straps her down to the ground or bed. A drawing of a woman sitting on a toilet is superimposed so that her ass is directly over the larger woman's face, a further reminder of her disgusting physicality. A white profile of Abraham Lincoln acts as a representative representation of honest male activity distanced from the physical functions of woman, for, to quote Salle, "the ass is the opposite end of the person, so to speak, the most ignoble part of the person and the face is the most noble, the site of all the specificity."[21] As the *butt* of the ironist, woman is "trapped and submerged in time and matter, blind, contingent, limited and unfree."[22]

Carter Ratcliff comes close to grappling with Salle's treatment of women, admitting that "to glamorize cruelty is the pornographer's tactic."[23] *But* "Salle's images of nude women" are "not exactly pornographic. He brings some of his nudes to the verge of gynecological objectivity."[24] Perhaps Ratcliff means veterinary gynecology, because I have only seen dogs take poses remotely as contorted as the one a naked woman is forced into in a 1983 Salle watercolor: flat on her back, her thighs spread apart, her legs up. Footless, armless, helpless, she serves as the base for a set table in a pleasantly appointed room. In *Midday* (1984) a woman is on the floor of a similarly decorated room. Flat on her back, legs up, she holds up her hands as if to help her focus on, or protect herself from, the actively painted face of a man floating above her.

For Ratcliff, Salle is "like a self-conscious pornographer, one capable of embarrassment."[25] A repentant rapist then, who can be

excused from culpability. However, Ratcliff continues, "to see his paintings is to *empathize with his intentions,* which is to deploy images in configurations that *permit them to be possessed.*" [26] It is crucial to emphasize that this form of possession implies a male spectator and is condoned by the male art critic. Linda Nochlin writes that "certain conventions of eroticism are so deeply engrained that one scarcely bothers to think of them: one is that the very term 'erotic art' is understood to imply 'erotic for men.'" [27] The hierarchy of erotic art is clear: "the male image is one of power, possession, and domination, the female one of submission, passivity, and availability." [28] Carol Duncan stresses the violence with which "the male confronts the female nude as an adversary whose independent existence as a physical or a spiritual being must be assimilated to male needs, converted to abstractions, enfeebled, or destroyed." [29]

Salle's reduction "of woman to so much animal flesh, a headless body" [30] seems, in part, to be a response to the radical avant-garde feminism that he was exposed to while a student at the California Institute of the Arts in the early seventies. The Feminist Art Program at CalArts, created and led by Judy Chicago and Miriam Schapiro, which I was part of, aimed at channeling reconsidered personal experiences into subject matter for art. Personal content, often of a sexual nature, found its way into figuration. Analyses and quotes (i.e., "appropriation") of mass-media representations of woman influenced artwork. "Layering"—a technique favored by Salle—was a buzzword of radical feminist art and discourse, as a basic metaphor for female sexuality. The Feminist Art Program received national attention and was the subject of excitement, envy, and curiosity at CalArts. Even students, male and female, who were hostile to the program, could not ignore its existence or remain unchallenged by its aims.

The history of this period at CalArts has been blurred, for instance in the curating of the CalArts Ten Year Alumni Show (1981), which excluded most women and any of the former Feminist Art Program students. In Craig Owens' review of that show, he mourned the resurgence of painting by artists nurtured in the supposed post-studio Eden of CalArts. His point may be well taken on the nature of the sell-out by certain artists, but he does not probe beneath the given composition of the show to see that the Feminist Art Program, excluded from the retrospective, was truly radical and subversive in daring to

question male hegemony of art and art history, whereas post-studio work at CalArts often simply continued an affectless commentary on art history.

Salle's lack of belief in the meaning of imagery is in striking and significant contrast to much work by women artists. From Paula Modersohn-Becker, Florine Stettheimer, and Frida Kahlo to Eva Hesse, Louise Bourgeois, Nancy Spero, and countless other artists working today, women artists have shown a vitality that shuns strategy and stylistics in order to honestly depict the image of the core of their being. A comparison of two artists' statements speaks to this difference in belief, and, parenthetically, of motivation:

> I am interested in solving an unknown factor of art, an unknown factor of life. It can't be divorced as an idea or composition or form. I don't believe art can be based on that. . . . In fact my idea now is to counteract everything I've ever learnt or ever been taught about those things—to find something inevitable that is my life, my thoughts, my feelings.[31] —Eva Hesse

> I am interested in infiltration, usurpation, beating people at their own game (meaning scheme). I am interested in making people suffer, not through some external plague, but simply because of who they are (how they know).[32] —David Salle

Salle's abuse of the female nude is a political strategy that feeds on the backlash against feminism increasingly evident in the national political atmosphere. The current rise of the right in this country puts issues pertaining to female organs and women's freedom or loss of choice at the top of the right's list of priorities. It is not surprising that in such an atmosphere Salle's theater of mastery of humiliated female *Fleisch* (the title of a Salle painting) is so acceptable despite its bad-boy shock value.

Just as the black leather trappings of the Nazi SS have become trivially eroticized, so too it is possible for some critics to openly succumb to the cult of the artist as magical misogynist. Michael Krüger describes a day spent with Salle in the snow-covered Alps: from a patio, the two consider the "breathtaking scenery" before them, as they drink "a dry Swiss wine from inexhaustible bottles," and Salle smokes "one of those excessively long cigars which cause one to won-

der whether they can ever be brought to a successful conclusion." Salle draws an imaginary picture on the view, and then, apparently, a real one in the snow.

> And then he did something that left me completely perplexed. I had always assumed that a painter begins his picture in one corner, for example, top left, if he is right-handed, bottom right, if he is left-handed. But, *without removing the cigar from his mouth,* David concentrated his attention on the center, where he placed the gigantic figure of a woman, naked, her thighs spread wide apart. And he did all this in such a convincing matter-of-factness that the obsceneness of the gesture with which he had drawn so quickly in the snow only struck me as my view, still dazzled by the sunlight, slowly began to penetrate and rapidly melt. . . . The most obvious explanation that occurred to me was that David was using a symbolic action to liberate the instrumentalized body from the constraints of economy, to *return it to nature.* So there was this splendid body before us, several hundred meters across, and there were the skiers, their tiny bodies wrapped in the most incredible disguises, registering naked shock The route back down the valley obligated them to *desecrate this naked figure.*[33]

Woman apparently cannot win; either she *is* nature, or must be *returned to it,* in order to be *desecrated,* in a scene that rivals the imaginings of Ian Fleming—a giant cunt, a scenic mountain full of skiers, and the heroic male artist, James Bond/David Salle, cigar/pacifier in his mouth, poker-faced no doubt. One can only wonder what the reaction of the critic and the skiers might have been if an artist had drawn a giant male figure with erect penis, positioned so as to invite castration.

Recent attention has been focused on Paul Outerbridge's photographs of oppressed-looking female nudes posed with the standard trappings of fetishism and sadomasochism, and on Balthus's pedophilic portrayals of little girls who just happen to have their skirts flipped up around their waist. This attention represents an effort to give art-historical validation to present styles and content. A pertinent example of this art historical bolstering, and one that is revealing as to the sources of his misogyny, is Salle's choice of "appropriation"

in *Black Bra* (1983), in which a real, large, black brassiere hangs off of
a peg attached to a large image of a Cézanne-like bowl of apples.
As Meyer Schapiro's "The Apples of Cézanne: An Essay on the
Meaning of Still-life" illuminates, still lifes provided Cézanne with
a method of self-control, a "self-chastening process."[34] "I paint still
lifes. Models frighten me. The sluts are always watching to catch you
off your guard. You've got to be on the defensive all the time and
the motif vanishes."[35] Indeed, Cézanne's early paintings of nudes are
anxious, uncontrolled, and violent, as the thick, gloppy brush marks
demonstrate. Through painting careful arrangements of "perfectly
submissive things" that have "latent erotic sense,"[36] Cézanne achieves
self-possession, possession of the object of desire, and control of his
medium. Needless to say, the comparison between Salle and Cézanne,
invited by Salle's appropriation of the apples, goes no further than the
original misogyny. Cézanne was able to arrive at a restructured vision
of erotic struggle, in which the original violence is transcended and
the link between sexuality and death is addressed beyond the target of
female flesh. In short, Cézanne grew up.

But, by his quoting of Cézanne, Salle only links himself to the mas-
ter's subjugation of the uncontrollable forces of sexuality and death
incarnated by man in woman. By positing the artwork as being about
the self-consciousness of the artist in relation to art history, he deflects
the perception of its content for what it is—misogyny, narcissism,
impotence. To condemn that content is to betray a misunderstanding
of the whole purpose, which seems to be a continuation of a male
conversation that is centuries old, to which women are irrelevant ex-
cept as depersonalized projections of man's fears and fantasies, and in
which even a man's failure is always more important than a woman's
success. In Laura Mulvey's formulation, "the function of woman in
forming the patriarchal unconscious is two-fold, she first symbolizes
the castration threat by her real absence of a penis and second thereby
raises her child into the symbolic. Once this has been achieved, her
meaning in the process is at an end, it does not last into the world of
law and language except as a memory which oscillates between mem-
ory of maternal plenitude and memory of lack."[37]

If, in a painting as in a dream, all the elements can be seen to repre-
sent the artist's psyche, then Salle is the impaled upside-down nude,
as well as the rubber-tipped *Cane*. The identification with martyrdom

indicates that the artist is subjugating the woman in himself. In sub-
jugating woman, who is historically linked with painting as muse,
model, and embodiment of sensuality, he is suppressing the painter in
himself. Perhaps he is conquering fears about his virility, for "the vic-
tim of rape is not inclined to question the virility of her assailant." [38]

To some extent this essay was suggested by a male artist who ex-
plained to me that Salle's work was not misogynist but was a coded
message to other men of his own impotence. Well, like the little girl
in the old cartoon, "I say it's spinach and I say the hell with it." [39]
Whatever the message is—be it homoeroticism, self-hatred, suici-
dal fantasy—the "desecration" of woman is Salle's expressive vehicle,
his "code."

The painting *What Is the Reason for Your Visit to Germany* (1984),
which could also be titled "Bend Over Baby, While I Quote Jasper
Johns," seems a temporary summation of Salle's constant themes. In
one panel a naked woman bends over, her breasts dangling as she per-
forms for the artist and the spectator. The word "fromage" is written
across the center of the panel, at the very least indicating the con-
descending relationship of photographer to child—"say cheese," cer-
tainly a reference to "cheesecake," maybe a derogatory reference to
the very smell of her sex. A companion panel of a lead-covered saxo-
phone provides a phallic bulge and a competitive allusion to an older
master. Over the woman is drawn, twice, the image of Lee Harvey
Oswald being shot; once, so that the physical resemblance to Salle
himself is immediately apparent, and then again as his head explodes
into paint.

We see in this one painting a conflation of Salle's humiliation of
woman, his glamorization and martyrdom of the assassin/artist, as
he links woman, death, and paint.

A vicarious suicide, David Salle savages woman rather than savage
himself. This is considered appropriate sexuality, and this is a source
of his market value.

Representations of the Penis

Beginning with a major exhibition in London in 1980, *Women's Images of Men*, there has been an increasing amount of work on the subject of male representation, and specifically on the male nude and the penis. In the *Village Voice*, the "Problem Lady" writes that "right now, for some reason, penises are the new hot topic of conversation" (12 January 1988, p. 47). On TV we are treated to diagrams of President Reagan's penis, as well as a nearby part of his anatomy. For perhaps the first time it is acknowledged that our leader *has* a penis (and a nearby part of his anatomy). All we *haven't* seen is a diagram of his brain.

Nevertheless, until very recently, Western art, and the typically male art historians who have formulated the illusory image of its progression, have been singularly protective of the male member. A person who would seek to learn about the physiognomy of male genitalia solely through the visual documentation of painting and sculpture (rather than that of pornography) would be sorely puzzled by the discrepancy between the evidently phallocentric world of culture, of political and sexual dominance by men, and the less than impressive appendage to representations of male nudes in art.

When you look for something, you tend to find it, and so this study has undermined my initial assumption that there were few de-

pictions of the penis in Western art. Yet it must be stated that for every image of male genitalia found, there were 100 representations of female genitalia. And, as will become clear, representations of the penis are, more often than not, misrepresentations and mystifications. Also, to state the obvious, this essay is not about actual male anatomy but, rather, its representation.

A good deal of writing about representation has been about gender or sexual representation, and most of that has been on the representation of woman. Woman is the *site* of representation. Consider an old Swiss postcard from around 1900: four male mountain climbers clamber over the body of a giant, scantily dressed woman recumbent in the Alps, one of her breasts and elbows forming peaks as steep and challenging as those of her granite bed. This woman's body is the stage of a drama whose characters have been particularly developed by Lacanian psychoanalytic theory. One character in the drama, according to Jane Gallop, is the "Phallic Mother," the "pre-Oedipal mother, apparently omnipotent and omniscient, until the 'discovery of her castration,' the discovery that she is not a 'whole,' but a 'hole.' "[1]

The "Phallus" which "unlike the penis, is lacking to any subject, male or female,"[2] is the (absent) hero of the drama. "Neither sex can be, or have the phallus." It is an "originary, essential, transcendental power."[3] "This is so for the female too, but the male has the means of representing the phallus as an integral part of his body, in the form of the penis."[4] And so man privileges (the) visibility (of his penis); yet, paradoxically, representation has focused on the invisibility, the "*nothing to see,*"[5] the "lack" of woman. "Lack" is the last character on the stage of woman's body, in the drama that is all about castration. It is a circular drama: in every mirror, the phallus sees itself, in lack, or it sees the lack in itself. Phallus *is* lack—and representation and patriarchy take place in the gaps between phallus and lack.

In the painting *Adam and Eve* by Hans Baldung Grien (1484–1545), Adam hides behind Eve, so that his penis is hidden, while Eve's (lack of one) is quite visible, even emphasized by a mimetically triangular sheer cloth placed over her sex. If the penis is hidden, the phallus is everywhere, as an erect tree, as Adam's hand (in front of where his penis would be), and as the apple that serves as balls. But, preeminently, the phallus is in the veil of woman's lack, hiding man's lack.

The phallus is also the law of the Father, language, philosophy, and

history, the written history from which woman has largely been excluded. Jane Gallop locates the motivation for the Lacanian effort to separate phallus from penis in the desire to maintain the phallocentrism, and the androcentrism, of discourse.

> The Lacanians' desire clearly to separate *phallus* from *penis,* to control the meaning of the signifier phallus, is precisely symptomatic of their desire to have the phallus, that is, their desire to be at the center of language, at its origin. . . . But as long as the attribute of power is a phallus which can only have meaning by referring to and being confused with a penis, this confusion will support a structure in which it seems reasonable that men have power and women do not. And as long as psychoanalysts maintain the ideal separability of *phallus* from *penis,* they can hold on to their *phallus* in the belief that their phallocentric discourse need have no relation to sexual inequality, no relation to politics.[6]

In the animal world staring is confrontational. In our species it is acceptable for the stare, the gaze to go one way: man looks at woman. The gaze is a male privilege, and what is visible is privileged in Western culture. "But 'what' if the object [of the gaze] started to speak? Which also means beginning to 'see,' etc. What disaggregation of the subject [man] would that entail?"[7] This essay is an effort to resituate the gaze. So how does one begin to see behind the screen of the phallus and lack, to speculate on the penis?

I began by taking my camera to the Metropolitan Museum. I imagined the guards commenting on their walkie-talkies as I took point-blank close-ups of the genitalia of Greek and Roman statuary. Time and Christianity have eroded the penises of the large marble statues, and small bronze figurines were endowed with improbably button-sized ones; a larger than life-size Roman bronze figure pointed his left index finger, exactly parallel to his uncircumcised penis—although both pointed to the law, the finger was slightly longer.

The reasons for these proportions can be found in Kenneth Clark's baseline art-historical text, *The Nude,* according to which the nude is an idea, and an ideal. The male nude is conceptualized in terms of mathematics, symmetry, canons of proportion: "The Greeks had no doubts that the God Apollo was like a perfectly beautiful man. He was beautiful because his body conformed to certain laws of propor-

tion and so partook of the divine beauty of mathematics."[8] In the area Clark refers to euphemistically as the "division of the legs"[9] the progression toward the mathematical ideal of proportion entails a shift from the thickset, better-endowed early Kouroi, to the button-sized penises of later works. The male ideal of perfection is an inconspicuous appendage with no sense of eroticism *or* verisimilitude.[10] Male nudes that drift into some sort of sensuality are regarded by Clark as deviant—deviant, in art-historical terminology, signifying "decorative," "decadent" (i.e., feminine and homosexual).[11] These sensual male nudes are not reproduced, merely referred to. Clark uses two languages in *The Nude:* to describe the male nude he uses the language of mathematics and proportion, but he yields to frank eroticism when it comes to the female nude, where the "lust of the goat [the male artist in all cases] is the bounty of God."[12]

Leonardo's drawing of *Vetruvian Man* is an effort to schematize the geometrically divine proportions of man. Clark and others hasten to remind us that Leonardo misread Vetruvius and got the proportions wrong, so that the man's arms are too long. But what of the genitalia of this ideal schema of man? Yes, this icon of Western representation has a penis of reasonable proportions. It is close to the center of the circle (the navel), it *is* the central point of the square. However, the radiating arms and legs have a centrifugal effect, pulling our eyes away from the body toward the circle and the square, the geometry that is meant to be the true subject of the image. Disrupting the whole schema is the powerful, square-jawed, lion-maned, sternly frontal face, an overpoweringly expressive idealization of male subjectivity, identity, and authority. Clark, speaking of the shocking effect of Manet's *Olympia,* notes that "to place on a naked body a head with so much individual character is to jeopardize the whole premise of the nude."[13] Even Leonardo's schema for a proportional ideal of male representation is thrown off track, not by its sexual member, but by its intellectual idealization.

In the theatrically condensed moment of the touching fingers, Michelangelo's *Creation of Adam* from the Sistine Chapel's Ceiling is a prototypical male representation and allegory of male creativity. But there are curious aspects to this image. Adam is endowed with a splendid musculature, disproportionately wide chest, and disproportionately tiny, limp penis, which seems as vestigial as an appendix.

It is rendered in the same dimension as his (disproportionately wide) navel. Adding to the femininity of the about-to-be-enlivened Adam is his lazily recumbent position. God, on the other hand, despite white hair and beard, is an equally splendid, muscular, young male. His sex may be indicated by his beard and his procreative finger, but his sex organ is hidden in the folds of a lavender dress. This Father has all the power of the *phallus:* he is emblematic of the triumph of monotheism and the principle of male creativity over the fertility of the ancient earth goddesses; but his penis is covered, and though the drapery of his robe clings to his pecs and biceps, it doesn't cling to anything in "the division of the legs."

Leo Steinberg's *The Sexuality of Christ* (1983) is a significant study of representations of the penis. Steinberg calls our attention to the iconography of an "ostentatio genitalium," imagery in which the genitalia of Christ receive "demonstrative emphasis." [14] This iconography is intended to make materially evident the incarnation of the Word of God in man. He was born a man because He has a penis, because the proof is visible, this child who is the product of a penis-less impregnation. So naked baby boys, tiny penises on putti proliferate in Western art. It has been suggested that these are miniaturized adult penises in which "the Renaissance artist uncovers his body and is revealed through the reduction of the scale of proportions and exposed as a sensitive, sensual, corporeal entity." [15] This is already an oddity: adult men able to reveal their penises only in the guise of infantile genitalia. In addition, even their placement is rarely "anatomically correct."

As Steinberg points out, the adult Christ is never naked, but an erection is sometimes indicated via exaggerated drapery—a *symbolic* erection, of course, which denotes the resurrection, not a real erection, since the superior power of the penis of Christ is due to its "abstinence." [16] The dead Christ is almost never naked. The very fact of his death proves he lived. Yet even in death his hidden penis is covered and emphasized by Mary's hand, his own, or even, in what Steinberg tells us is rare iconography, by the hand of God the Father (rare because the Father/Son relationship is so fraught with taboo).

Christian iconography offers us a naked baby with an uncanny penis, and a dead man in a shroud. And even in death, if there is no loincloth, no sheet, there are always hands to shield man's sign of "humanation." [17]

The pattern of diminishing or hiding the penis while revealing the phallus is evident in the work of Auguste Rodin, considered an artist who broke through the politeness and prudery of centuries to bring a frank, realistic sensuality to depictions of the human figure. "No surface aspect of the figure's anatomy seems to have escaped his eye,"[18] except for the penis. *John the Baptist* (1878) sports some sort of fig leaf jockstrap without a string. The *Balzac* of Rodin (1897), a single rugged shaft with a massive head, is phallic in the extreme. The sculpture's history is indicative of a phallocentric strategy of power via mystification and occultation: after many initial studies, Rodin modeled a naked Balzac clutching a huge, erect penis. This version was well known in Paris; one contemporary record describes the man "holding himself erect, the hands firmly grasping his virility."[19] (Appropriately, Rodin expressed his doubts about the ever-changing sculpture by varying reports: "Je le tiens"—I hold it—or "Je ne le tiens pas"—I don't.)[20] Finally, wet, plaster-soaked cloth was draped over the model, transformed into a dressing gown, *et voilà!*

John Berger has suggested that the *Balzac* is Rodin's masterpiece, his only masterpiece, because for once in his life the clay seemed to be masculine, in other words, equal to him, so that he could not compress, manipulate, and oppress it as he does the clay women of his other figures.[21] But Balzac's "virility" is ultimately, deliberately, veiled, shrouded. As Luce Irigaray writes (about Freud): "it would be good to take issue with the cloak of the law in which he wraps his desire, his penis."[22]

The major developments in male representation, the beginning of a coming to terms with the penis, occurred in the 1960s and 1970s, at a time when movements of liberation, including sexual, came to the forefront of society. The feminist movement, in particular, organized a continuing critique of gender and representation, and provoked a group of responses in art by men—either examples of exacerbated misogyny, or attempts at self-representation and analysis.

The works of Herman Nitsch, Vito Acconci, and Eric Fischl exemplify several strategies for male representation and their progression from the 1960s to the 1980s. In his *Aktions,* from the early sixties to the present, the Austrian artist Herman Nitsch reenacts Catholic narrative and ritual, and blends its tableaux of suffering with a Dionysian theater of excess, chaos, and violence. Nitsch strips the shroud

off of Christ and casts his own body in the role of Christ as sacrifi-
cial animal. Naked and blindfolded, he is covered with the blood and
guts of drawn and quartered (and crucified) cattle. In early black-and-
white documentation, his head is cropped out of the picture, his torso
is segmented photographically, and his penis appears, amidst animal
organs, as glistening, limp, animal flesh. In one of these photographs
(1965) he is seen from the armpits down; blood from a barely stanched
wounded heart pours onto his penis, which is ritualistically placed on
a sheet of white paper on a table. His cock is on the block (of art) in
a pose strikingly reminiscent of the painting *Man of Sorrows* (Michele
Giambono, ca. 1430), in which a dead Christ stands out of his sep-
ulchre, the rim of which just covers his penis, while a cloth draped
over its edge is ornamented with a red spot where his penis would be
(would bleed).

In the use of blood and body, this work connects to issues of
femaleness. Max Kozloff writes about Nitsch and other male body/
performance artists of the sixties and seventies: "the most revealing
images or presences are males transposing themselves into females."
He quotes Nitsch: "Many of the theater actions are like births. And
a birth is like a crucifixion and resurrection together. There is blood,
and meat, and pain, and then comes the newly born child, and he cries
and begins to live. . . . I want to celebrate existence."[23] Whereas Rodin
glorified the male creative principle but veiled his penis, Nitsch, even
as he uses his own, for once, naked body, looks to the procreative
power of the "phallic mother," to the birth blood he truly lacks. To
unveil his penis, he must use the language of femininity.

Vito Acconci's performance/body artwork of the early seventies
also incarnates a struggle over the gender of creativity. In attempting
to depict his own body and its creative functions, he is compelled to
reinvestigate principles of femaleness and femininity. Acconci, like
Nitsch, returns to the female body when he seeks to represent his
own. Acconci's work was the subject of lively debate at the time, and
is an important focus for any exploration of male representation.

In *Seedbed* (1971), lurking under a wedge-shaped ramp constructed
in a gallery, Acconci passed two afternoons a week engaged in "pri-
vate sexual activity," that is to say, jerking himself off. "The goal of
my activity is the production of seed."[24] The gallery is thus the site
for the production and display (although unseen) of male sexuality.

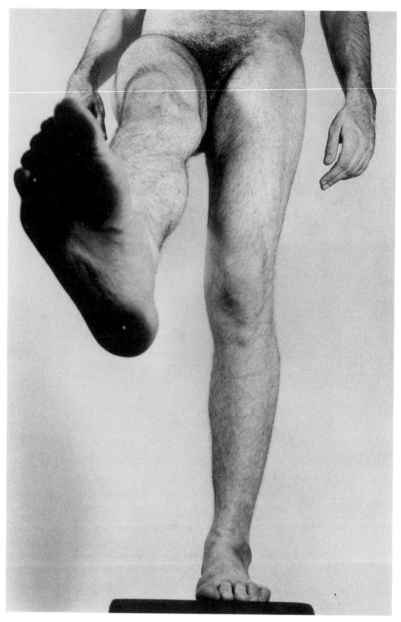

Vito Acconci, *Conversions (Part II: Insistence, Adaptation, Groundwork, Display)*, 1971, still of Super 8 film, b/w, silent, 18 min. (Courtesy Barbara Gladstone Gallery, New York)

Vito Acconci, *Conversions (Part II: Insistence, Adaptation, Groundwork, Display)*, 1971, still of Super 8 film, b/w, silent, 18 min. (Courtesy Barbara Gladstone Gallery, New York)

Art and male sexuality are both represented as masturbation. There is reference and allusion to the penis, but the artist and his penis, like the *Balzac* of Rodin, remain hidden in a mantle of art. Despite claims to the contrary, in some ways this is a very traditional artwork.

Acconci finds new (but equally traditional) hiding places for his penis in *Conversions* (1971). In one segment he tries to walk and run "all the while attempting to keep [his] penis 'removed,' held between [his] legs." Acconci finds another hiding place in a segment of *Conversions* entitled *Associations/Assistance/Dependence:* "A woman kneels behind me: I push my penis behind me, between my legs, she takes my penis into her mouth . . . when I'm seen from the front, the woman disappears behind me and I have no penis. I become the woman I've canceled out."[25]

Acconci, an atavistically hairy male, has presented a male representation by becoming a woman. He strips, but then he seeks to strip away all signs of maleness: first, the hairs off the breasts, then the penis from his body. But he *has* a penis and must put it someplace—in the mouth of a disappeared woman. So, the phallus reinscribes itself over the erased/lacking woman, even as the penis is hidden, as usual.

Acconci's penis is finally revealed, more or less, dressed like a doll, in *Trappings* (1971). The artist placed himself in a closet space cluttered with shawls, foam, flowers, toys (items associated with femininity and childhood), a "location for regressive activity."

> Activity: Turning on myself—dividing myself in two—attempting to turn my penis into a separate being, another person.
> 1. Dressing my penis in doll's clothes.
> 2. Talking to my penis as a playmate—talking myself into believing this.[26]

It is worthwhile noting how these experimentations in sexuality were treated by the art press, which indicates significant differences in the critical language and reception of body/performance art by men and that by women in the early seventies. Robert Pincus-Witten, for example, stresses the link between Acconci's work and that of Duchamp. The possibility of a genuine discussion on what it might mean that a man was trying to give himself a woman's body is averted by the emphasis on the association to Duchamp's androgynous transformations and objects: the Rrose Sélavy portrait and *The Wedge of*

Chastity. Acconci's outrageous performance is crucially validated as high art by the linkage to the Big Daddy of conceptual art. This is *crucial:* here is a man trying to investigate his sexuality by playing with himself in public and playing at being a woman, at a time when feminism was beginning to question prevailing assumptions regarding sex and gender, and the male critic immediately relates the work to the transvestism of another male artist, to an artist who preeminently represents the phallus as law, de-emphasizing the visual and the sensual for an ironically distanced intellectual erotica. So Acconci's hidden penis becomes the phallus of Duchamp. Whatever the meaning of Acconci's transsexual experiments, male hegemony over art history is assured.[27]

Society often tolerates and even encourages the femininity of male artists. Catherine Elwes, who helped organize the *Women's Images of Men* exhibition in London in 1980, writes that "their role is often to provide the opportunity for other men vicariously to experience their buried femininity. The power and prestige of the artist's biological masculinity is *reinforced* rather than undermined by artistic forays into the feminine. His status as an artist partly depends on this poetic femininity."[28] In fact, Acconci's work is an early example of what has come to be described as the *Tootsie* syndrome, in which the best woman is a man.

A double standard, predictably, exists in the critical reception of works by women who have used their naked bodies in parallel investigations of representation and sexuality. Carolee Schneemann, Hannah Wilke, and others have more often than not had to deal with accusations of narcissism and sluttishness. Instead of phallic validation, they have had to struggle to keep the perception of their work from collapsing into issues of notoriety.

No series of events better documents this than the scandal created by the Lynda Benglis ad in the November 1974 issue of *ArtForum.*[29] Benglis first attempted to have the representation in question placed in the "editorial matter of the magazine, proposing it as a 'centerfold.'"[30] While Acconci tries to hide his penis, Benglis—oiled and tanned, bikini marks highlighting her breasts and ass—wears nothing but sunglasses and a huge double dildo, which she holds so that, while it juts out a foot from her vagina, it also hints at a somewhat gingerly insertion. But whereas Acconci was compared in *Art-*

Forum to Duchamp, Benglis is decried in letters to the editor (*Art-Forum,* December 1974) as a "shameless hussy" (in a letter from Peter Plagens). On the same page a disclaimer signed by Lawrence Alloway, Max Kozloff, Rosalind Krauss, Joseph Masheck, and Annette Michelson states that Benglis's ad "exists as an object of extreme vulgarity," an example of self-exploitation, "deeply symptomatic of conditions that call for critical analysis," and that "infect the reality around us."[31]

These editors state that while the Benglis ad "is by no means the first instance of vulgarity to appear in the magazine, it represents a qualitative leap in that genre, brutalizing ourselves and, we think, our readers." Might Robert Morris's ad in the April 1974 issue be one such "instance of vulgarity"? Benglis and Morris lived together at the time and it has been said that they were daring each other to exhibitionist heights in their presentations of self. In his ad, Morris turns himself into a penis, a GI helmet forming the head, and his bare and oiled pecs and biceps the shaft. But, decorously, he is shot from the waist up and for good measure you can spot his BVDs waistband at the bottom edge of the photograph.

Both pictures *are* incredibly vulgar, but Benglis loses the dare because she manages to offend women by using her body in a pornographic display, and men because she doesn't just assume a penis, but a huge and defiant one (or perhaps, as one friend has suggested, her true error was in not giving herself balls as well). While male representations may safely take the route of investigations into femaleness, Benglis's venture into maleness is truly transgressive (and thereby dismissed as mere vulgarity).

To turn to the work of a currently successful figurative painter, Eric Fischl's work is chronologically and to some extent conceptually indebted to issues raised by the feminist movement and to the permissions it gave to representations of sexuality and vulnerability. An early work on glassine (1982) presents an interesting baseline for a study of Fischl's representations: men and women shower, a couple of them interact, the others are self-absorbed and contained in their individual space (and sheet of glassine). The overlapping, autonomous, transparent layers of the drawing surfaces echo the autonomy of the figures. This image is open-ended formally and iconographically.

Fischl, in other works that deal with the male and female nude, continued to go beyond conventions of representation of the nude

in that he not only placed women in situations where nudity seems uncalled for, but also men.[32] Several paintings examine relationships between men and either reveal or allude to representations of phallus and penis. In *Boys at Bat* (1980) a boy ponders his masculinity in relation, not to the "phallic mother" (as in other works by Fischl, or metaphorically in Nitsch and Acconci's works), but to the big penis, big bat of the adult "boy." For once the child is clothed and the adult is naked, his power marked by the bat on the ball and his unveiled penis.

Father and Son (1980) presents an unusual subject—two men on a bed—and an ambiguous situation. The parallel lines between the father and son that emphasize their similarity is broken by the wall of pillows separating them, a wall of taboo that keeps the hairy-chested large male from touching the younger and curiously feminine or androgynous male beside him. The relationship between father and son, father and wife, the interchangeability of son and wife, son and mother, are touched on in a subtle manner. Nevertheless, the taboo subject imposes a veil on the representation of the penis, and one might note that again a male artist identifies his sexuality in an allusion to the mother.

Portrait of the Artist as an Old Man (1984) imagines the aging Fischl before his (blank) canvas and easel, near a field shaded by a late afternoon sun. Facing us, his eyes are hidden by dark glasses and his hand reaches beneath a folded copy of the *New York Times* to hold his covered penis. In an interview, Fischl equates fears about success in art and the art world with fears about sexual potency. He says of this painting: "You think you have caught him or captured him in some way but you haven't gotten him—he remains inscrutable. It's all about the anxiety of whether he can ever get it up again."[33] The assertion of phallic creativity as male sexual act has returned us to the veiled penis of traditional male representation.

The pattern of mystification and occultation of the penis in the service of phallic domination finds its sources, certainly, in the castration complex. Further, if, as theorists from Lévi-Strauss to Lacan have made clear, women are "useful" principally as exchange value between men, patriarchy rests also on repressed and veiled homosexuality. The fear of an open representation of the penis is the fear held by heterosexual male artists of the possibility or the revelation of this latent homosexuality. "As the site of a sublimated homosexual encounter,

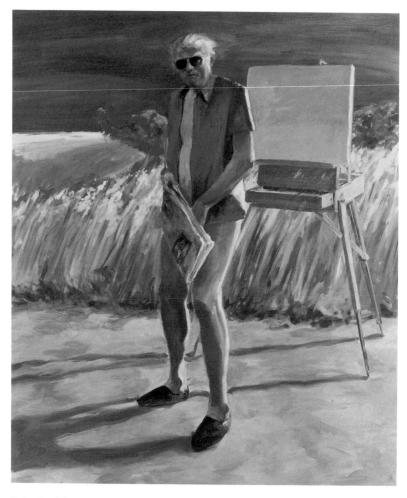

Eric Fischl, *Portrait of the Artist As An Old Man,* 1984, oil on linen, 85 × 70 ins. (Courtesy Mary Boone Gallery, New York)

the male nude may be too explicit and therefore too threatening to encourage fantasy. 'Man is reluctant,' argues Laura Mulvey, 'to gaze on his exhibitionist like. Even Renoir . . . is said to have been too embarrassed to work from a male model. The man who painted "with his prick" could not countenance the appearance of a rival one.'"[34] Rival or eroticized. It is worth considering representations of the penis by gay male artists to see how the appearance of the penis is "countenanced" in less sublimated homosexual encounters.

In Florence, postcards of close-ups of the penis of the *David* of Michelangelo are perennial best-sellers. Although a conventional representation in its stylization and in the small scale relative to the *David*'s huge hands and feet, it is a beautiful carving and denotes, along with the languor of the *contrapposto,* an eroticized male.

For gay male artists, the male nude is the sexual object of desire. The penis is larger and, iconographically, as well as formally, more central to homosexual depictions. Note Charles Demuth's long secreted watercolors of sailors and other men with big penises at the beach, at the baths, in bed, or pissing in the street. In Demuth's *Distinguished Air* (1930) a group of spectators surround a sculpture of a penis with an eye at its tip. In the watercolor *Harbor* (1986) the Los Angeles artist Tom Knechtel centralizes the penis: the subjectivity of the male figure is erased as the face drowns in the shadows, while the penis is in the spotlight. In this sea, it is the penis (body/sexuality) not the face (mind/subjectivity) that is the harbor.

In their proper British suits, Gilbert and George were personifications of *phallus:* only their red-painted faces indicated a difference that becomes explicit in more recent work such as *Two Cocks,* (1983) in which two huge, cartoonlike cocks sport red heads. Of these giant cocks Gilbert says "Yes, we're very interested in sex. And in sexy art." [35] And George tells a story about a critic who was "furious that one of our pieces had a penis in it. I took him to task on the phone—the only time we've ever responded in this way—I said I was amazed because museums are filled with penises, the National Gallery, the British Museum, I said you can even find them in trousers. Panic immediately! A few years later he invited us to take part in a group show in Liverpool and wrote us a letter saying but no cocks please." [36]

These big, bright works and Gilbert and George's amusing affirmation of penis pride may seem painful right now, in the era of AIDS (although the interview quoted is from 1987). And works by Robert Mapplethorpe from the late seventies and early eighties now also carry a distressing resonance, made more poignant by the recent public report that the artist himself is suffering from the illness. [37]

Mapplethorpe glorifies the male nude as homoerotic spectacle: large penises are the isolated subject/still life object of the image. If traditionally, "it is illegal to show an erection," [38] Mapplethorpe thrusts erections in our face: in one photograph there is nothing but a clenched fist "firmly grasping [his] virility." The confrontational as-

pect of this imagery is developed in pieces such as *Bill, New York* (1976–77), in which two shots of an erect penis frame a mirror for the viewer's own reacting face.

Although certain photographs show activities that are unclear or unimaginable to an uninitiated audience, it has been noted that Mapplethorpe's male images are in some respects aligned with a phallocratic ideology, "confirming rather than questioning the myth of masculine virility."[39] These images are in their own way an ideal of perfection, a gay ideal at the very least. Arthur Danto points to the role of "immensity . . . in this aestheticizing, and hence in the vision from within which the (male) genitals are perceived as beautiful. And this is disappointingly as reductive and mechanistic an attitude as that which thematizes big breasts in women" (*Nation,* 26 September 1988, 248). Certainly, many of Mapplethorpe's models lose their individuality, whether to their leather masks or to the exclusive focus on their penises. *Richard* (1978) is the ironically personal title of a diptych of an anonymous penis tightly strapped into a wooden contraption, splattered with blood in the second frame—Richard *is* his penis and its tortured sexual narrative.

Thomas (1987) presents Mapplethorpe's revision of Leonardo's *Vetruvian Man:* a black man pushes at the corners of a square framing his body. His head is bowed so that we cannot distinguish the "individual character" of his face. Set off by his squatting pose, his genitals are literally "well hung" away from his body to form the center of the square photograph; they are central to this work's geometry. Mapplethorpe's photographs frequently allude to racial myths. Many of his photographs of full nudes and close-ups of penises and other body fragments are of black men. Like tribesmen seen in travelogues, they are pictured as "outside culture."[40] Black men may be allowed big penises because, in the myopia of a Eurocentric culture, they are *denied* the *phallus* of language and history; like women they are considered closer to nature and unmediated sexuality.

Recent works such as *Calla Lilly* (1988) return to the aestheticized and veiled phallus of a flower's pistil. And, in a striking self-portrait (1988), Mapplethorpe's face floats in blackness, while in the foreground his hand grasps a cane tipped by a tiny skull: a triumphant dick head has become a threatening death's head. It is a powerful recapitulation of a sexual subculture's flowering and suffering.

The gay subculture documented by Mapplethorpe in the seventies and eighties is prefigured in works by Nancy Grossman from the sixties and early seventies. Blackness is transposed to the black leather encasing the taut, erect phallic male figures who have real penises and balls, representationally carved in wood from live models. In collages from the seventies the gun is phallic substitute for the face, so male subjectivity is associated with physicality, violence, and comic machismo. Grossman, as a lesbian artist, is in an interesting position culturally. Her work reflects gay male attire and sensibility, her figures are phallically erect, yet action is prevented by bondage. Whose action, one wonders? That of the male image or of the woman artist? The identification of female artist and male model is one of a variety of strategies deployed by women artists in their representations of men, and of the penis in particular.

In the circular drama of representation, woman is a stage and also a specially constructed mirror. In *A Room of One's Own* Virginia Woolf writes, "Women have served all these centuries as looking-glasses possessing the magic and delicious power of reflecting the figure of man at twice its natural size. Without that power probably the earth would still be swamp and jungle . . . mirrors are essential to all violent and heroic action. That is why Napoleon and Mussolini both insist so emphatically upon the inferiority of women, for if they were not inferior, they would cease to enlarge. . . . if she begins to tell the truth, the figure in the looking glass shrinks."[41] Whereas some straight men rely on strategies of diminution and dissembling, or resort to explorations of their femininity, some gay men and many women accord the emblem of maleness, the sign of patriarchy, a more proportionate degree of centrality and importance.

Women's representations of the male nude, and of the penis, often forego conventional eroticism for a critique based on anger and humor. In *Male Bomb* (1966) Nancy Spero transforms and multiplies the penis into fire- and blood-spitting weapons. Spero reconnects the phallic weapon to its human embodiment; she does not tolerate the distance between phallus and penis some might seek to advance. And snakelike penis heads bursting like shrapnel from the head of the male figure displace the legend of Medusa, with its connotations of castration and lack, onto a male head.

Jonathan Borofsky's *Male Aggression Now Playing Everywhere* (1985) is

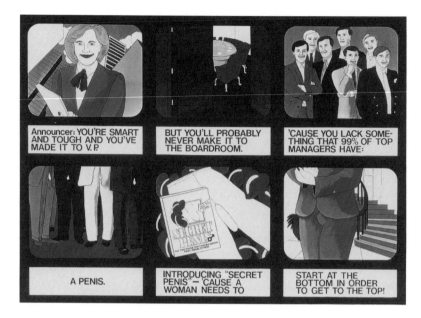

Erika Rothenberg, *Secret Penis,* 1987, acrylic on canvas, 50 × 60 ins. (Courtesy of the artist and P.P.O.W. Gallery, New York)

formally very similar to *Male Bomb:* a rampaging male has as genitalia every form of military hardware. Also a critique of phallic oppression and aggression, it is nonetheless a very *cheerful* image. It emits a kind of confidence, unlike the nervous fragility of Spero's explosively violent figure. As a man in our culture, not having to struggle against patriarchy to quite the same degree, Borofsky can afford comfortable humor even as he takes a critical stance.

An ironic and humorous approach is evident in works by such younger artists as Erika Rothenberg. In *Secret Penis* (1986) Rothenberg uses a resolutely cheerful storyboard/cartoon format to trace the tribulations of the female executive. Rothenberg then suggests (and in other pieces proposes the marketing of) "SECRET PENIS," a special kind of pantyhose. A life-size, bottom-half mannequin model for this work is the centerpiece of the total installation work. *Prick License Plate* (1986) is even more economical in its comic means: this painting is a straightforward representation of a New York State 1980s orange-and-black license plate, customized so as to proudly affirm the character of its presumed driver, "prick."

Jane Dickson, Untitled from *Hey Honey Wanna Lift?*, 1981, page of artist's
book, 8½ × 5½ ins. (Courtesy of the artist)

Joyce Kozloff, *Pornament is Crime #14: Koranic Quotations or Who's King?*, 1987, watercolor on paper, 22 × 22 ins. (Courtesy of the artist and D.C. Moore Gallery, New York)

The (eponymously named?) Jane Dickson's *Hey Honey Wanna Lift* (1981) is a cartoon book documenting the love affair of a man with his Dick, including a tender scene where he, in a suit, has his arm around and eyes on, her/it (in a skirt). A very proper couple indeed. Later they go dancing.

An instance of the ambivalent combination of anger and humor is *Pornament is Crime* (1987),[42] a group of watercolors by Joyce Kozloff, in which characters and styles from Indian, Chinese, Arab, and Western art meet in sexually ambiguous and compromising situations. In *Koranic Quotations or Who's King?,* on an Islamic-styled background of pattern and writing, Greek figures carry, balance on, and kiss huge

penises while a Persian man puts his rather smaller one into an un-happy, bound-up donkey. These "appropriated" images are mixed up in an insistent manner that suggests the universality of certain (male) sexual practices and hegemonies.

Even without anger or satire, a degree of unsentimentality perme-ates male representations by women artists, even when the mutuality and coexistence of the sexes is examined. Joan Semmel paints from a neutral point looking down the bodies of a naked man and woman in bed, barely touching in *Intimacy/Autonomy* (1974); Bailey Doogan in *Couple I* (1986) has a man and a woman clinging to each other. Their naked flesh is bloody and translucent, a thread of blood links the genitals of two human beings in a state of mutual vulnerability and fragility.

Alice Neel deserves a special place in any study of male repre-sentation, if only for her *Portrait of Joe Gould* (1933), which combines vivid realism, humorous exaggeration in the multiplicity of the penis (three figure studies have a total of five penises), and sympathy for this slightly foolish looking individual. His face is easily as memo-rable as the rest of his richly painted anatomy. As she put it, "He was just a little bit off his rocker, of course." [43] Neel is realistic, imagina-tive, sympathetic, and *irreverent*. One hopes that these are characteris-tics no one would fear, but, as she continues, "Malcom Cowley saw it one time, and he said: 'the trouble with you, Alice, is you're not ro-mantic.'"

Neel's *Portrait of John Perreault* (1972) also centralizes the penis with-out romanticizing it. In both paintings the model's face and his sexual organ are given equal importance and individuality, not often the case in paintings of female nudes by male artists. In a portrait of her in-fant grandson, Neel approaches a hallowed subject with a fresh real-ism, which replaces the uncanny "wee wee" of the Renaissance Christ with a purple-and-brown growth of living flesh that foretells his adult sexuality more than his godly death.

If the penis has been hidden to protect it from the female gaze, it is partly because man is uncomfortably aware that, from his birth and infancy, through illness and death, woman, as mother, lover, and nurse, knows the male body in all conditions, from tiny penis to erect sexual organ to the limp, bloodless appendage of the aged father or husband. Neel and Doogan make clear that the penis can be depicted

honestly, not as a stylized button, or an afterthought of clay, nor even mythically erect, but as a vulnerable piece of flesh without the humanity of the man being impaired; rather, in this kind of representation, man's "humanation" is evident. This, however, may impair patriarchal hegemony.

A final strategy of depiction of the penis by women artists returns to the "phallic mother." The woman artist arrogates to herself and her creations the power of the phallus and the erect penis. If no one has the phallus, but man has the means to represent it on his body, so one might suggest that while no one, including woman, can return to the phallic mother, woman might have greater access to her legendary power.

Mia Westerlund Roosen's *Orlando* (1982) and Louise Bourgeois's *Labyrinthine Tower* (1968) and *Pregnant Woman* (1947–68) are all not only phallic sculptures in the traditional sense; despite their degrees of abstraction, these sculptures' shafts and heads more than coincidentally recall the anatomy of the penis, while they also share a "virile" sense of outgrowth and projection. The assumption of virility by a woman is emphasized by the transvestism of the titles: Roosen's *Orlando* directs the interpretation of the work to the transsexuality of Woolf's heroine/hero; similarly, two of Bourgeois's penis sculptures are gendered in their titles as female—*Pregnant Woman* and *Fillette* (1968). *Fillette* is the astonishing title to a very graphic modeling of a penis and balls: in a photographic portrait of Bourgeois by Robert Mapplethorpe, she holds her penis/girl doll, and her wickedly witty face lets us in on the sexual nature of her sculpture. This penis is everything: as *Fillette*/little girl it is the baby as penis substitute, as rugged depiction of a stiff penis and big balls it is a sexual instrument of pleasure (again her knowing smile), and as creator of this polysexual object, which she cradles in her arms, Bourgeois is indeed the all-powerful phallic mother.

Feminism, gay culture, and AIDS have each contributed to recent examinations of the phallus and penis. The frequent reference to the female body in attempts to reveal male sexuality may result from millennia of thinking about sexuality in general as a problem of femininity (always from a male point of view), but it also may explain, along with the logical development of feminist thought from only

reevaluating woman toward examining man, my own interest in the subject. Yet I confess I remain dubious about the wisdom of focusing on man, in an "everlasting return of the same."[44]

Nevertheless, resituating the gaze seems a necessary step. One can hope for a true revelation and "humanation" of the penis. An "if you've got it flaunt it" representation such as the *Cerne Giant* (first or second century A.D., Britain), a 180-foot figure of a man with a big, erect penis and brandishing a huge club is at least refreshingly honest as to his intentions and mentality. The great murals by Giulio Romano of Venus and Mars, in the Hall of Cupid and Psyche in Mantua's Palazzo del Tè, present splendid prototypes of man and woman as equally luscious and strong sexual partners. Although I was not able to discuss non-Western art in this essay, a Dogon Door Post, as well as many other African artworks, speaks to the same vision, of man and woman, together, equals in life and pleasure, without the repression or veiling of either element.

Can penis be separated from phallus? Can phallus/penis as interlinked concepts be separated from narcissism and function in a more interactive role, as an instrument of desire for another body, rather than a negation of another's subjectivity?

If penis is represented, then phallus may become unveiled in the process. Once seen, phallus may be reevaluated and its power could be undermined, and the "phallosensical hommologue"[45] of Western civilization might be interrupted, and, only then, when lack is not seen as a "hole" but "whole," and phallus/penis is unveiled, can art attain the possibility of its own reintegration, reanimation, reincorporation, and de-castration.

Forensics: The Part for the Hole

*Is that blue dot over your face a hole in the signifying economy,
or are you just glad to see me?*

They say that a picture is worth a thousand words. But the odd
congruence of two recent, sexually explicit, shows—the nationally
televised William Kennedy Smith rape trial in Palm Beach, Florida,
and the Jeff Koons exhibition in New York City—casts doubt on such
common wisdom. Putting aside for a moment questions of guilt or
innocence (does it matter to which exhibition I refer?), these media
events spoke to the continued erotic and aesthetic value of metonymy,
the problematics of female representation and narrative, and the hardy
survival of patriarchy despite superficially deconstructive revelations.

The visual elements deployed in both cases were strikingly similar:
sex acts engaged in by a naked man and a partially but expensively
(and seductively) clothed woman involving an audience in a exhibi-
tionism/voyeurism tango. In one case the entire act was the image,
as reflected by the titles: *Blow Job, Dirty—Jeff on top*. In the other, the
act was endlessly fractured and delayed. Evidentiary rules, forensic
analysis of "trace" evidence, the vagaries of human memory, and the
monocularity of television formed a kind of Duchampian peephole,
as jury and national audience attempted to put together a complete
narrative while only being exposed to a single frame at a time.

The alleged victim's bra, for example, was depicted through increasingly more detailed studies. It was first handled by each man and woman on the jury. At this stage of disclosure, the national audience could see the *handling* of the bra but could barely make out its delicate form. Later a forensics expert described verbally the layered series of analyses to which it had been subjected. Although legally inconsequential, it was held up as a sign of prurient femininity: black, transparent, decorated with navy blue satin and four fake pearls sewn to the front with fragile, and significantly unbroken thread. Photomicrographs were introduced to show that it was unmarked by trauma. Examination of the outer layer of her dress, showing that "the pattern of the material under the microscope was not disrupted," proved to be the determining evidence for at least one, female, juror. The bra, the dress, the panties, the pantyhose, each in turn was the focus of the most intense technological scrutiny available to modern criminal science. Each item then became an agent in two separate and conflicting narratives. This process alone could be interpreted as constituting a rape, with the jury and television audience as participants.

At the trial the brand name of the item of clothing—the bra was by *Jezebel!*—was but one element in a complex picture as pixillated as the shimmering analytic cubist manipulation of the alleged victim's face. In contrast, the Koons pictures might well have been tableaux in a lingerie catalogue gone slightly amok. We could at one glance see Jeff's cock in Ilona's cunt, his hands on her ass, her white lace stockings and bustier, and her gold, high-heeled, mesh slippers. The only thing lacking was a price list: Ilona's red, patent-leather, thigh-high boots, $395.99. In both cases the focus on fancy underwear as a woman's work clothes proved that fetishism dies hard.

But did the woman in either case have any other choice than playing the part for/of the (w)hole? When the woman's only choice is between portraying orgasm, crying rape, or crying wolf, when her only directorial order is to "ask for it," then an alternative narrative of female eroticism cannot even be imagined. The "climax" of the rape trial was not the testimony of the alleged victim but that of the accused, which not only more accurately matched the forensic evidence but which even made more sense as a story of sexual intercourse so callous that it could be interpreted as a psychic, if not a physical, rape. The climax of the Koons/La Cicciolina enactments is literally come spilling over her face. His face and body are not visible except for the presence of

Lutz Bacher, *My Penis,* 1992, video still, contact sheet. (Courtesy Pat Hearn Gallery, New York)

penis and éjaculate. She lies on a lawn, in a blue chiffon top, a pearl tiara, blue mascara on her open but glazed-over eyes. The title is *Exaltation,* but how can this be a picture of *her* pleasure when she looks dead? Another image is of Jeff going down on La Cicciolina, so one might at first imagine this at least to be her narrative, but the title — *Manet* — gives away the patriarchal orientation. The manipulation and display of a courtesan, the validation of male eroticism through an allusion to a powerful father figure, these are as emblematic of traditional male heterosexuality, no matter how transgressive the work

Lutz Bacher, *My Penis,* 1992, video still (detail), 10 × 8 ins. (Courtesy Pat Hearn Gallery, New York)

"The Bitter Tea of General Yen": Paintings by David Diao

Among the relatively few painters today seeking to infuse modernist painting with political content and conceptual rigor, David Diao is one of the most elegantly subversive.

Diao's early success with minimalist, process-based abstraction was followed by a hiatus of creative doubt from which the artist emerged, in the mid-1980s, with a new mechanism for the continuation of painting: he began to look to the history of modernist painting for iconic images whose appropriation provided a framework, almost an excuse, to keep painting. Colorful, abstract paintings were based, for example, on the shapes of the objects in a famous photo of a 1915 Malevich exhibition; other subjects included emblems and logos of the Bauhaus and DeStijl, artist signatures and atelier stamps. In the early 1990s, Diao, struck by how few works Barnett Newman had made, began a series of works detailing that production in a format and style analogous to Newman's. These led to paintings examining his own career: for example, in *Sales* (1991), red dots of different sizes turn out to be symbols for Diao's checkered sales history.

Diao's spring 1995 exhibition at Postmasters Gallery in New York City, entitled *The Bitter Tea of General Yen,* continued this area of in-vestigation, keeping the artist on an intriguingly dangerous course

between the low road of petty self-absorption and the high road of sociohistorical commentary.

In *Synecdoche* (1993), a collage and silkscreen on paper on five panels, he has reproduced, with alterations, a catalogue text by the highly respected and canonical art historian Benjamin Buchloh on the equally respected and canonical Gerhard Richter, placing reproductions of *similar* but *earlier* (by about a decade) works of his own on top of Richter's, crossing out Richter's name wherever it appears, inserting his own above it in red marker and recaptioning the inserted paintings. Behind Diao's color xeroxes of his abstract paintings of broad, squeegeed, vertical expanses of color are what appear to be similar paintings by Richter. Similar, except that Diao's paintings were done in the moment of the particular style, whereas Richter's are ironic (or so it is generally thought, although this is sometimes denied by Richter himself) retakes of this late modernist phase of painting. A sentence will thus read, for example, "Diao's" [formerly "Richter's"] "so-called 'Abstract Paintings'—a series that originated around 1966" [formerly "1976"] "and has since undergone a number of subtle transformations—has elicited on numerous occasions, in particular with American viewers [crossed out]," "the question concerning their historical place and their aesthetic attitude." Diao addresses the question of *his* historical place and of Buchloh's role in the maintenance of a closed system that may prefer ironic *re*-creation (commentary on, i.e., erasure of) painting to its most primary, sincere cousin, abstract painting, and may not permit to artists considered "Other" access to modernism, abstraction, or, indeed, irony.

Diao is a male artist with a curious attitude toward patriarchy. Seemingly less oedipally rebellious than most, a respectful admirer of modern art, he is nevertheless compelled to critically needle its iconic institutions and personalities: Buchloh and Richter are bulwarks of late modernism's infrastructure, while other works develop Diao's fascinated and fascinating relationship to the Museum of Modern Art (MoMA).

It is many artists' dream to have a retrospective at the MoMA. One can hardly trust any artist who denies planning what she or he will wear to the opening. Diao presents various "documentation" and "evidence" of such an event: *Board of Trustees* (1994) requests "the pleasure of your company at the opening of the exhibition *David Diao:*

25 Years of his art on Tuesday, August 7 from nine o'clock until midnight." The creamy color and block letters clearly evoke the heavy matte card-stock of such invitations. A private joke is that this date is that of the artist's birthday but also the worst time of the year to exhibit! *MoMA I, II,* and *III* (1994) are three monochromatic paintings of possible covers for his MoMA catalogue: the angle of the words "David Diao" at the top and "The Museum of Modern Art" at the bottom produce a frowning face in optically hallucinatory red letters on brilliant blue (*MoMA III*), and a smiling face with blue letters on a golden ochre yellow ground (*MoMA II*). "25 years of his art" forms the nose of these masks of tragedy and comedy.

Carton d'invitation (1994), a large silkscreen, vinyl, and acrylic on canvas, continues the examination of career fantasy while tracing the actual mechanics, the bits and pieces of business, of career production—inviting us to Diao's retrospective at the Centre Pompidou in Paris. Lettering on the right is juxtaposed to a larger than life-sized image of a half-naked Bruce Lee in mid karate chop—the humorous return of the repressed aggressing the institution as surely as Diao's erasures and insertions in the Buchloh/Richter text.

An enigmatic work represents the title of the exhibition: *The Bitter Tea of General Yen* (1995). A silkscreened still from the 1933 movie catches as if in mid projection three frames of a scene in which the elegantly handsome General Yen (Caucasian actor Nils Asther), in Westernized military attire, sits between and slightly below a loutishly attired Walter Connolly and an exotically robed Barbara Stanwyck. Despite Yen's visual centrality in the frame, the power of his uniform, and his aura of forbidden sexuality, he seems trapped and subjectified by these two white people. It is tempting to see Yen as a stand-in for the always already displaced Diao. Born in mainland China, as a young boy he rejoined his father in America while his mother remained permanently behind the bamboo curtain. Fully Americanized and a total Europhile, deeply committed to the discourse of Western modernism, in this work he allows the dualism of his personal history, his consciousness of cultural ambivalence to emerge with a trace of anger, of eroticized sadness, and of perverse humor.

Diao takes a tremendous risk of appearing uppity (how dare he question Buchloh's authority or put his name in the place of Richter's?), deluded and vulnerable (hey, pal, don't hold your breath for

David Diao, *The Bitter Tea of General Yen,* 1995, silkscreen, vinyl, and acrylic on canvas, 75 × 46 ins. (Courtesy Postmasters Gallery, New York)

that MoMA retrospective), and "bitter." But his analysis of career production points to broader realities that he is able to comment upon only because he has understood the limitations on his own career desires. And the humor in the work has strategic value: in a work not in the Postmasters exhibition, are the words "Pardon me, your chinoiserie is showing." Diao pokes fun at the West's double standard: Western art can boast of its usage of Asian influences while restricting Asian, including Asian American, artists' access to Western modernism.

You might think that it would be enough to just hear about the concepts behind these works and yet, while not painterly, they have undeniable physical presence and continue to grow and surprise even after repeated viewing. The impact of the statistics of Newman's production in *Barnett Newman I* (1992) is enhanced by its Newmanesque expanse of red with optically striking "zips" of lettering. If the MoMA were as committed to the meaning of its collection as Diao is, it would acquire this work as a historically necessary companion to Newman's *Vir Heroicus Sublimis* (1950–51).

Diao evokes and mocks the artist's desire, or "yen," for success, which like all desire, can never be sated. What removes this work from a sour grapes reading is the certainty it produces that if Diao ever achieved his MoMA retrospective, despite his own wish to fit in, he would surely spot more flaws in the institution, rekindling the heat under the kettle of *The Bitter Tea* of this perversely subversive artist.

FEMININITY AND FEMINISM

From Liberation to Lack

The three phases of the historical and political development of femi-
nism—from the demand for equality, through the rejection of patri-
archy by radical feminism, toward a third position that sees the male/
female dichotomy as "metaphysical"—present a dilemma to femi-
nists whose own personal maturation has been synchronous with the
women's liberation movement of the early seventies, the feminist art
movement, and the recent influx of French feminist psychoanalytic
and linguistic theories, a dilemma that is replicated in the disposition
of the books in my library on feminism and feminist art and art-
historical analysis.

Equality[1]

In a cardboard box stored at my mother's house: a dog-eared copy of
Our Bodies Ourselves, Everywoman (by the Fresno Feminist Art Program,
1971), and the first issue of *Ms.*

In my closet: a yellowed photocopy of Linda Nochlin's 1971 essay
"Why Have There Been No Great Women Artists?"

On my shelves: *A Room of One's Own* (every sentence underlined and
then reunderlined in darker graphite); *The Second Sex* (inherited from
my older sister, the pages nearly powder).

Radical Feminism

From the Center by Lucy Lippard; *Women Artists 1550/1950* by Ann Sutherland Harris and Linda Nochlin; *Feminism and Art History* edited by Nochlin and Thomas Hess; monographs, catalogues, autobiographies, and biographies of women artists: Frida Kahlo, Charlotte Salomon, Louise Bourgeois, Alice Neel, Georgia O'Keeffe, Agnes Martin.

Rejecting the Dichotomy

More accessibly placed in the front row of my shelves: *Old Mistresses: Women, Art and Ideology* by Rozsika Parker and Griselda Pollock; *The Madwoman in the Attic* by Sandra Gilbert and Susan Gubar; *New French Feminism: An Anthology* edited by Elaine Marks and Isabelle de Courtivron; *The New Feminist Criticism* edited by Elaine Showalter.

On my sofa, bookmarks stuck between pages: *The Daughter's Seduction* by Jane Gallop; *Speculum of the Other Woman* by Luce Irigaray; *The Newly Born Woman* by Hélène Cixous and Catherine Clément; *Sexual/Textual Politics* by Toril Moi.

All is not on the distaff side: back shelf, *Letters to a Young Poet* by Rilke; in the front, *Ways of Seeing* and *The Sense of Sight* by John Berger, *Art After Modernism: Rethinking Representation* edited by Brian Wallis, *Recodings* by Hal Foster; on my sofa, *Male Fantasies* by Klaus Theweleit.

The purpose of this list is not to boast of erudition but to illustrate the feminist dilemma, which is that all of these books remain relevant. Feminism has little institutional memory, there has been no collective absorption of early achievements and ideas, and therefore feminism cannot yet afford the luxury of storage. Teaching young women to paint, I have found that every young woman who feels in herself the inchoate desire to do something, say something about her life, must begin at the same beginning, or very close to it, that my sisters and I did seventeen years ago. The rose-filtered lenses that camouflage patriarchal domination need to be removed, and the ABCs of feminist art history and thought must be learned anew. Thus, a feminist art teacher cannot afford to pack away Linda Nochlin's signal essay "Why Have There Been No Great Women Artists?" yet she must also

be cognizant of the psychoanalytic and linguistic writings implicit in the very title of Nochlin's more recent essay "Courbet's *L'Origine du Monde*: The Origin without an Original."² While alert to the need of unformed art students, the feminist teacher must be responsible to the growth of her own work. Women of my generation form a living bridge across ebb tides of feminist thought. It is in the spirit of this role that this essay on feminist art is written.

The earliest proposals for what might constitute feminist art concentrated, in terms of content, on personal experiences reexamined in consciousness-raising sessions. Previously untold stories of marginality and repression were shared and reworked into statements of rebellion and affirmation. There was an awakening of body awareness, pride, and anger. Satiric readings of female images in popular culture were attempted. Formally, central-core imagery and layering were proposed as metaphors of female sexuality. Previously trivialized methods of production, such as quilting and embroidery, were redeemed for "high art."

These proposals were based on empirical observations of thematic and formal recurrences in art by women (and it is remarkable how persistent these occurrences are), and fueled by the understandable desire (urge) to define and validate what a visible "Other" might be. Innocent and idealistic, and also in opposition to male representations, women artists sought to create representations of female sexuality, of femaleness, and femininity. In their search a belief in representation was evident and implicit.

In the last decade, the work of French psychoanalytic and linguistic theorists has served to undermine the stability of concepts such as identity, authorship, origin, representation—precisely the concepts that American feminists had been trying to resituate within the artwork of women artists.

It is a familiar irony in the history of feminism that the goals feminists fight to achieve are declared insignificant or in error just as the goals are at last met. For example, in the nineteenth century, just when women artists were finally admitted to drawing classes with a male nude model, the nude lost its primacy as a concern of art. Some of the ideas of French feminism might seem to operate in a similar pattern of frustration. This is not to say that there are no threads linking the old feminism (Anglo-American) and the new (French). There

are times when the description that an Italian waiter once nightly af-
fixed to a pensione's endless re-presentations of veal—*la même chose*
("the same thing")—applies, but with different references and more
sophisticated and erudite methods of analysis and critique. Ameri-
can feminism of the early seventies unveiled the sexism embedded
in the quotidian experience of our culture, and further, in Western,
Greco-Roman, Judeo-Christian civilization. French feminism restates
the problem, indeed deepens it, by positing that a person's very ac-
quisition of language, her entry into culture, is an inscription into the
world of the phallus, the law of the Father, which language *is*. (These
are ideas primarily developed by the French psychoanalytic theorist
Jacques Lacan.) Any effort to ignore this law, to search for a defini-
tion and a representation of female sexuality, crosses a field mined
and snared by phallocentric logic; to seek to define the "Other" is still
to operate within the framework of a "binary system" in which the
phallus is the primary referent, yet to try to expose the flaws in phallo-
centric thought by taking its arguments to their logical ends, to use
phallocentric thought against itself by "miming" it, is to risk being
"recuperated" (remember how feminist art themes and forms used to
be "co-opted" by male artists?—*la même chose*, only different). So one
can find oneself literally in a *no-man's* land, where, as Janis Joplin so
aptly put it, "women is losers."

A question central to the visual artist, then, is how women artists
have represented female sexuality, which has been specularized[3] and
fetishized by men, yet posited as unrepresentable because unseeable,
unknowable, and unthinkable. This question is addressed in the work
of more women artists than one essay could sensibly deal with; ac-
cordingly, this essay will concentrate on some work dealing with the
representation of female sexuality as interpreted in recent feminist
critical writings, or work perceived by contemporary art critics to be
dealing with "issues of representation" and "originality."

Cindy Sherman's work is generally considered an exemplar of the in-
stability of identity. Also, her work functions as a textbook illustra-
tion of recent critical analyses of the "specularization" of woman; it
seems to spring from and to cause a proliferation of text:

> Is it necessary to add, or repeat that woman's "improper" access
> to representation, her entry into a specular and speculative econ-

omy that affords her instincts no signs, no symbols, or emblems, or methods of writing that could figure her instincts, make it impossible for her to work out or transpose specific representatives of her instinctual object-goals? The latter are in fact subjected to a particularly peremptory repression and will only be translated into a script of body language. —Luce Irigaray[4]

Now the little girl, the woman, supposedly has *nothing* you can see. She exposes, exhibits the possibility of a nothing to see. — Luce Irigaray[5]

When you lose your mind, it's great to have a body to fall back on. —Shari, Calvin Klein commercial

Formally mimicking "cultural productions" dominated by male specularity—movies and commercial photography—Sherman poses and *makes herself* up; there is no one "I" in her work. She is a blonde lying on a bed dressed in a black bra and panties, mouth half-open, eyes unfocused, body akimbo in a pose hinting at postorgasmic stupor, or, more likely, a police photographer's view of a crime victim. She is a crouching young girl in a red calico dress, looking up innocently and fearfully. She is a sweating, open-mouthed, vacant-eyed, prone woman in a wet T-shirt. She is a witch, a pig, a pimply ass, a corpse half-visible under dirt and debris. A complete survey would indicate that a substantial number of the women "enacted" by Sherman are either squatting, crouching, or prone, crazed or dead. More "positive" images tend to look stupid or have a slight mustache.

The possible interpretations of this category of "negative" representations (representations of negativity, a "nothing to be seen") unfold in a peculiar sequence that reflects the changes in her work. The ironic intention of these textbook representations of the "Other"—cunt, witch, shrew, bimbo, victim—presumably ensures that they will be seen as *critiques* of this vision of woman, in much the same way that critics have explained away images of woman in the work of her male contemporaries (such as David Salle).

One has to see a Sherman photograph on a person's wall to understand the nature of its appeal: a wet T-shirt clinging suggestively to breasts is *la même chose,* whether you call it *draperie mouillée* (see Kenneth Clark, in his *The Nude*), miming of popular culture, or tits and ass. These negative representations are disturbingly close to the way men

have traditionally experienced or fantasized women. Sherman's camera is male. Her images are successful partly because they do not threaten phallocracy, but reiterate and confirm it.

Yet another interpretation of Sherman's negative representations allows the female artist's sense of her own monstrosity, the monstrosity of her project of being an artist, to seep to the surface. The "anxiety of authorship" proposed in Gilbert and Gubar's *The Madwoman in the Attic* results from the conflation of two phenomena faced by women artists: "the dominant patriarchal ideology presents artistic creativity as a fundamentally male quality" and the "dominant images of femininity are male fantasies"[6] — the Angel in the House and the Whore. Women artists seek to adopt/adapt male forms in order to be read (in order not to be thought to babble incoherently in "no-man's" language), but their sense of monstrosity in rejecting these fantasy images and of the monstrousness of their anger against these images lurks more or less veiled within their work, like Mr. Rochester's first wife, hidden but uncontainably violent.

Sherman denies the element of self-portraiture, and there is much criticism of the autobiographical "phallacy" that would limit women artists to their (biologically determined) experience and limit the work of art by chaining it to one author. Nevertheless, Sherman is the artist and her model, the camera and its image. The more successful she becomes commercially, the more she dares her public to turn away from images so hideous they couldn't possibly sell (predictably they do)—images of the relentless degradation of woman until she molders underground. In a 1985 tableau (*Untitled #150*) she is seen from above, her face is covered with sweat, her hand touches a grotesquely large red tongue. Her expression is one of subservience yet rebellion. Perhaps a sexual slave, she is also monstrously huge in relation to the teeny "normal" figures in the background. A 1987 image (*Untitled #175*) presents a bulimic apocalypse in which only Sherman's tiny, prone, screaming reflection in mirrored sunglasses remains amid half-eaten junk food and vomit. A rejection of junk culture, it is also a case history of a female disorder—disruptive of the more conventional sexuality of her early work. The monstrosity and self-hatred of female authorship, increasingly evident in Sherman's impersonations, run rampant over the irony and create, paradoxically, a powerful feminist body of work.

But *woman has sex organs just about everywhere*. She experiences plea-
sure almost everywhere. Even without speaking of the hysteri-
zation of her entire body, one can say that the geography of
her pleasure is much more diversified, more multiple in its dif-
ferences, more complex, more subtle, than is imagined—in an
imaginary centered a bit too much on one and the same.—Luce
Irigaray[7]

Sherman's hysterical reenactments of specularization and of the mon-
strosity of a woman artist's rebellion focus on aspects of female sexu-
ality related to woman as the object of the male "gaze," as a "nothing
to see." Works by other women artists move toward metaphors of the
multiplicity of female sexuality, of "This sex which is not one." The
"geography of her pleasure" is mapped out on the scattered leaves of
the "Cumaean Sibyl" discovered by Percy and Mary Shelley and re-
illuminated by Gilbert and Gubar in *The Madwoman in the Attic*. The
legendary poetess's histories and prophecies, traced in undecipherable
languages, are strewn about a dark cave. This vision of "the body of
her precursor's art, and thus the body of her own art, [lying] in pieces
around her, dismembered, dis-remembered, disintegrated"[8] is brac-
ingly close to the experience and the work of many significant women
artists.

Significant and monumental works by women artists have been
constituted by a proliferation of "Sibyl's pages," multiple images,
often rectangular, framed and placed along a grid. The works I have
chosen to examine in content and intent span several phases and fami-
lies of recent art and feminist thought.

Hanne Darboven covers the walls of the gallery (cave) with iden-
tically framed works that bypass the pitfalls of male language by
presenting texts that are not texts, in any decipherable sense. Her
environments, of systems, indexes, and numbers, hint at an infinity
of references. The pages of this Sibyl are covered with an uncracked
code, but laid out in the irreproachable (male) grid.

Darboven's austerely neutral (neuter) and obsessively expansive
ciphers can be bookended with Mary Kelly's obsessional documenta-
tion of what is truly the oldest female profession, being the mother of
a son. Kelly's *Post-Partum Document* (1976–80), a diary of her son's early
years, is considered the epitome of art informed by Lacanian theory.

Kelly's work is an attempt to find a way to expose these processes [representation, language, and sexual position] and their significance for both woman and art. She has constructed the document in order to show what lies behind the sexual division of labour in child care, what is ideological in the notion of natural maternal instinct, what is repressed and almost unrepresentable in patriarchal language, female subjectivity. In making the mother and child relation the subject of her art work, she is addressing some of the most politically important and fundamental issues of women, art and ideology. — Rozsika Parker and Griselda Pollock[9]

Indeed, Kelly's work has many characteristics of feminist art in its early stages: it is multiple, layered in time; its subjects are motherhood, nurturing, separating. It is autobiographical and biographical in its obsessively complete narration of infant development. From Darboven's barren but infinite cryptography, we have come in *Post-Partum Document* to the all too familiarly decipherable saga, whose heroic subject is a little boy-child who triumphs against the engulfing intimacy with the mother's body as he enters into language. The piece, which begins with impressions of the boy's shit on his diapers — a Lacanian Shroud of Turin — ends when he learns to write his own name.

The name of the Mother remains unwritten. And exegeses of Kelly's work, while illuminating, leave important (and obvious) questions unasked. Would a work based on the development of a hypothetical girl-child lead to an as predictably Lacanian conclusion? And would the critical realm have valued a piece dedicated to a "nothing to be seen"? As Irigaray has noted, "the mother/daughter, daughter/mother relation constitutes an extremely explosive core in our cultures. To think it, to change it, amounts to knocking over the patriarchal order."[10]

Between these bookends lie the pages of the supposedly genderless, successful artists of the eighties. Multiplicity of forms and images, a type of layering, occurs in the works of Jennifer Bartlett and Pat Steir. Bartlett's *Rhapsody* (1975–76) and *In the Garden* (1980) and Steir's *The Brueghel Series (A Vanitas of Style)* (1984) and her self-portraits in the style of great (male) masters are major works in which mimicry

of male styles is inscribed and deconstructed within the format of "ready-made grids, a code prepared in advance"[11] (male).

Bartlett's pieces are encyclopedic assemblages of basic subjects of traditional representation (tree, house, figure) and visual components (color, geometry, mark), all on identically measured squares or rectangles. There is no "I" at all, only a hundred mimings of other identities. In *Vanitas* Steir brilliantly mimics styles and techniques from the history of art. In her self-portraits, an "I" appears repeatedly, yet transformed, disfigured, by the lens of male self-portraiture. A new Alice in Wonderland, she leaps through the "mirror phase" into the symbolic order.

This art of the mynah bird is a virtuoso brand of guerrilla warfare, for the Annie-Oakley-I-can-do-anything-you-can-do-better excellence of its "mimicry of male discourse."[12] The equivalence implied by the multiplicity of imagery seeks to undermine the coherent face of phallic identity, by belying its claim to uniqueness or originality. Both Steir and Bartlett make no effort to represent a female Other. They confront a male audience with its own image, in a fractured, albeit gridded, mirror.

One can detect a link between current theories about origin and originality, representation and reproduction, and the "law of the same," which ordains that "woman's only relation to origin is one dictated by man's."[13] The injunctions against concepts of origin and originality central to "simulationist" art, for example, seem to go hand in hand with those injunctions against female representation. The undermining, in deconstruction and simulation theory, of any integrity of representation specifically represses female representation. The art that is presently validated relies on theory and language, and language, we are told, is the Father and the phallus. In its repression, representation is feminized.

One returns then to the problem of representations of female sexuality or femininity, that is to say, the problem of essentialism:

Essentialism in the specific context of feminism consists in the belief that woman has an essence, that woman can be specified by one or a number of inborn attributes which define across cultures and throughout history her unchanging being and in the absence of which she ceases to be categorized as a woman. In

less abstract, more practical terms, an essentialist in the context of feminism, is one who instead of carefully holding apart the poles of sex and gender maps the feminine onto femaleness, one for whom the body, the female body that is, remains in however complex and problematic a way the rock of feminism. — Naomi Schor[14]

Women are waved away from the door marked "essentialism" by deconstructionist critics and by others afraid of the biologistic implications and dangers: they altruistically warn of essentialism's error of logic, the trapdoor of binary oppositions (male/female, active/passive, culture/nature). Woman is waved back, but to what? . . . to phallus and lack, lack, lack, the keystones of Freudian/Lacanian psychoanalytic theory. Like Bluebeard's last wife, she may nevertheless be impelled to open the forbidden door, even if that act reeks of the illogical, the biologistic, the binary. And in there are the wives Bluebeard has killed, a locked room full of lacks (whose portraits Cindy Sherman may have limned in her tableaux of self). But what of the still-alive wife, who opens the door?

Phallic culture (from all accounts a redundancy) has done everything to prevent, to disable women from achieving any representation of self that would not return to the primacy of the phallus, one way or another. And while it is certain that all women are permeated by the phallocratic order, efforts to escape the system, to enter a no-man's land, are understandable, even laudable, however quixotic. The injunction against essentialism seems a continuation of the repression by Western civilization of woman's experience (of which sexuality is only a part), and it should be defied, no matter the risk.

Opening Bluebeard's door takes many forms. One, certainly, is the feminist spin I have sought to put on works by women who attempt to bypass feminist interpretation in order to gain wider acceptability. It is a common reflex of women artists wishing serious consideration (and deservedly so) by mainstream standards of judgment to suppress and deny the female quotient of their art, to refuse to admit to difference. Georgia O'Keeffe's vehement denial of the sexual content of her images is a classic example of the wish to "pass." Cindy Sherman's denials of self-portraiture and of feminist intent (female rage) are a contemporary version of the same reflex. It is quick and deep: "of

course my work is of universal import, I am an artist first, a woman second." As Susan Rothenberg remarked in an interview, "When I'm in the studio, I'm just a painter."[15] No one wants to be part of a second class, no one wants to be marginal (although men can freely co-opt feminist ideas and forms, and can self-righteously search for and claim an anima . . . and get brownie points for trying).

It may be worthwhile heeding Cynthia Ozick's warning to Jewish writers with a comparable desire to assimilate: "We can give ourselves over altogether to Gentile Culture and be lost to history, becoming a vestige nation without a literature; or we can do what we never dared to do in a Diaspora language: make it our own, our own necessary instrument, understanding ourselves in it while being understood by everyone who cares to listen or read."[16] In our difference is our best hope for universality, or specificity. The Surrealist movement, in its preoccupation with the irrational and the unconscious, was in a sense the artistic apotheosis of lack (significantly the surrealist movement begins with Freud and ends with Jacques Lacan). The very intensity of its focus on lack makes it the perfect site for its reinvestigation by women artists.

> The male Surrealists . . . passionately desired woman's ability to bear children, which is why they desired woman. Indeed, I would argue that much of Surrealism is an attempt to appropriate woman's power to give birth by every treacherous means possible. Much Surrealist imagery can be understood as the product of a false pregnancy—a strangely aborted product from a female point of view.—Donald Kuspit[17]

Works by women artists such as Frida Kahlo, Louise Bourgeois, and Elizabeth Murray are representations of femininity whose organic forms and stylistic peculiarities owe much to these "strangely aborted" surrealist products. These characteristics are often described by postmodernist critics as narcissistic and fetishistic, yet these works deal directly with female body experience, sexuality, fruition, barrenness, and the quotidian facts of woman's life.

To begin by juxtaposing Kahlo's self-portraits to Sherman's, one might note that Sherman's work clearly has a surrealist dimension, as it slides into dreamlike irrationality and fairy-tale grotesquerie. Whether self-portraits or not, hers are hardly "realist" works. In

Kahlo's openly autobiographical work, an exactly controlled, detailed, and smooth paint surface, biomorphic forms and dreamlike scenes that are *retablos* of her own life parallel work by male surrealists. But, in her work, the tragedy of truncation (real) and infertility (real, not, as in the case of the surrealists, fanciful), and the possibility of fruition through art, are depicted directly, without disgust, without sentimentality, without irony. In *Henry Ford Hospital* (1932) she lies naked in a pool of blood on a large hospital bed in an empty space far away from "man's land" (the factories of Detroit); from her hands flow veins of red blood/paint toward images of sexuality and loss. She is alone with pain and paint. It is a rich solitude, transfiguring clots of endometrial blood into the richly colored matter of painting.

Louise Bourgeois also claims no distance from physical experience and autobiography. Her insistence that the source of her work resides in the psychological wounds inflicted on her by her father contravenes any formal theories of art and yet embodies the Oedipal crisis that psycholinguistic theory interprets as the entrance of human beings into the symbolic order of the Father. Bourgeois obsessively returns the critical audience of her work to its motivating source—the murderous rage of a betrayed daughter. Her admission to the symbolic order has been warped by her father's open affair with her governess, yet her link back to the imaginary (completeness of relation to the Mother) is damaged by her mother's presumed complicity.

The forms that Bourgeois's anger takes are directly related to those of surrealism. The influence of "primitive" sculptures and totems is pervasive. "Primitive" art was a locus of the (female) unconscious of "civilized" (nonprimitive) Western man; its influence on a woman artist is bound to differ. Bourgeois's *Femme/Couteau* and Giacometti's *Spoon Woman* are kin but they are not sisters. *Spoon Woman* has a tiny head and a large receptive body. *Femme/Couteau*, in its degree of abstraction, is ambivalent and bisexual. It is a vulva and a knife—what woman is and is feared to be. Bourgeois's forms are blatantly vaginal, mammary, and womblike, yet exuberantly, mischievously phallic. It would betray her intent to deny the role of her own body experience. The rawness of her surfaces and the openly sexual nature of her forms vitalize the organic/biomorphic surrealist vision of lack and dissolve the distance the male viewer seeks to place between himself and the art object and between consciousness and his own suppressed physicality and mortality.

Elizabeth Murray's paintings are not only *of* organic forms, they *are* organic forms. Like the fluids of Irigaray, like the creature in *Alien* (a mother, it turns out!), the paintings push away the rectangular frame and the picture plane, not in the additive and self-consciously art referential (reverential) manner of Frank Stella, but in a stream of interlooping, thrusting, and curving sweeps of saturated color—as their subjects, the contents of daily and studio life, are swept off their feet toward abstraction. Even her drawings insist on reshaping the frame of traditional art; but while the frame is forced to zigzag around the drawing, the drawings often center around a round, wooden clitoral plug affixed to the gritty pastel surface.

These works by Kahlo, Bourgeois, and Murray may seem subservient to surrealist influence. But they are *by* women, and, as such, the disturbing possibility of his own castration inherent in the fetishized object is doubled for the male viewer. "The idea that a 'nothing to be seen,' a something not subject to the rule of visibility or of specula(riza)tion, might yet have some reality would indeed be intolerable to man."[18] Perhaps more disturbing, then, is the possibility that the female experience of container/contained, inside/outside, evidenced in these works intimates that woman is not just a lack, not just a hole, but a w/hole, that the lacks represented in these works are full metaphors for the membrane between thought and matter, life and death, which is at the core of art.

Ana Mendieta

"What can you say about a twenty-five-year-old girl who died?"
—Erich Segal. *Love Story*

Ana Mendieta was two months shy of her thirty-seventh birthday the night she died. My reflections on the retrospective of her work at the New Museum of Contemporary Art are colored by the knowledge that when she died she was the age that I am now, and also by my awareness of the similarity of our interest in developing a female form in its relationship to nature, and, further, of those art roots we share in the rich mixture of feminism and the anticommodifying tendencies of earth, performance, and process art characteristic of the early seventies. These self-reflexive echoes heighten my sense of the unfairness of her being judged by the standard of oeuvres of dead artists, instead of the less reverent ones applied to young, living, and developing artists. Although her career was illuminated by flares of brilliance, the imposition of *oeuvre* on *work* is experienced as a sharp injustice. An effort must be made to do her the favor of keeping her work a little longer within the hustle and controversy of contemporary art discussions.

Mendieta's work is dedicated to an earth "Goddess": giant breasts and buttocks, spiraling wombs, slits, labia shaped like hearts, and vulvae abound within rock, tree, leaves, and the earth itself. Her assertion

of the bond between her body and that of Mother Earth reveals an enviable simplicity yet a problematic lack of ambivalence that seems a relic of the first years of feminist art. The unity of her identification with nature is the source of her work's most vivid images, yet also the site of its weaknesses.

Mendieta's work can be divided into three phases: performance pieces where her own body or its image interact with earth, blood, and fire (the *Fireworks Silhouette* series, *Fetish* series, *Tree of Life* series, *Silhouette* series — 1976–77); the Rupestrian sculptures (1981), in which a more exaggerated, paleolithic female archetype is carved into stone caves in Cuba, and the more traditional art objects, in which similar figures appear in drawings and sculptures of wood and earth (1981–85).

Mendieta's subject in the early pieces, visible only through photographic and filmic documentation, is woman as traditionally understood as "nature" to man's "culture." Although Mendieta's actions upon sand, earth, and stone are dramatically direct and her images archetypal, as art these pieces (the *Silhouettes* and the Rupestrian sculptures) reveal layers of intervention, impermanence, distance, vulnerability, and remoteness. As artist she functions as culture to nature's nature, reinscribing woman as hole and cave onto the cervix of the actual stone caves of her (Mother-)land of birth, Cuba. Whether carving a female spoor onto limestone, or entombing her own body or its replica in blood, sand, and mud (woman as matter encased within itself), or searing her shadow onto the earth, she interacts with the image and the material in a way that enriches the connotations of her work. The interrupted synapses between the permanence of the stone carvings, the vulnerability of the female image imprisoned in them, and the remoteness of their cave matrices enhance the sense of loss that is associated with the body of the Mother. We sense her physical intimacy with her work, yet our only contact is through ethnographic photographs and grainy, rather spooky home movies, doubling our personal separation from the Mat(t)er. We are as distanced from the actual presence of these earth pieces as we are from nature, Mother, the imaginary.

Mendieta's action upon the earth and the subsequent separation from/or destruction of the action leavens her archetypes with a welcome ambiguity. Nature's actual *matter* and the temporality of performance provide a crucial *resistance* to her generic "Venuses." Also, because of their presentation in time and position in geographic space,

Ana Mendieta, *Untitled (The Black Venus),* 1980, life-size silueta of carved earth
and gunpowder, Amana, Iowa. (Courtesy of the Estate of Ana Mendieta and
Galerie Lelong, New York)

these images may be icons and fetishes, but not talismans that can be
carried about and traded in the market. Thus, the commodification of
woman (and art) is averted.

Mendieta's later works exist in our presence. Drawings on bark
paper, giant mud cookies presented flat on the ground, tree trunks
altered to include and represent the female body, leaves burned onto
shield-like wooden planks stand close to us, they are our size and art
size, the scale of traditional drawing and sculpture. Fresh and clean
in shape and design, the later works are visually attractive and excit-
ing artifacts. The *Tree Trunks* of 1985 are particularly successful in the
clarity of their concept and execution. These pieces look very good —
but the important dialectic layers of mediation and resistance present
in the complex artist/material, audience/work interactions character-
istic of the earlier works are lost. The vulvae, leaves, and spirals stand
without counterpoint, nature to nature.

The audience's interaction is similarly diminished. Imagining the
act of burning a body into the earth is a more active and *activating* in-

volvement for the viewer than seeing a brown design on wood. One is told the line was produced by burning gunpowder, but it could have been manufactured by other methods. As the method's evocative power is diminished, the image itself must carry more critical responsibility.

Despite the violence implicit in using gunpowder or cutting the sharp point of a burin into living plant tissue, no violence is done to the concept of femaleness presented. To grow, the daughter must question the Mother. She must act out her *own* sexuality, as Mendieta does in her performance pieces, and not only look to the Mother as the "Sex." It is only in the necessary questioning of what she holds dearest that an artist's work lives most fully, not in the easy acceptance of a beloved form or concept.

Recent critical theory has investigated and developed the problems of female representation. Although representations of the "nothing

Ana Mendieta, *Untitled (from the "Totem Grove" series)*, 1985, carving and gunpowder etching on tree trunk, 79½ × 25 ins. (Courtesy of the Estate of Ana Mendieta and Galerie LeLong, New York)

to be seen," posited by Freud and Lacan and commented on by French feminists such as Luce Irigaray, must be attempted by women artists, an undifferentiated allegiance to the vulval half of the basic male/female, culture/nature binary opposition that one associates with the early stages of feminism and feminist art begs rethinking and reworking. Even if the woman artist ultimately asserts her femaleness, *chooses* her difference, the choice will be all the more powerful for an intervening interaction with culture, or, simply, with doubt.

Mendieta's work surely would be shown if she were alive today. One can easily envision a show of the last works in wood and the floor pieces. But separated from their past—the documentation of the earlier works—it is possible that they would succeed only insofar as they could be (mis)interpreted as postmodern *artifacts,* as beautiful, sophisticated commodities. A failure to "succeed," in market terms, would only be due to the extent to which they would still be perceived as feminist *actions.* The art world does not seem very interested in new infusions of feminist art (especially any that smack of "stage one" feminism), although such works by women who were accepted into the art world during the "window of opportunity" period of the early to mid-seventies are permissible, and Mendieta might qualify for this group. Yet even these women (Spero, Bourgeois, Murray, Applebroog) remain somewhat marginal to mainstream art, even as they are applauded and respected, while images by male artists that repress woman into her role as nature flourish in the spotlight. And, within the development of feminist thought, the post–avant-garde proposes a subtle critique of the nature/culture opposition, influenced by deconstructionist philosophy, Lacanian psycholinguistic theory, and cultural studies. Mendieta's "essentialism," her embrace of a female essence implicit in her generic female forms might well be criticized by contemporary feminist writers.

Mendieta's Woman, particularly in the later works, is only female, she presents a limited view of the form and experience of femininity out of the limitless possibilities of femaleness. Because dialogue and conflict do not flourish within a significant portion of her work, it does not have the depth of an oeuvre. In Mendieta's work there are many deeply moving and rivetingly memorable images, but, ultimately, the constant repetition of an unquestioned, generic (gyneric) Great Mother is deeply, and now, poignantly problematic.

Medusa Redux: Ida Applebroog and the Spaces of Postmodernity

The favored imago of the artist in the nineteenth century was the flâneur. Ambling through the spaces of the "spectacular city which was open to a class and gender-specific gaze,"[1] this voyeur and participant in public entertainments—bars, brothels, racetracks—had access to visual experiences and panoramas off-limits to an unchaperoned, respectable woman. There could be no "flâneuse."[2] Informal interior scenes of domestic life were of course not exclusively spaces for women artists; but codes of propriety organized the limits of most women artists' mobility within the spaces of modernity, both in daily life and in paint. To venture forth into a wider arena, Rosa Bonheur, for example, had to secure a *permission de travestissement*.[3]

To *flâner*—through the city, the picture plane, and art history—remains a necessity, even if the spaces of postmodernity may differ from those of modernity, even if revisionist art history, which takes social context and gender into account, is changing the discipline. In significant ways Ida Applebroog should be considered a true successor to Baudelaire's urban wanderer. And yet her work is often not referenced either to such a heritage or to the works of younger contemporaries who are credited with that heritage, such as David Salle, Eric Fischl, or Robert Longo. Indeed, her work is rarely discussed in relation to

that of other artists she was surely aware of in her developmental years, though one might compare and contrast Applebroog's penchant for grotesque facial masks with the mordant and hallucinatory distortions of figuration by artists from the Hairy Who (Jim Nutt, Gladys Nilsson, Ed Paschke, Karl Wirsum et al.), who were dominant in Chicago when Applebroog attended the School of the Art Institute of Chicago in the mid-sixties. Nor do critics note the affinities with West Coast performance or feminist artists (particularly active in the early seventies, when Applebroog lived in Southern California). Yet the poker-faced humor of William Wegman's early videos finds a kindred spirit in the maddeningly understated punchlines of the small books—significantly titled "performances"—that Applebroog mailed to unsuspecting correspondents in the seventies, and Eleanor Antin's elaborate masquerades of feminine performative genius are offered another kind of stage in Applebroog's presentations of women.

Instead, Applebroog's subject matter is generally described in detail and her emotional message editorialized; the indecipherability of a complete narrative is noted but poststructuralist analysis does not follow, even though such discourse is the lingua franca of postmodernist art writing.

The central action in Ida Applebroog's recent paintings takes place in a hostile, ruined, falsely or perilously idyllic outdoor space: a woman and child embrace in a pumpkin field in *Tomorrowland* (1986); a woman strapped into a strange pair of stiltlike shoes appears in the apple orchard of *Emetic Fields* (1989). Yet to describe these spaces as primary in any thematic or dramatic sense would be misleading. Each painting is a large, complex orchestration of big and small canvases, architecturally disposed with a musical sense of counterpoint. In each work, human figures appear in a variety of scales: often a giant looms alongside the central scape occupied by a "life-size" inhabitant, and narrow bands of single, enigmatic images that frame the larger canvases telegraph intimations of domesticity. In *Marginalia* (1991), and other recent works, the installation space becomes a three-dimensional pictorial field, in which paintings of varying size and scale are freestanding, and the viewer becomes but another figure on Applebroog's complex and ever expanding ground.

Formal decisions are not formulaic, despite these recurrent visual elements. Small and large, interior and exterior, oppressed and op-

pressor are not disposed in the same configuration twice. In a disconcerting manner, edges do not meet, walls show through segments, narrative strips do not coincide with the larger canvases or images they abut. The peculiar flow of narratives through these different spaces and scales, and the locking and unlocking of time and space in these disjointed scripts and scapes, serve to disembody the very evident physicality of these architectural paint-things.

In Applebroog's work, as in television, "the global village" tunes in to an unhierarchic toxic waste dump of places, images, and events. Earthquakes and ball games, assassinations, space walks, the "Love Canal" and *The Love Boat,* Donahue in a dress, the inside of a human ovary, serial murder, plastic surgery—you are there, you are they, they are here. Applebroog's basic compositional techniques for the dispositions of these spaces of postmodernity are related to the visual strategies of such artists as David Salle and Eric Fischl. However, for all their multiples canvases, images, and figures, Salle's and Fischl's works retain the conventional position of gazing *into* a chamber (whose occupant is most likely to be a woman). In Applebroog's work, on the other hand, the traditional spaces of femininity—living room, bedroom, kitchen—become the viewfinder of a vast camera obscura. She is a global flâneuse whose paintings play host to an outer world, inhabited by men, women, children, and animals who spill into "woman's world" at great speed and in tumultuous moral equivalence.

It is the tumult of these spaces that animates the architectural elements of her paintings, transmuting archaic post-and-lintel construction into filmic space and montage. Yet Applebroog's call to the visual-narrative techniques of both old high art and recent low art builds on film's capacity to intercut unrelated images and actions. The narrow bands that horizontally or vertically frame most of the larger paintings have often been referred to as "predellalike," linking these works to medieval and early-Renaissance altarpieces. In these, the predellas were the narrative scenes painted on small panels, usually at the bottom or side of the central, larger image. While the main scenes might contain a static and symbolic portrayal of the principal iconography and be painted in a refined, "advanced," highly finished style, in the High Church Latin of visual language, the predellas were painted in the vernacular. They often appear more "primitive," as they tell a story in vivid movement and detail. But in Applebroog's work,

the predella narrative is reduced to simple repeating images that func-
tion as cell animation and as frames from a silent movie with titles.
Tomorrowland's pumpkin field, for example, features a strip of images
at its top: a man presses his faces to a woman's skirt/crotch, a man
presses his face to a woman's skirt/crotch, a man presses his face
to a woman's skirt/crotch—the caption is "It smells nice." Another
repeated image on the same narrow band, of two little girls, bears
the subtitle "Are you bleeding yet?" Intercut between these anima-
tion strips is a slightly bigger single image of a chorus line, and of
a guy on a sofa saying "Want Chinese tonight?" Predella or cartoon?
Applebroog reaches back to a very old technique and a very low-
brow, "infantile" form of storytelling, not to instruct us on the life
of a saint, but rather to offer us only ciphers of modern life. These
images are previews for a film run through a Super-8 projector while
the main screen may be in Cinemascope, and fragments float around
like "smart window" television.

 As Griselda Pollock points out in *Vision & Difference,* such Brecht-
ian strategies of montage are particularly useful to an artist engaged
in cultural critique. Briefly stated, in order for art to get beyond or be-
hind conventions of representation, in order to expose the ideology
these conventions serve, artworks should employ "dis-identificatory
practices" that disrupt " 'the dance of ideology,' " [4] and "distanciation"
that would "liberate the viewer from the state of being captured by
illusions of art which encourages passive identification with fictional
worlds." [5] This "critique of realism," as Pollock notes, depends on
"the use of montage, disruption of narrative, refusal of identifications
with heroes and heroines, the intermingling of modes from high and
popular culture, the use of different registers such as the comic, tragic
as well as a confection of songs, images, sounds, film and so forth.
Complex seeing and complex multilayered texts [are] the project." [6]

 Clearly Applebroog deploys these prescribed strategies as she draws
from "high and popular culture" and combines "comic" and "tragic"
registers: the presumed hero of her *Tomorrowland* has a potentially
noble body but a clown face. A large bodybuilder, this time a woman
flexing her biceps in Applebroog's *Rainbow Caverns,* (1987) is juxta-
posed with a small image of a girl, a single strand of spaghetti sus-
pended between her fork and mouth, bonding a Michelangelesque
tradition of heroic sculptural rendering to cartoonlike figuration and
action.

"Dis-identificatory practices," of course, have constituted significant, even dominant strategies in the art of the past decade, particularly in works that offer important critiques of the position of women in representation. Mary Kelly's *Post-Partum Document* (1976–80), in which every form of documentation except figural representation is used to expose the writing-out of the mother as the child enters into language, is a frequently cited example of the usefulness of these techniques to dismantle the repressive aspects of representation. But in the 1980s these strategies became standardized; image appropriation and juxtaposition are by now routine visual devices whose very ubiquity seems to have itself become a repressive discourse. At its best, appropriation can be construed as one more space of postmodernity, a fifth dimension of imagery and art-historical recycling, a flâneur's knowing stroll through an open library of representations whose reconfiguration will expose and critique ideology. Nevertheless, the actual practice of appropriation and juxtaposition can result in work that remains so close to its visual sources and the ideology they represent that it cannot be distinguished from them, or it can result in work that is simply mundane or flat-footed in its literal one-plus-one approach.

If Applebroog shares certain references with her contemporaries—TV, pornography, pre- and post-1945 art—she distinguishes herself by her transformations of much of what she appropriates, and uses appropriation as a catalyst for her own meanings. Willem de Kooning's *Woman I* (1950–52), becomes an afterimage in Applebroog's *Two Women III* (1985), a blurred echo hovering over the shoulder of a fat, girdled woman screaming past de Kooning's *vagina dentata,* in counterpoint to a repeated predella image of male beauty queens whose rather foolish lumpiness suggests the Other's Other. Goya's *Saturn Devouring His Children* (1820–23) becomes, in Applebroog's *Camp Compazine* (1988), an elderly retiree eating a screaming homunculus during his afternoon snooze. From the high drama of mythology, evil is reinstated within the banality of daily life in a senior-citizen community. If one imagines a Mike Bidlo–esque use of the Goya image, would it have the disquieting effect of making you suspect that your grandfather in Miami might eat you up like bridge mix?

As in the work of Leon Golub, the materiality of paint intensifies the disruptive potential of appropriation. Both engage us in an uneasy relationship with figures we might prefer not even to look

at. Painterly surfaces serve as a moral agent for both artists: Apple-
broog's palette-knifed, thick, but translucent, paint resonates with
Golub's painfully scraped surfaces. Both offer us canvases as wounded
as the body of Grünewald's Christ. And just as we don't want to iden-
tify with Golub's torturers—or their victims—it is hard to identify
with Applebroog's "heroes and heroines." Many of her figures wear
grotesque masks—or *are* they masks? Those who appear "normal" are
even harder to identify with. Think of the nice grandmotherly lady in
an armchair with a rifle across her lap in *Chronic Hollow* (1989). Every
figure's moral position is up for grabs—an interesting device in work
whose overall sense of moral outrage is unquestionable.

Belladonna (1989), a video by Applebroog and her daughter Beth B.,
in both its content and its very title offers a rich congruence of Apple-
broog's subversive practices. Its sound track permeated the Ronald
Feldman gallery during Applebroog's 1989 New York exhibition: "I'm
not a bad person, I'm not a bad person," one could hear a little boy's
angelic voice repeating now and then, from the black-curtained room
where the video was periodically screened, as one moved from paint-
ing to painting, many of which featured children moving in and out of
centrality and in and out of moral high ground. The pink-faced baby
peeking out of an old man's brown coat in *Idiopathic Center* (1988), for
example, may retain a certain innocence relative to the other children
and adolescents depicted in the painting—some nearly vanishing be-
hind bars, others weeping—but this baby face is also the living heart
of a man turned to stone, or it might be a boil, an eruption from
the old man's earlier promise. This might even be Oedipus, but when
he was an unknowing infant in the arms of a loving foster parent.
In *Lithium Square* (1988) another sleeping baby, cradled in the lap of a
figure whose identity and gender are hidden by a veil, becomes sinis-
ter: fat and stone colored, he emits smug indifference to the suffering
of his guardian Pietà, who is as successfully erased from representa-
tion as the mother in Kelly's *Post-Partum Document*. In *Crimson Gardens*
(1986) vignettes of children in scary masks and blindfolds confront
a chorus line of women in a concentration camp. One of the chil-
dren is a ringer: he or she also has a shaved head and striped prison
clothes. Is this child a Holocaust victim, an adult woman infantilized
by her bared skull, or a child's truly creepy Halloween disguise? Is this
Sluggo or little Elie Wiesel? Many of the children in *Marginalia* also

possess an uncertain moral valence: a little girl in hair curlers seems distressingly pleased by the (figurative) torture instruments in the construction of femininity—in French it is said that "il faut souffrir pour être belle." A boy in an iron collar grins toothily. This image from 1991 eerily prefigured an actual news story from 1993 about a little girl abducted by a family friend and chained by her neck in a Long Island dungeon. The child was said to perfectly fit the victim profile for such pedophilic crimes: prepubescent, abused, and adrift, with unknowing complicity, she gravitated toward any phantasmic image of love or kindness.

At the end of *Belladonna,* the credits reveal that all of the script we have heard delivered in brief, intercut monologues by a cast of several men and women and one little boy are statements taken from testimonies of Joseph Mengele's victims, Joel Steinberg's trial, and Freud's 1919 essay "A Child Is Being Beaten." The line spoken by the angelic child, "I'm not a bad person," could well have been the self-pitying justification of Joel Steinberg, a child killer. The moral purity of the child speaker is damaged by this possible ventriloquism. All preconceptions and sentimentality we may attach to the idea of childhood are dissolved.

On the other hand, by juxtaposing quotes from stories of actual physical abuse with erotic fantasies of abuse theorized by Freud, Applebroog and Beth B. effectively resist Freud's denial of the father's guilt. Despite Applebroog's adherence to narrative techniques (storyboard, figuration, captions), *Belladonna* indicates her divergence from the traditional Oedipal narrative: something bad really has been done by the father. Like Laura Mulvey, who, in her essay "The Oedipus Myth: Beyond the Riddles of the Sphinx," questions what "has been systematically ignored in both classical tragedy and later tradition,"[7] Applebroog explores the obvious mystery, namely, why were Oedipus and his family cursed? Mulvey reveals the prehistory of the myth: the rape, by Oedipus's father, Laius, of his host's young son, Chrysippos.

According to this pre-history of the myth, Laius's aggressive and violent homosexual act is the latent cause of the curse and of Oedipus's later suffering. Chrysippos's experience with Laius can act as a displacement on to another young boy from a primal anxiety in son-to-father relations; the repression of this aspect

of the myth then becomes a repression of the father's fault in the Oedipal scenario. Marie Balmary explains Freud's oversight in terms of his need to repress the Laius-like qualities of his own father Jacob Freud. She argues that the logical consequence of this (personal) repression was the (theoretical) repression of the father's fault and Freud's decision to "exonerate" the father of seduction and "incriminate" the child's fantasy of seduction. It is known that Freud adopted the fantasy theory of seduction during the period of mourning over his own father's death.[8]

A child speaks the words of a child killer, a man reads the fantasies of child abuse recorded by Freud: these position transfers mark Applebroog's rebellion against the repressive aspects of the Freudian Oedipal narrative that dominates Western systems of aesthetic interpretation. This reading of *Belladonna* is consistent with and enriches our understanding of the child-eating old man in *Camp Compazine,* the stone Snuggli-carrier of *Idiopathic Center,* and the enthralled children of *Marginalia.*

Disidentificatory practice and refunctioning of mythic narrative is at its greatest play in Applebroog's depiction of women. It is hard to project any kind of narcissism onto her figures. The title *Belladonna* is ironically apt because there are no traditionally, overtly beautiful women in her work, whereas within dominant representation, old and ugly women are conventionally relegated to the margins of "culturally overdetermined scopophilia."[9] They are the old crones doing housework through a doorway in the background of a painting by Vermeer, or attending the beautiful young lady in too many paintings of nudes to be specific. As such they are as the fly on the perfect fruit of a *vanitas,* allegorical emblems for the inevitability of decay and death embedded in Woman by patriarchy. When the aged and the ugly do appear as central subjects, it is in genre painting, a second-class citizen within art history. By placing ugly and plain old women (and men and children), with whom no one wishes to identify, at the center of her project, Applebroog in effect genetically alters genre painting, in a sense "elevates" it to the level of history painting. Her painting exists in a continuum with such large-scale history painting as Géricault's *The Raft of the "Medusa"* (1818–19), Delacroix's *Death of Sardanapalus* (1827), and Courbet's *The Artist's Studio* (1855).[10] Just as

contemporary media culture trivializes history, so Applebroog brings the trivial details of a collapsing order to the scale and tragic dimension of history painting. But if the "Grand Tradition" of painting is understood as fundamentally masculinist,[11] then Applebroog's place within it is an anomaly and represents a hostile takeover. Perhaps part of what makes this possible is the fact that the artist herself is beyond the "age" of representation. As Kelly notes, *"Being a woman is but a brief moment in one's life!"*[12] In dominant representation, a female human is only a woman between menses and menopause, and thus only woman's youth is pictured. When the woman artist has aged *out of the picture,* she can return to alter it without compunction. It is significant in this regard that the mainstream avant-garde continues to focus on representations of youth by young women artists, if anything privileging a regression to "teenage girl art" in terms of its sources, content, and style. Works by Karen Kilimnik, Pam Butler, Elizabeth Payton, and Jenny Watson fall into this category.

Belladonna also allows us to travel through ideas about female representation toward the possibility of a repositioned gaze. At a time when writing about femininity is focused on a specular economy in which woman is an object of vision, in which male subjectivity depends on Woman's disappearance into representation, *Belladonna* is a significant title on another level. Belladonna (also known as deadly nightshade), a poisonous hallucinogen found in certain plants, induces widely dilated pupils and can cause psychosis in greater dosages. It was used by women in the nineteenth century to make their eyes appear fashionably large and limpid. Applebroog uses belladonna, the poisonous prison of female beauty, to dilate her pupils and sharpen her vision of patriarchy, transforming Woman from a *site* of representation and a *sight* into a *seer.*

It is said that children and animals have often become the victims of belladonna, accidentally poisoned by eating its fruit.[13] Patriarchy aptly is the worm in the apples that have fallen off a tree at the center of *Emetic Fields:* a woman walks on stilts to avoid touching these tainted fruit, while on the tree, apples are inhabited by images of elderly men, blindfolded men, and a guy with "Mother" embroidered on the back of his jacket. This Eve bows her head—or is it that she's watching her step?

Applebroog's belladonnas are "Medusa and the Sphinx," who, "like

the other ancient monsters, have survived inscribed in hero narratives, in someone else's story, not their own."[14] In contrast to the Oedipal narrative, which renders women only as enigmatic monsters threatening "to man's vision,"[15] Applebroog hallucinogenically depicts the triumph and the decay of Oedipus, the de-inscriber of women, in her representation of the return of the repressed female, the prescient child, and the ancient monster. A bald Medusa now sits for her portrait in an evening gown and an arm cast, while little Oeddy, nearby, eats a watermelon in *Noble Fields* (1987). Medusa's gaze turned men to stone, to that which is not action, that which is representation, to art. Pygmalion's transformations are a miracle, Medusa's a crime. Applebroog's figures, significantly, are often rendered in a stone color. Applebroog becomes both Medusa and Pygmalion; it is her belladonna-widened gaze that turns action into representation.

The monstrous aspect of these major figures in Applebroog's work recalls the theory of female creativity proposed by Sandra M. Gilbert and Susan Gubar in their 1979 *Madwoman in the Attic:*[16] women artists, Gilbert and Gubar argue, have internalized patriarchy's myth about the destructive, monstrous nature of female creativity and power, and are fearful about using a language that incorporates these defamatory images. This double anxiety erupts in their art through monstrous, mad, violent alter egos; Rochester's mad wife in the attic of Thornfield in *Jane Eyre* is the eponymous example. The conflict implicit in the negotiation of these monstrous alter egos is manifest in works by a range of women artists. Diane Arbus's photographs, while they often show a voyeuristic identification with their "freaky" subjects, also suggest a tacit acceptance of mainstream categorizations of what constitutes normalcy and monstrosity. Cindy Sherman's baroque self-representation as a dead pig is another example of this pattern, as are her male and female figures from art history endowed with a fairy-tale profusion of false noses and disfiguring moles. Applebroog, like Sherman, moves away from a limited, binarist acceptance of the monster/woman artist identification by placing monstrousness on so many heads.

Finally, if these paintings use narrative techniques borrowed from altarpieces, one may wonder to whom these particular altarpieces are dedicated. Certainly not to female figures who have been subsumed to patriarchal religion (the Virgin Mary). They do not celebrate bella-

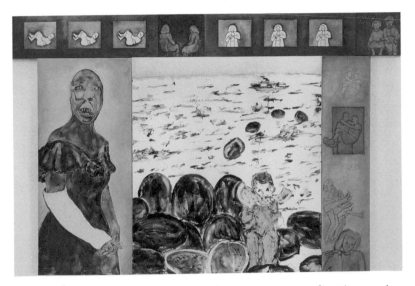

Ida Applebroog, *Noble Fields,* 1987, oil on canvas, 5 panels, 86 × 132 ins. (Courtesy Ronald Feldman Fine Arts, New York)

donna, but Donna. They reflect the vision of Galatea, perhaps, but more likely that of Mary Shelley's "monster," or of Cassandra.

In *Emetic Fields* Queen Elizabeth, like all the large-scale figures in Applebroog's paintings, is painted with a gelatinous, translucent brown or gray matter, oil paint extended with gel and troweled on. At times it looks like gleaming sludge. No wonder the queen sports such a still upper lip. Visceral, gleaming paint is as much the key to Applebroog's apparent exclusion from the canon-forming texts of the current feminist avant-garde as is her creation—rather than re-presentation—of female representation, for paint is not the space of choice for postmodern women artists. Applebroog's trust in the ma-teriality of paint to convey a political message, to effect a feminist intervention, brings her up against the profound distrust of figura-tion and narrative arrived at through the manipulation of slithery pig-mented matter on a ground, a distrust held by a school of criticism that in another context I have dubbed "aesthetic terrorism."[17] Mod-ernism and postmodernism have added one last element to the ata-vistic association of woman/blood/guts/mud/slime/putrefaction/death—that element is paint, a viscous flowing matter capable of dis-

turbing multiformity.[18] The "distanciation" most devoutly wished for by this school of criticism is that from the body, and Applebroog's paint is particularly grounded in the body. The group of works that she exhibited in New York in 1987 was painted in colors and textures of bodily fluids and excretions: blood red, shit brown, urine yellow. In her 1989 New York exhibition, *Nostrums,* all the titles referred to psychiatric care or physical/psychosomatic management, and Applebroog's color range expanded to include sappy pinks, mauves, and peach, colors meant to subdue crazy people, which in this case meant, at least temporarily, the viewers.

Applebroog's use of paint is at once spartan and baroque, noncommittal and passionate. In one sense her application of paint is instrumental: nothing is ever more than it needs to be. The predella sections are quite flat, minimal in color and surface. The paint is used functionally, applied as necessary to cover a particular area or create a form (note how the palette knife fashions an orange-draped figure in *Lithium Square,* for example, or how the transparency of the gel medium conveniently renders the black nylons in *Elixir Tabernacle* [1989]). There are no special effects here, but there is effective authority, indeed old-fashioned mastery: the old man eating a child is as sculpturally rendered as the Belvedere Torso that inspired Michelangelo, but constructed with economy rather than showy virtuosity. Applebroog's gift to painters and to other viewers is precisely in what she achieves beyond the merely instrumental: "unnecessary" moments of visual pleasure within grim pictures. As an example, *Camp Compazine* is a condemnatory exposé of America—with its slumbering child-eater to one side, somber businessmen on the other, and bornagain Christians on top—a country and a painting overrun by turkeys whose feathers are built up in waxy, bas-relief slabs of paint. And yet the transition from translucent red to translucent pink in the empty center effects a fluid, almost gentle passage from dark to darker panel, in color, tone, and subject. Such incidences of visual pleasure buy the paintings time to be read over a long period. The layering of paint, and of paintings within paintings, moves the viewer through time in a manner more akin to film than many artworks that far more explicitly and self-consciously remind us that they have appropriated the syntax and formal elements of cinematic language.

Applebroog's paintings are never easy to describe in a single ex-

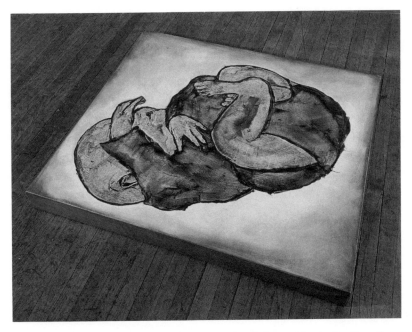

Ida Applebroog, *Marginalia (baby)*, 1991, detail from *Marginalia #2*, oil on canvas, 38 × 34 × 3 ins. (Courtesy Ronald Feldman Fine Arts, New York)

planatory sentence. Of the painting *Chronic Hollow*, is it sufficient to say it is a painting of a girl in a dog mask? A girl interrupting a purple landscape with a bench and people tumbling? And what of the predella scenes? But as we stand in front of it, a complex interplay of a thinly applied, pale pinkish brown (dare we call it puce?), slabs of gray gel, nervously applied white, and a "natural" canvas color make up the central scene in which the dog-masked "heroine" interrupts the flow of figures tumbling through a space of uncertain scale. The tumblers' mobile white-brush-marked outlines strike a delicate balance between virtuosity and functionality, replicating and augmenting their movements through the canvas segments, causing them to move past our gaze like a film run sprocket hole by sprocket hole. At the top of the painting, the starker contrasts of dark crimson, blood red, and white, thinly layered, construct a montage of Applebroog's gun-toting grandma in an armchair, a couple supporting a woman whose head has vaporized into a delicate white haze.

Applebroog's infusion of trust in painting is perhaps most eloquently displayed in *Marginalia (baby)* (1991), laid on the floor of the gallery: its vulnerability and that of paint are made one.

Contemporary critics have pointed to the work of Sue Williams, expressing amazement that she is "the first painter in recent memory to plunge deep into the taboo-ridden areas of the psyche"[19] and to do so *"from within painting,"*[20] thereby disregarding Applebroog's considerable contributions to the renewal of painting as a locus of feminist discourse. Applebroog's formal influence on Williams should be noted, although Williams remains, perhaps deliberately, much more primitive in her pictorial means. Williams and other artists who romance the abject may unfortunately be popular because female victimization, as graphically expressed through references to pornography, is male oriented, although it may express some women's personal experiences. Applebroog understands the deeper meaning of the 1970s' feminist motto, "The personal is the political": the goal was to release individual women from the bondage of isolation, from self-destructive delusions of unique abnormality, to provide a sense of commonality, to illuminate the existence of a determinative patriarchal system of difference, and to focus anger away from the self toward the culture in order to achieve *voice* and *agency*. Applebroog's work has the scope to encompass personal suffering, identification with many sufferings, including those of monkeys and men, and the levels of ambiguity between victim and victimizer. She has, and offers to the viewer, both no emotional distance and totally ironic authorial distance. She may have infiltrated the "Grand Tradition" of nineteenth-century painting, literally deconstructing its surface, but her work offers a reconfiguration as broad, ambitious, and inclusive as any nineteenth-century narrative oeuvre.

Applebroog's functional, emotionally expressive, and fearless use of paint to reposition ancient female "monsters" at the center of political narrative suggests another space of postmodernity, beyond what is becoming the limited, hackneyed space of poststructuralist theory. It is a space in which narrative has power, but it is a narrative of difference, a different narrative than that of the death of painting or of the ideological prison of late-capitalist commodity culture.

The difficulty in properly contextualizing Applebroog may be the result of her persistent slippage between theoretical positions and

visual strategies: she uses Brechtian practices called for by postmodern feminist writers, but she does so in paint. She calls on ancient and popular narrative techniques, but her paintings do not tell familiar stories. Twentieth-century viewers and readers are accustomed to the Oedipal narrative as it is traditionally explicated. Ida Applebroog resists these readings, refocuses the "destructive" female gaze. No wonder conventional readings can only operate at the level of emotional reaction and political commonplaces. We do not recognize the narrative of the Sphinx or *The Raft of the "Medusa"* as painted by Watson's shark.

The Return of the Same

Until recently, there was no problem in determining who were the subjects of history. They were the largely Caucasian males whose actions and thoughts were inscribed into a history whose very formulation as a science they defined. Discourse was a continuous loop of what the French philosopher Luce Irigaray has termed the "phallosensical hommologue" of Western civilization.

Whether this system has been altered by three decades of liberation movements was an issue tested by "Subjects of History: A Day of Discussion," a symposium presented in March 1990 at the Columns by the New Museum of Contemporary Art in New York, "in conjunction with the exhibition *Interim* by Mary Kelly." This symposium—moderated by Hal Foster and including papers and comments by Kelly, British feminist theorists and art historians Laura Mulvey, Parveen Adams, and Griselda Pollock, American literary theorist Emily Apter, and British video- and filmmaker Isaac Julien—warrants analysis, separate from the exhibition, because it both illuminated the historical context of Kelly's work and the crisis in representation, and also because, unconsciously or unintentionally, it highlighted a theoretical/artistic movement's transition from vilified "other" to intellectual elite.

Mulvey and Pollock vividly recalled the initial work of the London Women's Liberation Art Workshop in the early seventies. "The importance of women's lives to become history, to be interpreted," said Pollock, led to a utopian search for the origin of women's oppression. A "history group" met for readings and discussions of texts by Engels, Freud, Lévi-Strauss, and of theories on sexual difference and the Oedipus complex. Mulvey concurred: "Theory was exciting," an "instrument for decipherment." Such activities are emblematic of differences between the American and British feminist art movements at their onset, which clearly prefigured contemporary rifts within feminism. In 1971 the Feminist Art Program at CalArts held consciousness-raising sessions about our periods, our mothers, our fathers, and researched neglected women artists of the past; in London, they were reading Engels. Both groups understood that the representation of women was a political field. The American approach was, generally, empirical: the creation of new visual and textural representation. The British were discursively problematizing representation itself, and promoting "scripto-visual" subversive strategies, with the emphasis on "scripto."

Pollock spoke of the "traps of visuality," condemning the traditional aesthetic values of beauty and visual sensuality that have been dominant methods for turning women from potential subjects of history into objects of the male gaze. Adams developed these themes as they are expressed in *Interim* by positing a Lacanian equation—*Interim* is to the viewer as the analyst is to the analysand. The work refuses to offer the viewer an idealized superego (as painting would). "The artist does not have the object any more than the analyst. . . . *Interim* will not make the spectator feel lovable. . . . These are pictures which work at the limit of the image."

However, both *Interim* and "Subjects of History"—constructed to mount a critical attack on the misuses of visual seduction—suggested, but did not satisfactorily admit to, some inherent contradictions. For example, by embedding a discourse on the aging of the female body (usually neglected or distorted in dominant representation) in a visual project that withholds any visual indication of age, the reality of age as subject was lost in a field of words. As individual pictorial elements, words have no age, and, in English at any rate, most often no gender. The symposium's emphasis on the "traps of visuality" and the

Mary Kelly, *Interim, Part IV: Potestas,* 1989, etching, brass, and mild steel, 14 units, 100 × 114 × 2 ins. overall dimension. (Courtesy Postmasters Gallery, New York)

potential of language as a critical tool may have served to perpetuate the lack of focus on female aging—thereby, Kelly's subject remained invisible.

Yet *Interim*'s critique of visual seduction *is* embedded in a visual project, and thus raises questions about the use of representation and the strategies of commodification for making aging desirable to history. But the panelists seemed only to offer arguments (albeit sophisticated ones) to explain why *Interim* succeeded in being visually frustrating. Further contradictions emerged and were suppressed: if, as Adams suggested, the strength of Kelly's work is in its uncompromising refusal to present the viewer with a seductive self-image, then the considerable elegance of her impeccably manufactured works may be problematic. Kelly, however, firmly redirected Mulvey's questions about the materiality of her work, detailing, instead, her intentions for each and every choice of material and typeface—intentions often not self-evident even to a reasonably well-informed viewer (for example, confronted with photographs of folded clothing, subtitled *Extase,* not everyone will recall Jean-Martin Charcot's iconography of hysteria). The emphasis on authorial intention and predetermined interpretation seemed curious in the context of a work said to refuse an omniscient role, and at a time when the creative role of the reader/viewer is acknowledged. *Interim*'s relationship to conventional sculpture, its references to the work of minimalist artists such as Richard Serra, David Smith, and Donald Judd, were avoided. And if the strength of the work is in its refusal to assume univocal mastery, then how does one explain the symposium's choice of Kelly as the only successful exponent of representation in crisis, positing and positioning her as *the* solution, *the* subject?

Just as baseball fans are given to imagining ideal teams (made up of only short players, only Italian American southpaws, etc.), the lack of oppositional voices on the panel, and the reduction of a movement to the work of one artist, suggested an endless list of alternate panelists whose presence might have enriched the discussion. How about provoking a discussion between modernism and feminism by having Rosalind Krauss on the panel? How about a Lacanian feminist from another generation and milieu, such as Jane Gallop? How about "others" within American art, such as Hung Liu or Trinh T. Minh-ha, whose aesthetic practices are not so different from Kelly's, who are as

theory adept, but who might have contributed to the "polyvocality" that Kelly believes *Interim* provides? Most important, the gracious presence of British filmmaker Isaac Julien as token "other" (conveniently conflating gay, black, and avant-garde) did not make up for the voices of women of color working in England in the late seventies and the eighties. Lubiana Himid or Sutapa Biswas, among others, were not invited or mentioned. Was the audience being presented with a retotalized version of the history of the London movement, whose actual discursive vitality and variety is evidenced in Pollock and Rozsika Parker's lively anthology of original documents, *Framing Feminism: Art and the Women's Movement 1970–1985?*

In fact, operating at the intersection of feminism, critical theory, and the crisis of representation, "Subjects of History" (presented to an almost all-white, middle-class, well-educated audience) managed to replace one system of exclusion with another. Excluded were representational strategies such as painting, crafts, even language that is not theory language. One thinks of the works of the Reverend Howard Finster, Chéri Samba, or Faith Ringgold in this regard. "Subjects of History"'s aesthetic system would, by inference, consider a majority of Third World artists as primitives. Does one need an advanced degree in (white male) philosophy and psychoanalytic theory to be a subject of (the "new") history? The considerable value of critical theory is compromised if, when transferred to visual practice and discourse, it threatens to reinscribe colonialism.

The goals of the feminist movements in 1971, avowedly Kelly's as well, were to displace the f/phallacy of the (male) universal, to inscribe *other* subjects into history, to reformulate what history could be, to break down the closed, exclusionary loop of discourse. Yet here we were subjected to a "return of the same"—the One—presented in an academic cryptography of theoretical language, without sufficient time for questions. A new system of exclusion and exclusivity, or misguided attempts at the kind of artist hagiography that Kelly's apologists claim her art refutes, does not serve the ideal of a new discourse of history.

"Just the Facts, Ma'am"

Intervention is the buzzword that defined and prescribed the kind of
political act considered effective and correct during the 1980s. In the
culture at large, cynicism and exhaustion numbed survivors of the
political activism of the sixties and seventies; at the same time, within
the academy, aspects of simulation and deconstruction theories de-
stabilized "humanistic" concepts of identity and action, contributing
to a sense of moral equivocation. In the political arena internation-
ally, easily visible and identifiable white, Western males did not fare
too well fighting wars against often not white, seemingly invisible,
unidentifiable guerrillas (or terrorists) who fought carefully chosen,
limited engagements. Nationally, single-issue candidates or issues
predominated: pro-choice, pro-life, animal rights, the environment,
"read-my-lips." Across the political spectrum, only small "interven-
tions," therefore, were believed to be possible, always already under-
stood by their initiators as ephemeral and of limited effectiveness.

"Guerrilla Girls—Conscience of the Art World." The name and
Homeric epithet immediately indicate both the timeliness and the
character of their chosen form of intervention. These self-styled guer-
rillas chose as their subject and target, sexism and racism in the art
world, and as primary site for their ambushes, the SoHo and Tribeca

neighborhoods of Manhattan. Further, recuperating the word *conscience* might in itself be seen as an intervention. During a notably materialistic and selfish era, the Guerrilla Girls recalled to public notice the strategies and values of earlier political groups: isn't conscience dated as a concept? Naive, religious even? The Guerrilla Girls' adoption of it was characteristically tongue-in-cheek *and* sincere (another retro trait in the 1980s).

Since an intervention is meant to be brief, site- and instant-specific, it is amazing that Guerrilla Girls, formed in 1985, is still active. A press release dated 6 May 1985 announces the appearance in SoHo of "posters pointing to the inadequate numbers of women artists represented in leading New York galleries," and, further, states that "Guerrilla Girls plans to continue its campaign throughout the next weeks and next season, drawing attention to the retrograde attitudes toward women artists that characterize certain segments of the art world of the mid-80's." There is something touching about "next weeks and next season"—not season*s,* mind you. No spontaneously formed underground group could imagine that something done out of righteous anger *and* as a lark could last five years and counting. Their fifth anniversary may be the appropriate moment to consider *what* Guerrilla Girls is and what Guerrilla Girls has done and does, rather than that perennially asked question, *who* are the Guerrilla Girls? (Sophisticated players in the political game of intervention, the Guerrilla Girls, as we enter the nineties, are assuredly involved in their own process of self-evaluation.)

In June 1984 the Museum of Modern Art (MoMA) was picketed by demonstrators protesting the lamentable underrepresentation of women artists in the *International Survey of Painting and Sculpture* exhibition that had reopened the enlarged, "Trumped-up" museum. Of 169 artists chosen, only nineteen were women. This gender percentage symbolized either how few inroads had been made by women into the bedrock mainstream (to be oxymoronic) of the art world, or the degree of backlash and slippage that had taken place as a decade of noisy activism gave way to complacency and careerism even among women artists. Public pressure on mainstream institutions had let up. MoMA could act with impunity, and Leo Castelli could say, in response to the Guerrilla Girls' protests, that they suffered from a "chip that some women have on their shoulders. There is absolutely no dis-

crimination against good women artists. There are just fewer women artists."[1] The art world certainly needed a conscience—especially a gendered one. Guerrilla Girls began early in 1985.

The Guerrilla Girls' first two posters pointed the finger at specific galleries ("THESE GALLERIES SHOW NO MORE THAN 10% WOMEN ARTISTS OR NONE AT ALL") and named names ("WHAT DO THESE ARTISTS HAVE IN COMMON?"). Twenty major galleries from BlumHelman, Mary Boone, Castelli, and Marlborough to Tony Shafrazi, Ed Thorp, and Washburn, and forty-two male artists from Arman, Francesco Clemente, and Eric Fischl to Bill Jensen, and Richard Serra were depicted as either actively responsible for or, in the case of the artists, complicit in the egregious sexism of the art world. The naming of institutions and individuals continued into 1986: "ONLY 4 OF THE 42 ARTISTS IN THE CARNEGIE INTERNATIONAL ARE WOMEN," "THE GUGGENHEIM TRANSFORMED 4 DECADES OF SCULPTURE BY EXCLUDING WOMEN ARTISTS. Only 5 of the 58 artists chosen by Diane Waldman for 'Transformations in Sculpture: 4 Decades of European and American Art' are women." That year Guerrilla Girls were unrelenting, posting at least eight "public service messages" bringing the art world to task. At the same time, a "hits" list at Printed Matter of "people [who] are making things better for women artists" provided a positive counterpoint to the steady barrage of negative statistics, commending, among others, the gallerists Brooke Alexander, Paula Cooper, and Robert Miller, and the critics Barbara Kruger, Jeanne Silverthorne, and Judd Tully. The Guerrilla Girls placed major museums "under surveillance," indicating an ironic understanding of the group's own marginality and powerlessness, and, paradoxically, their awareness that the art community was becoming sensitive to their critiques. After a suitable pause: "It's even worse in Europe" (ba-ba-boom!).

Who were these women? Excuse me, *girls?* Their "victims" wanted to know. Like that "damned elusive Pimpernel," they seek them here, they seek them there, and some threatened to sue if only their individual identities could be revealed. To this day, however, the precise identities and numbers of the Guerrilla Girls are unknown.

"Indeed, I would venture to guess that Anon, who wrote so many poems without signing them, was often a woman."[2] If anonymity reflects the traditional condition of feminine accomplishment, or

the pressure to choose between anger and self-repression, there may be a significant difference between enforced and chosen anonymity. Whereas in the past anonymity has been a curse on female artistic creativity, the Guerrilla Girls have embraced the strategic benefits of their covert existence. Since no one knows who is a Guerrilla Girl, *anyone* may be one: MoMA curator Kirk Varnedoe's secretary, or David Salle's studio assistant. There is strength in the potential threat of an unknown "Big Sister." But there are also poignant undertones in what the Guerrilla Girls have said about being anonymous: "Publishing our names would destroy our anonymity, and therefore both our effectivity and our careers as artists would be gone, be dead,"[3] and, "We gain a lot of leverage by being anonymous. The dealers and collectors don't know who among their friends is a Guerrilla Girl so they can't single anyone out and say, it's just sour grapes."[4] The fear of mockery and retribution indicates that perhaps their anonymity, like Anon's, has *not* been so freely chosen.

Curiosity about the Guerrilla Girls, a wish to tear off the gorilla masks, seems deeply rooted in a desire to interfere with women's privacy and either to diminish or to appropriate and co-opt their activities, even when the curiosity passes for good will. In the spring of 1990, for example, a male student of mine, newly interested in feminism, wanted to "help" the Guerrilla Girls—an act of chivalry perhaps, or a wish to absorb some of the glamour, the "feminine mystique," of the group (as if dodging armed guards in SoHo at 4 A.M. while carrying pots of glue is glamorous). When I suggested that he enjoy their work, learn from their statistics and tactics, but find his own space and subject for intervention, he was upset by what he considered separatism. That women should do anything behind closed doors, for themselves, without help, immediately calls up choruses of "let me in."

The Guerrilla Girls' anonymity has other, conflicting implications. Staunchly committed to their interventions, they have been incredibly generous in giving their time to the art world. They have engaged in secret guerrilla actions, invisible to the public: in a constant needling process, they send letters to galleries, critics, curators, and journalists, catching them red-handed in incidences of sexism. A typical letter returned the offending show card or review, asking a polite question: "Dear ———: is there a hidden agender [*sic*] at ———?" Art Park,

Castelli, the New York Foundation for the Arts, the *Village Voice,* Robert Hughes and *Time* magazine, and even Artists Space, have received similar missives tailored to the specific offense. The Guerrilla Girls have also papered the ladies' rooms of the Carnegie Institute (in 1985–86) and placed messages in books, catalogues, and the postcard racks at the Guggenheim Museum's bookstore. And yet, of course, the Guerrilla Girls have a career. They have a résumé, which, if it riffs ironically on the idea of a career, is not itself a parody of a résumé: the Guerrilla Girls really have been in many exhibitions, curated shows, been published in journals, lectured in art institutions around the country, been written up, even received awards and grants.[5]

Furthermore, while the Guerrilla Girls' anonymity may have its uses, it puts them at philosophical odds with earlier feminist groups to whom they may owe a debt. Actions taken by the New York Radical Women in 1968 are worth remembering in this regard, including the notorious and wildly misreported "Miss America protest," at which radical feminists did *not* burn a bra but *did* put their bodies and their names on the line.[6] Thus, there is a slight sense of betrayal of these pioneers in the words of one Guerrilla Girl: "We certainly don't want people to think we're all militant feminists just because we think women artists should get a fair deal—that's just another stereotype to deal with."[7] This seems a bit disingenuous. Who is stereotyping whom? What is wrong with being a "militant feminist," except that some "people" might not like it? And which group, after all, has had a greater impact on society?

Yet, the Guerrilla Girls' anonymity and, particularly in the posters, the gap created between the concreteness of the group's gendered message and the disguised actuality of the women who created it, are consistent with an era that has seen widespread efforts to impede women's autonomy over their own bodies. Even within the academy, deconstruction theory has sought distance from the female body, preferring to focus on femininity as a position disconnected from actual females. In *Technologies of Gender,* Teresa de Lauretis notes "the consistent refusal by each philosopher [Foucault, Lyotard, and Derrida] to identify femininity with real women. . . . This kind of deconstruction of the subject is effectively a way to recontain women in femininity (Woman) and to reposition female subjectivity *in* the male subject, however that will be defined."[8] So how convenient that we never

see the Guerrilla Girls, except as type on white posters or as gorilla-masked performers.

Curiously, their anonymity allows the Guerrilla Girls to employ a cute tone, with a dash of sexual innuendo. "Dearest Art Collector," they handwrite in 1986 on pink paper, "It has come to our attention that your collection, like most, does not contain enough art by women.

We know that you feel terrible about this and will rectify the situation immediately.

All our love, Guerrilla Girls."

Another of their "signatures" continues the sexual play: a lipstick imprint, à la Marilyn Monroe, and unmistakably labial. The Guerrilla Girls are sexy and the news media—from *Mother Jones* to *Esquire* and *Playboy*—love them. The language used to describe them is often as flirtatious as the Guerrilla Girls' impertinent soubrette voice: "sassy," [9] "shapely, fish-net-hosed legs to a leather mini-skirt, a *bustier* and, hm, a gorilla mask," "politically sexy," "the group's real turn-on is its wit." [10]

One might compare the Guerrilla Girls to the V-Girls, an art performance group composed of five charming, young women visibly arrayed on a dais. The V-Girls use their given names (they are Martha Baer, Jessica Chalmers, Erin Cramer, Andrea Fraser, and Marianne Weems), but it remains unclear how close their carefully scripted roles are to their "real" personalities. Though unmasked, they remain partially veiled by theater. The Guerrilla Girls' persona, on the other hand, has the sexual allure of the veiled woman, of the voice on the telephone, and, along with humor, they use titillation as one of their political tools. They can risk that strategy because no individual is compromised.

Consistent with the Guerrilla Girls' tactical use of anonymity, for a long time the group did not publish any women artists' names. This seemed a strategic flaw: not only could Castelli get away with saying "there are fewer women artists," but the "man on the street" might infer that there really are no women artists. At last, the Guerrilla Girls countered these reactions with two posters. "WHEN RACISM & SEXISM ARE NO LONGER FASHIONABLE, WHAT WILL YOUR ART COLLECTION BE WORTH?" (1989), listed sixty-seven distinguished women artists whose work is available for a song relative to the prices of work

by men on the inflated and gender-biased art-auction market. That a collection of works by such artists as Natalia Goncharova, Frida Kahlo, Paula Modersohn-Becker, Berthe Morisot, Georgia O'Keeffe, Sophie Taeuber-Arp, Elizabeth Vigée Le Brun, and sixty others—all together—would still be worth less than one painting by Jasper Johns borders on the tragic. The second poster, also from 1989, proved that the intensity of the public's desire to know who the Guerrilla Girls are defies common sense: "GUERRILLA GIRLS' IDENTITIES EXPOSED!" listed 500 women in the art world. I am one of those women, and people now regularly assume that I really am a Guerrilla Girl:[11] "So why don't you guys put up posters on 57th Street?" I'm asked, or, confidentially, "They're a huge group, right?" Why the Guerrilla Girls would suddenly reveal their identities, and how 500 people could be kept secret, stretches one's notion of gullibility! My name being on this poster, I can also testify to the speed with which Guerrilla Girls posters are ripped up and disappear (out of anger, obsessive architectural hygiene, or desire to own the posters). Two or three days is the maximum life span on regularly trafficked streets in SoHo.

But is it art? To critique Guerilla Girls' work solely on the basis of aesthetic criteria is to miss the point, or even to seek to diminish the power of its political message. Yet, the format of the work—the choice of media, the use of language as a primary visual element, the unusual siting—echoes the style of established artists such as Jenny Holzer, Barbara Kruger, Erika Rothenberg, or Hans Haacke, and is consistent with much contemporary art practice, particularly in view of expanded definitions of public art and sculpture. In the early seventies, one learned to call anything not nailed to canvas stretchers "sculpture," including living human beings (namely, Gilbert & George). Joyce Kozloff notes that "public art also includes temporal events . . . and short-lived art pieces that remain in our memories."[12] Writing of the contradiction between the value society places on "immutability" and the value, in the context of art, that it places on contemporaneity and temporality, Patricia Phillips reveals the potential for political critique inherent in "temporal" public art: "[It] may stir controversy and rage; it may cause confusion; it may occur in nontraditional, marginal and private spaces."[13] Phillips considers works by such artists as Holzer and Alfredo Jaar noteworthy for their ability to "raise questions about the relationship of public art to information

and [to] stimulate wry speculations about art and advertising."[14] It is significant that these artists, among many others, were included in MoMA's 1988 *Committed to Print* exhibition curated by Deborah Wye, while the Guerrilla Girls, who had been active for three years, were not. This is particularly surprising considering Wye's description of one type of work deemed appropriate for the show: "The conceptual pieces present *information* in *poster format* that is often ambiguous, *provocative*, and *pointedly unusual for the sites* in which they are placed. Often *simply employing text*, or text and imagery, such pieces have been *posted in the streets.* . . . Yet these prints do not furnish the clear information we expect in a traditional poster."[15]

Included in *Committed to Print* were works involving language: Holzer's *Truisms*, Haacke's *Tiffany Cares;* street works by Holzer and Christy Rupp; and feminist works such as Ilona Granet's *Curb Your Animal Instincts.* Collectives were included: Group Material and the Guerrilla Art Action Group, among others. All or none or some of this work may be considered art, depending on one's generation or one's aesthetic education. What is certain is that the formal strategies, the media employed, its visual appearance, and the degree of political content were identical to those in Guerilla Girls' posters. So while the implied reason for the Guerrilla Girls' exclusion may have been the spurious notion that what they do is not "art," it seems more likely that they were omitted because of their chosen target—the art world, including, of course, MoMA itself.

Other artists and collectives making comparable work have been more easily accepted by art institutions than the Guerrilla Girls. Holzer's oeuvre exists perhaps more in the realm of fiction than politics, and she has moved to more permanent and expensive materials than posters. Many of the artists in *Committed to Print* were protesting the Vietnam War, which by 1988 was a comparatively safe subject for museum display. It is, perhaps, precisely their disregard for individual career concerns and their persistent lack of politesse regarding art-world matters that assures the Guerrilla Girls' critical position and their relatively gritty marginality. However, under the stress of recent forces of suppression, new, angrier, more confrontational, and messily embodied groups are forming. Among them are Sister-Serpents, who are also anonymous, also self-identified as "guerrillas in the war against sexism."[16] New political situations inevitably call

for new interventions, and this group's choice of raw, sexual repre-
sentational imagery and language—a poster at a recent show they
organized at ABC No Rio read, "For all you folks who consider a
fetus more valuable than a woman, Fuck a Fetus"—provides an inter-
esting contrast to the Guerrilla Girls' coolly provocative ironies and
statistics (which, after all, have made it to the pages of the *New York
Times* and *ArtForum*).

It must also be admitted that not all of the Guerrilla Girls' inter-
ventions, especially their public performances, are equally effective.
Two not very articulate Guerrilla Girls disappointed a packed house
at the San Francisco Art Institute in 1987 with a poor-quality video
and off-putting, "Oh sure. The art world's a pit, but I want an equal
opportunity to climb into that pit"[17] answers to questions from audi-
ence members who were struggling with the problem of art-world
"fairness" to anyone, male or female. These particular Girls seemed
unable to step back from the art world as it is presently constituted,
so as to engage in a more sophisticated analysis of patterns of success
and failure, including the art world's calibrated hierarchy of "per-
missible" transgressions. Most distressingly, they failed to educate an
audience intrigued by their posters. Some other public performances
have occasioned similar lapses.[18]

The Guerrilla Girls' poster work, on the other hand, has been more
consistently satisfying. It is almost unfortunate that they have chosen
to move on from where one might want, even need, them to stay.
The Banana Report: The Guerrilla Girls Review the Whitney (1987) was one
of the Guerrilla Girls' most ambitious projects, filling the Clocktower
Gallery in Tribeca with a very complete analysis of the Whitney's cura-
torial and acquisitional practices. Surely this type of report needs con-
tinual updating, as the art world, ever threatening to slip backward,
demands continual vigilance. Roberta Smith points to improvements
in the Whitney's gender percentages in her recent *New York Times*
article on the Guerrilla Girls,[19] but finds merely "worth noting," in a
recent review of new galleries in SoHo, that "except for Eva Hesse
and Agnes Martin, there is not a woman among them."[20] As they say
in France, "*Plus ça change*" (*plus c'est la même chose*).

The Guerrilla Girls have tackled the hypocrisy that underscores
the art world's holier-than-thou reactions to efforts to destroy the
National Endowment for the Arts and censor controversial art: "RE-

THE ADVANTAGES OF BEING A WOMAN ARTIST:

Working without the pressure of success.
Not having to be in shows with men.
Having an escape from the art world in your 4 free-lance jobs.
Knowing your career might pick up after you're eighty.
Being reassured that whatever kind of art you make it will be labeled feminine.
Not being stuck in a tenured teaching position.
Seeing your ideas live on in the work of others.
Having the opportunity to choose between career and motherhood.
Not having to choke on those big cigars or paint in Italian suits.
Having more time to work after your mate dumps you for someone younger.
Being included in revised versions of art history.
Not having to undergo the embarrassment of being called a genius.
Getting your picture in the art magazines wearing a gorilla suit.

Please send $ and comments to:
Box 1056 Cooper Sta. NY, NY 10276 **GUERRILLA GIRLS** CONSCIENCE OF THE ART WORLD

The Guerrilla Girls, Poster, 1988, 17 × 22 ins. (Courtesy the Guerrilla Girls)

LAX SENATOR HELMS, THE ART WORLD *IS* YOUR KIND OF PLACE!"
(that is, segregated and sexist), "GUERRILLA GIRLS' DEFINITION OF A
HYPOCRITE" ("An art collector who buys white male art at benefits for
liberal causes, but never buys art by women or artists of color"), and
a poster that uses the Guerrilla Girls' "cute" but acidic tone to perfec-
tion, "GUERRILLA GIRLS' POP QUIZ." The answer to "What happens
ten months of the year in the art world?" is printed upside down, like a
newspaper quiz, and one can just hear the mixture of condescension,
sarcasm, cloying sweetness, and triumph in the answer: "Discrimina-
tion."

Any criticism of the Guerrilla Girls must be understood as back-
seat driving on my part. For I've grown accustomed—if not to their
faces—to their impertinent "interventions" that so often continue to
hit the mark. The external force of reaction on all fronts may well im-
pel the Guerrilla Girls to grow politically beyond the narrow confines
of the art world, although in doing so they would risk losing their
acuity, specificity, and their particular constituency.[21]

At the end of *A Room of One's Own* Virginia Woolf speaks of the importance of anonymous forerunners to the development of women artists: "But I maintain that she ["the dead poet who was Shakespeare's sister"] would come if we worked for her, and that so to work, even in poverty and obscurity, is worth while." [22] The Guerrilla Girls work for me and for countless other women artists, by keeping the voice of feminism and social justice alive with a leavening sense of humor. I treasure my copy of "THE ADVANTAGES OF BEING A WOMAN ARTIST." Except for appearing "in the art magazines wearing a gorilla suit," how true to my life—too true—that poster is, and how nice to have it on a wall in my neighborhood, to be read, perhaps, by the "geniuses" who "choke on those big cigars or paint in Italian suits."

Patrilineage

Artists working today, particularly those who have come of age since 1970, belong to the first generation that can claim artistic matrilineage, in addition to the patrilineage that must be understood as a given in a patriarchal culture.

The past two decades have given rise to the systematic research and critical analysis of work by women artists, beginning with the goal of retrieving them from obscurity and misattribution, inserting such artists into an already constituted, "universal"—white male—art history, and, more recently, focusing on a critique of the discipline of art history itself. A second historical and critical system has grown in discursive relation to the first, as well as a substantial body of significant work by women artists contemporaneous with this rethinking of the gender of art discourse. Even if insertion into a predetermined system is no longer an unqualified goal, communication between systems remains unsatisfactory, incomplete.

One indicator of the separate but unequal status of this latter system, and the lack of communication between these systems of discourse and art practice, is the degree to which, despite the historical, critical, and creative practice of women artists, art historians, and cultural critics, current canon formation is still based on male fore-

bears, even when contemporary women artists—even contemporary feminist artists—are involved. Works by women whose paternity can be established and whose work can safely be assimilated into art discourse are privileged, and every effort is made to assure this patrilineage.

In a sense it is simply stating the obvious that legitimation is established through the father. It must be noted that, in this historical moment, some fathers are better than others. Optimal patrilineage is a perceived relationship to such mega-fathers as Marcel Duchamp, Andy Warhol, Joseph Beuys, and mega-sons such as Jasper Johns and Robert Rauschenberg. Irony, coolness, detachment, and criticality are favored genetic markers. Picasso is not a favored father in our time, and no one would claim more "feminine" fathers—Bonnard or even Matisse fall into this gendered category. The mega-fathers for the 1960s, 1970s, and 1980s have tended not to be painters; Johns is the exception to this, but his insertion of found objects into his paintings and his iconography of cultural emblems assures his patrilineage to Duchamp.

Legitimation is also found through the invocation of the names of a particular group of authors: six Bs spring to mind—Baudelaire, Benjamin, Brecht, Beckett, Barthes, and Baudrillard. Jacques Derrida, Sigmund Freud, Michel Foucault, and Jacques Lacan are other frequent sires for the purposes of art-historical legitimation. The preponderance of thin lips and aquiline profiles among these gentlemen suggests a holdover of Victorian ideas about phrenology. The game is still afoot for Sherlock Holmes, apparently the prototypical mega-father.

To fully analyze the persistence of patrilineage, one would have to develop a methodology to study a vast number of contemporary artists, male and female, white and non-white, straight and gay, exhibiting and being written about, to trace their artistic family trees, and then read through critical texts to see how their work is referenced to male or female artists and authors. Further controls would establish how various male and female authors undertake this process of legitimation via referencing.

This is a daunting project and not one that I can at present undertake. This essay can only offer a scattershot survey of incidences of patrilineal legitimation, and raise questions about matrilineage within

contemporary art practice, critical discourse, and teaching. I will examine texts from several stages of career construction: the exhibition review, the art-magazine feature article, the catalogue essay, and the essay anthology. The scope of my examples is by necessity limited, given the seemingly infinite applicability of the system of patrilineal validation at issue.

The exhibition review is one of the most basic, routine, preliminary elements in canon formation. Reviews at the back of the major, mainstream, international art magazines are generally short texts that usually refer to at least one other artist or author to offer context and validation for the artist being considered. Almost without exception men are always referenced to men; with few exceptions, women artists are also referenced to men. Such references do not usually involve serious efforts at comparison and analysis but rather function as subliminal mentions. Just the appearance of the name of the sire on the same page as that of the artist under discussion serves the purpose of legitimation, even if it is in a sentence that begins "Unlike . . ." Examples proliferate. One can start and end anywhere, anytime. An *Artscribe* review by Claudia Hart of Louise Lawler's work notes the number of "refined colour photographs of culturally mythological paintings—a Jasper Johns flag, drips by Pollock, a Miró . . . Her mock displays nevertheless set up a mannered Borgesian labyrinth." Her work is then related to that of Dan Graham, and of course, Duchamp.[1] An *ArtForum* review by Charles Hagen of Rebecca Purdum's work references her to J. M. W. Turner, Claude Monet, and Henry Moore, while a review by Lois E. Nesbitt of the painter Judy Ledgerwood's work references her to Mark Rothko, Johns, Peter Halley, and finally, to April Gornik, although a reference to Purdum seems called for by Ledgerwood's hazy, painterly surface.[2]

Women artists are rarely legitimating references for male artists—or should one say that women artists are rarely legitimated by the mention of their work in the contextualization of a male artist, even when significant visual and iconographic elements link a male artist's work to that of a female forebear or contemporary? For example, an *ArtForum* review of a Robert Morris exhibition, by Donald Kuspit, discusses the eroticism and spirituality of a work such as *House of the Vetti* (1983), described by the curator Pepe Karmel as "a central slit enclosed by narrow labial folds of pink felt."[3] Kuspit fails to note

the obvious reference by both Morris and Karmel to the multitude of "labial" works done by women artists in the 1970s, which preceded and informed this work by Morris. The description of the work and the work itself, reproduced with the review, particularly recall Hannah Wilke's "labial" latex wall sculptures from the early seventies.

Feature articles in the major art publications also yield a preponderance of references to fathers. A February 1990 *ArtForum* feature article by Christopher Lyons on Kiki Smith is a case in point. Smith's work, as Lyons immediately notes, is very much about the body, representing inner organs, "humors," egg and sperm, flayed skin, tongues, and hands. It is often made out of materials such as rice paper or glass, whose delicacy is a metaphor for the fragility of the living body. Smith is of the first generation of artists whose education could have included an awareness of art by women and of issues of gender and the role of the body in gender discussion. Her works on rice paper particularly recall the work of Nancy Spero, while certain other works recall Eva Hesse. Lyons seems aware of the problematics of tradition. He begins his article by stating that "much celebrated art comes at the end of a tradition, and is recognized in terms defined by it. But certain artists appear to rediscover, under the pressure of new conditions, a lost or buried concern. . . . Smith's is a timely subject — the body has become a political battleground, as the various organs of social control fight over it."[4] However, he does not define what these "new conditions" are or what the nature of the "political battleground" might be, although the feminist component of these questions appears obvious.

Instead, Smith is almost instantly given a mega-patrilineage: "The concept of self-empowerment, *Selbstverwaltung,* at the heart of Joseph Beuys' political activity is also, in a quieter way, a goal of Smith's emblematic employment of the body's elements."[5] Note that Smith's way is "quieter," that is, more feminine. This daughterhood (the term implies both relationship to a parent and good, filial behavior) is reinforced three paragraphs later when Smith's actual patrilineage is invoked; her father, the sculptor Tony Smith, is mentioned. Once Smith's patrilineage is safely (and doubly) established, Lyons briefly mentions that Smith follows "the path of Nancy Spero rather than Andy Warhol."[6]

Catalogues by curators deeply involved with trend setting and

Robert Morris, *House of the Vetti,* 1983, felt and metal grommets. (Courtesy 1996 Robert Morris/ARS, New York)

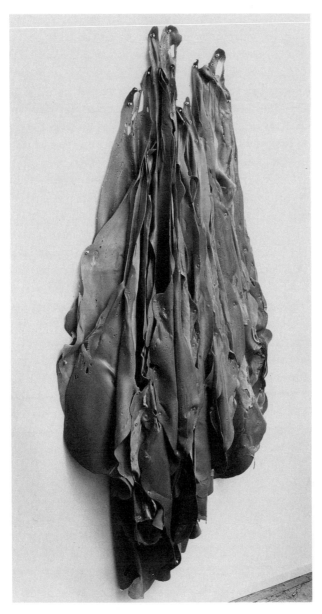

Hannah Wilke, *Of Radishes and Flowers,* 1972, latex and snaps, 76 × 32 ins. (Courtesy Ronald Feldman Fine Arts, New York)

career production also reveal a view of art history and lineage re-markably untouched by developments in feminist art and analysis. *Pre/Pop Post/Appropriation* is the exhibition catalogue by Collins and Milazzo for a show they curated at the Stux Gallery in New York in November 1989.[7] In this exhibition the younger artists showcased by Collins and Milazzo and Stux—Annette Lemieux, the Starn Twins, and Nancy Shaver, among others—are given historical context and legitimacy by the inclusion in the show of works by Rauschenberg and Johns. The catalogue goes further, listing, in elegant boldface, italic headings, Cézanne, Duchamp ("and the Meta-Game of Desire"), Rauschenberg, and Johns. Despite frequent references to the "Body" and "Desire" (as in, "The 'Body,' 'originally' coded for desire, is frozen in Cézanne, and meta-conceptualized and meta-eroticized in Duchamp"),[8] the catalogue essay betrays no awareness of the vast amount of available materials on sophisticated theorization of the body in works by artists, such as Mary Kelly, or philosophers, such as Luce Irigaray. The contextualization system of legitimation is ex-tended to the statements on each individual artist. The men are of course referenced to men (the Starn Twins to "Rembrandt, Picasso and the Mona Lisa"). And so are the women: "The 'Body' has always figured prominently in Suzan Etkin's work." In her early work, a "pro-cess of objectification had to do with reclaiming her own body as a woman, and historically, repossessing the body of the Woman as an object of desire, on a symbolic level, not only from the male artist in general, but specifically, from an artist whose work she, in fact, still very much admires: Yves Klein."[9] Does one need to be reminded at this juncture of Klein's piece, in which naked women, covered in pig-ment, rolled around a piece of paper on the floor in front of bemused onlookers?

Holt Quentel's "world literally sewn, patched together, willfully, intentionally; torn and then stitched back together; then worn away" is the world of the other male artists in the exhibition. But what of quilts by women, which gained legitimacy as aesthetic artifacts through the agency of the feminist art movement? What of Sonia De-launay? What of Lee Bontecou? Betsy Ross does get a mention in the section on Lemieux, but Lemieux's use of autobiography, female anonymous biography, receives no other historical context than that of modernism and postmodernism.

Meg Webster's "concrete effort to reassert immediacy in the work of

art, to bring (back) to consciousness the radical content and process of Nature, and to reassign Value to the element itself" is referenced in this catalogue and in an individual show catalogue by Collins and Milazzo (Scott Hanson Gallery, January 1990) to Rauschenberg, Ross Bleckner, and Robert Gober. Ana Mendieta, Michelle Stuart, Nancy Holt, Alice Aycock, and the many women artists represented in Lucy Lippard's *Overlay* who use earth to work on the concept of Nature have been occulted by the exclusivity of Collins and Milazzo's use of patrilineage to further their system of art-star production.

Critics and dealers may prefer to legitimate women artists whose very real self-referencing to male artists makes it possible for them to be inserted and then resubsumed to patriarchy. Clearly, all women are inculcated with patriarchal values and all women artists are taught about a male art history. Clearly, many women artists participate in the perpetuation of patrilineage by consciously associating their work with that of male forebears. Why link one's work and career to a weaker, less prestigious line? It seems likely that male critics in particular chose to write about women artists who conform best to this system. But this generation of artists, critics, and curators cannot pretend that there have been no women artists or writers. And yet, the elision of women is so seamless that, reading through a Collins and Milazzo catalogue essay or an *ArtForum* review, one forgets that there *are* women.

This seamless persistence of patrilineage is most frustrating at the intersection of postmodernist and feminist discourse. *Art After Modernism: Rethinking Representation,* edited by Brian Wallis, is an anthology positioned at just this intersection.[10] In the front of the book, the contents lists essays by Rosalind Krauss, Abigail Solomon-Godeau, Mary Kelly, Lucy Lippard, Laura Mulvey, Constance Penley, Kate Linker, and Kathy Acker (nine out of the twenty-four authors). But in the back of the book, the index reveals a pattern of referencing consistent with patrilineage. The index references at least eighty-three male visual artists, writers, and critics, with multiple page references to Duchamp, Warhol, Adorno, Baudelaire, Benjamin, and Brecht. Twenty-seven women are referenced; of these, fewer are writers and theorists, and the overall number of page references is smaller. This survey is unscientific but reveals something of the underlying persistence of male referencing in the process of art-historical construction.

Perhaps most disturbing is the use of patrilineal legitimation in

noteworthy feminist texts, such as Griselda Pollock's *Vision & Difference,* one of the most substantial exercises in feminist revision of art-historical practice. Her essay "Screening the Seventies: Sexuality and Representation in Feminist Practice—a Brechtian Perspective" reveals its basic reliance on patrilineage in its title. Pollock charmingly begins one early section of the essay by writing, "I want to start with boys,"[11] but in fact she never ends her use of the "boys." In order to position artists such as Silvia Kolbowski, Barbara Kruger, Sherrie Levine, Yve Lomax, Marie Yates, and, principally, Mary Kelly at the forefront of a critical avant-garde, Pollock rates their success in effectively intervening in patriarchal systems of representation by the degree of their adherence to Brechtian principles of "distanciation," as formulated by Brecht and promoted by Peter Wollen and Stephen Heath (the latter two, by publishing essays in *Screen* magazine).

Pollock first outlines the Brechtian program and its scripto-visual practices and techniques, then repeatedly inscribes Kelly's work into this context:

> While the major but not exclusive theoretical framework of the *PPD [Post-Partum Document]* was a revision of the psychoanalytical schemata of Lacan, the representational strategies were informed by the Brechtian uses of montage, texts, objects in a sequence of sections. . . .
>
> Although the *PPD* was produced within the spaces and discourses of the visual arts, its procedures echo Brecht's almost cinematic conception of the interplay of text, image, object. . . . The *PPD* fulfills Wollen's projection of a complex work of art confronting not Woman or women but the underlying mechanisms which produce the sexual discourses within which women are positioned in contemporary western patriarchal societies. . . . But in terms of artistic practice the questions of subjectivity and sexual difference need to be developed in relation to Brechtian strategies and their political priorities.[12]

The usefulness of Brechtian strategies to intervene in patriarchal representation should not, however, vitiate at least some discussion on the ambiguities and ironies of relying so heavily on a male system to validate a feminist practice. In this significant example of feminist avant-garde canon formation, the woman artist is still subsumed to her mega-father.

WHEN RACISM & SEXISM ARE NO LONGER FASHIONABLE, WHAT WILL YOUR ART COLLECTION BE WORTH?

The art market won't bestow mega-buck prices on the work of a few white males forever. For the 17.7 million you just spent on a single Jasper Johns painting, you could have bought at least one work by all of these women and artists of color:

Bernice Abbott
Anni Albers
Sofonisba Anguisolla
Diane Arbus
Vanessa Bell
Isabel Bishop
Rosa Bonheur
Elizabeth Bougereau
Margaret Bourke-White
Romaine Brooks
Julia Margaret Cameron
Emily Carr
Rosalba Carriera
Mary Cassatt
Constance Marie Charpentier
Imogen Cunningham
Sonia Delaunay

Elaine de Kooning
Lavinia Fontana
Meta Warwick Fuller
Artemisia Gentileschi
Marguérite Gérard
Natalia Goncharova
Kate Greenaway
Barbara Hepworth
Eva Hesse
Hannah Hoch
Anna Huntingdon
May Howard Jackson
Frida Kahlo
Angelica Kauffmann
Hilma af Klimt
Kathe Kollwitz
Lee Krasner

Dorothea Lange
Marie Laurencin
Edmonia Lewis
Judith Leyster
Barbara Longhi
Dora Maar
Lee Miller
Lisette Model
Paula Modersohn-Becker
Tina Modotti
Berthe Morisot
Grandma Moses
Gabriele Münter
Alice Neel
Louise Nevelson
Georgia O'Keeffe
Meret Oppenheim

Sarah Peale
Ljubova Popova
Olga Rosanova
Nellie Mae Rowe
Rachel Ruysch
Kay Sage
Augusta Savage
Vavara Stepanova
Florine Stettheimer
Sophie Taeuber-Arp
Alma Thomas
Marietta Robusti Tintoretto
Suzanne Valadon
Remedios Varo
Elizabeth Vigée Le Brun
Laura Wheeling Waring

Information courtesy of Christie's, Sotheby's, Mayor's International Auction Records and Leonard's Annual Price Index of Auctions

Please send $ and comments to: **GUERRILLA GIRLS** CONSCIENCE OF THE ART WORLD
Box 237, 496 LaGuardia Pl., NY 10012

The Guerrilla Girls, Poster, 1989, 17 × 22 ins. (Courtesy the Guerrilla Girls)

These samplings in the published material of mainstream art culture turn one into a de facto Guerrilla Girl: there are so few features on women artists, so few reviews—and those are so often placed further back in the review sections—so few references to women artists, writers, and theorists. Hence the significance of a 1989 Guerrilla Girls poster listing all the works by women artists that could be purchased for the price of one Jasper Johns. There *are* mothers. Matrilineage and sorority, though constantly re-occulted by patriarchy, exist now as systems of influence and ideology. In addition to the wealth of fathers that no sane woman could deny, as a painter and a critic, I place myself in a matrilineage and a sisterhood: Frida Kahlo, Charlotte Salomon, Florine Stettheimer, Miriam Schapiro, Pat Steir, Ida Applebroog, Elizabeth Murray, Ana Mendieta, Louise Bourgeois, Charlotte Brontë, Jane Austen, Louisa May Alcott, Emily Carr, Luce Irigaray, Griselda Pollock, Mary Kelly, Simone de Beauvoir, Simone Weil—all artists and writers whose works have influenced, informed, and, perhaps most important, challenged my visual and critical prac-

tice.[13] It is by now a vestigial cliché that the male art system offers me resistance as water does to the swimmer; at present I am most challenged by resistance within the present of feminist thought. To hone one's critical understanding by a vigorous debate with other women offers more hope for a revitalized art discourse than does the endless reinscription of a stale patrilineal system.

All studio art and art history students should know the names listed on the Guerrilla Girls poster. They should be aware of the multiplicity of feminist art history, practice, and theory. If there is a resolution or a solution to the persistence of patrilineage, it must be at the level of education. At the end of a semester survey course on the history of women artists one student, an art history major, asked, "Why do we have to have this course? Why didn't we learn about these artists and these issues before?"

Why indeed? Feminist art programs and women's art history courses had barely developed and been reinforced with a minimum of slides when the rightist backlash of the Reagan years intervened, cutting funds, attacking the ideal of affirmative action. In the art world, movements based on process, concept, and performance—not linked to the market—were replaced by art movements based on critiques, often collaborationist, of capitalism. Schools followed, or rather slipped back. Curricula lost courses on women; women faculty lost energy for teaching such courses. Slides of works by women artists were lost. Most art schools do not provide enough information on women artists, and what little material they do offer is often without a pedagogic and theoretical framework. Combined with the patrilineal tendencies of art writing and canon formation noted in this essay, the art student, female or male, has few tools for disrupting patrilineage.

To cause such a disruption is not a question of creating a Marceline Duchamp: it is exactly the opposite. The end game of postmodernism turns on the eternal ritual killing and resurrection of a limited type of father. Other models might provide a path to a new art history and a different system of validation and legitimation. And maybe some bastards and orphaned daughters (and the entire Third World) could find homes and genetic placement.

Postscript: Summer 1992

In researching and writing "Patrilineage" in the winter of 1990, I noted that "the scope of my examples" was "by necessity limited, given the seemingly infinite applicability of the system of patrilineal validation." I did not anticipate that this applicability was not only lateral in terms of the examples available to me at that particular moment, but also vertical in terms of consistent applicability into the future. Rather than radically interfere with the original text of the essay for the purposes of republication, I offer some afterthoughts and consider some more recent instances of patrilineage. Selecting a few examples among many candidates, I perversely feel a scientist's delight that my thesis still holds true, yet profound frustration that naming the syndrome has not effected a cure for it.

In writing this postscript, I benefit from criticism leveled at the original essay, particularly that I did not offer enough of an alternative to what seems like such an insidiously persistent art-historical mechanism. The instances of patrilineal validation addressed here, through examples of the critical reception of works by Karen Finley, Janine Antoni, and Sue Williams, articulate the absurdity and pathos of this mechanism when it is applied to clearly gender-oriented, feminist works. Also, precisely by pointing to the, at the very least, unconscious complicity of some women artists, these examples raise the possibility of methods for averting it.

Looking back on the 1980s, we find that some women artists used assaultive or flamboyant behavior or "transgressed" via their appropriation of pornography, often by the exploitation of their own bodies, in works that claimed or had claimed for them an ideologically oppositional position to works by artists such as Eric Fischl or David Salle, thereby achieving a similar, although not quite so lucrative, notoriety. Were these "bad girls" rewriting patriarchal representations of women and recuperating them with subversive, feminist intent or were they just "bad boys" with estrogen, replicating age-old exploitation of the female body? Works such as Cindy Sherman's self-portrait in a clinging T-shirt (*Untitled #86*, 1981) or low-cut camisole (*Untitled #103*, 1982) certainly strained an acceptance of the supposedly ironic, critical stance with which her work was credited. Some women have also felt ambivalent about performance works by Karen

Finley. The frightening conviction she brought to her invocation of a rapist hinted at a genuine—albeit unintentional—rather than simulated, hatred of women.

Regardless of what one thinks about these artists' works, it is an art-historical fact that this type of controversy over the problematic of self-exploitation by a woman artist has occurred before. In the 1970s, women argued over, and *worried about,* the political wisdom and the potentially negative repercussions of Lynda Benglis's 1974 *ArtForum* exhibition ad, in which she presented herself naked, wearing only sunglasses, and holding in her crotch a double dildo as if it were a huge phallus of her own; of Hannah Wilke's photographs of her body as an installation site for her little vaginal sculpted forms; or of Carolee Schneemann's performances involving the active use of her naked body and sexual orifices. It is also a fact that these women artists and others are not referenced in discussions of Sherman or Finley. Peter Schjeldahl's introduction to *Cindy Sherman,* a 1984 Pantheon book, enacts the type of eroticized response that, if not downright objectionable, is certainly problematic for work that is said to critique the eroticism of the traditional representations it appropriates. Schjeldahl writes, "I am interested to note that I automatically assume, without knowing, that the photographer of the 'film-frames' was always male. As a male, I also find these pictures sentimentally, charmingly, and sometimes pretty fiercely erotic: I'm in love again with every look at the insecure blonde in the nighttime city."[14] He then provides a patrilineal cohort for the artist: "The difference [from earlier artists' responses to received images] in the case of Sherman's generation—a farflung, international cadre, to which must be associated even the great German, Anselm Kiefer—is the steely concentration, the self-abnegating discipline, which they got from these avant-garde elders and with which they have solicited the oracles of images."[15] The mention of Kiefer is clearly superfluous, belonging to the subliminal type of patrilineal validation I noted in my essay. On the same page, Jean-Luc Godard, Rainer Werner Fassbinder, Andy Warhol, and David Salle are summoned to buttress Sherman's admissibility into the pantheon. Or is it that her work provides an opportunity for this critic to buttress *his own position in the patrilineage* by naming the powerful male artists he so admires?

A Woman's Life Isn't Worth Much, Finley's 1990 installation of wall

drawings and writings at Franklin Furnace, included a text written on the walls in simple, deliberately clumsy print, which was composed of fiery, but somewhat flat-footed, statements of feminist wishes and simple howls of female rage. These words were accompanied by drawings illustrating patriarchy's dos and don'ts for women's appearance. They were "primitive" in style and stereotypical of what people may think early-1970s feminist art looked like: see Jane with a bra—see Jane without a bra—see Jane burn a bra.

Yet it must first be said that while this work *seemed* to have the feel of early feminist art, a cursory look at documentation from the period between 1970 and 1973 reveals a much more varied and sophisticated assault on patriarchy, from raw and bloody performances by women in the Feminist Art Program at CalArts in 1973 to Suzanne Lacy's chillingly economical *Rape Is . . .* (1972), in which the reader must break the seal of a coolly corporate-looking book and rape the art object in order to read its contents. Many of the art objects and performances produced by women artists in New York in the late 1960s and early 1970s and by women involved with the Feminist Art Program at CalArts and later the Women's Building in Los Angeles in the early and mid-1970s would seem like obvious referents for Finley's work. She certainly owes a debt to Carolee Schneemann's 1975 performance, *Interior Scroll,* in which Schneemann pulled a scrolled text from her vagina and "read a text on 'vulvic space'—about the abstraction of the female body and its loss of meanings,"[16] or to *Up to and Including Her Limits* (1973), in which, tethered to a rope for eight hours a day, Schneemann would move her body so as to write on the wall and floor around her. In Faith Wilding's 1972 performance work, *Waiting,* the artist, dressed as an old woman keening in a rocking chair, relived her life as an endlessly passive process of waiting for things to happen to her body and for others to live her life for her, of waiting for life. The monotonous, eerily anxiety-producing aural tone of Wilding's incantation prefigures the tonality employed by Finley in many of her performances. Yet Finley's work has received critical validation via association with important male figures, which other feminist artists, themselves more relevant to Finley's work, are often denied. A review of the Franklin Furnace exhibition immediately links her to the proper fathers: "Mixing futurist aggression, Brechtian political performance strategies, Artaud's sensualism, and Allen Ginsberg's

hypnotic zeitgeist-attuned chanting, Karen Finley's work has always elicited impassioned response."[17]

Performances are notoriously ephemeral from the point of view of written history, but *Waiting* may be seen in Johanna Demetrakas's 1973 documentary *Womanhouse,* was discussed in *Ms.* magazine, and the full script is reprinted in the appendix of Judy Chicago's *Through the Flower: My Struggle as a Woman Artist.*[18] Schneemann's work is widely documented. It would stand to reason that a woman coming of age in this time and committed to a feminist and aesthetic edge would seek out such empowering works. Interesting in this regard is a comparison of interviews with both Schneemann and Finley in *Angry Women,* an edition of *Re/Search.* While Schneemann mentions several important women in her personal history and many "favorite female predecessors"[19]—Virginia Woolf, Marie Bashkirtseff, Paula Modersohn-Becker, Margaret Fuller, Simone de Beauvoir—Finley engages in the type of patrilineal self-validation I have described as referencing via the negative. She speaks about how she tried to live out Jack Kerouac's *On the Road* but ended up getting "picked up and at gunpoint [having] to give someone a hand job."[20] Immersed in its dark side, Finley seems nevertheless still enthralled by the masculine mystique. She "felt resentful of what was going on in the '6os and '7os with the cutting edge male Body Artists (Chris Burden, Vito Acconci, the Kipper Kids and Bruce Nauman) who did use their bodies—well, as soon as *I* (a woman) tried to do that, the situation changed, because the female body is *objectified.*"[21] Yet, almost incredibly, she never mentions any of the women performance artists using their bodies in those years who struggled with the same critical inequity.

Another example of the elision of matrilineal influence is to be found in reviews of a recent exhibition at the Sandra Gering Gallery of an emerging young artist, Janine Antoni. The exhibition, entitled *Gnaw,* consisted of two installations. In one room, resting on marble set on pallets low to the ground, were two six-hundred-pound blocks of hard, dark-brown chocolate and soft, white lard, respectively, sculpted slightly by what appeared to be chisel marks but in fact were the artist's bite marks. In an alcove, heart-shaped chocolate boxes made of molded chocolate and red lipsticks in fancy black-and-gold casings were displayed in glass cases. Despite the work's formal impact, statements by the artist were necessary to make the connec-

tion of process between all the elements and to clarify the intended signification of bulimia. In an *ArtForum* review, Lois E. Nesbitt writes about bulimia (a disorder primarily affecting women) and yet provides art-historical validation via allusions to "Joseph Beuys' lard works and Dieter Rot's chocolate sculptures."[22] A *New York Magazine* piece accomplishes the same patrilineal objective, albeit by what amounts to a double negative: "A German woman hissed, 'This isn't art, this is lipstick. I hate Joseph Beuys.' "[23]

Beuys is demonstrably a much favored mega-father and certainly a presence in Antoni's work. Yet recent works by two women artists of much more immediate relevance to Antoni are not mentioned, either in reviews or in statements by the artist, despite the fact that both had exhibited work in New York shortly before or immediately after her exhibition. In a performance-installation at LA Louver Gallery earlier the same season, Ann Hamilton sat at a table, surrounded by white cloths impregnated with wine, biting into lumps of dough, which she then spit out and placed in a basket for them to rise and decay. This work spoke of bulimia and waste, with undertones of Christian iconography.

Works done over the last few years by Maureen Connor, exhibited frequently in the year preceding Antoni's exhibition and collected in an exhibition that opened the day Antoni's closed, were indisputable influences on Antoni, her former student. For example, twice, in 1991 and 1992, Connor had exhibited *Ensemble for Three Female Voices* (1990), in which she expressively integrates the contingency of the female body, the cultural construction of femininity, and the silencing of women. These linked meanings are economically encapsulated in human larynxes, cast in red lipstick, stuck on microphone stands, within an installation that included the taped sounds of a baby girl, a middle-aged woman, and an old woman laughing and crying. *Ensemble for Three Female Voices* has been a truly *germinal* artwork—to change patrilineage, the word *seminal* must only be used when appropriate, but even some feminist art historians and critics find it difficult to wean themselves from the old language of influence. Not only Antoni, but also Rachel Lachowicz have used this novel, ingeniously gendered material, following in Connor's footsteps. Equally relevant to Antoni's work are Connor's many works that examine bulimia and anorexia as feminist tropes.[24]

Antoni, in personal conversation, has noted Connor's work as an important *competitive* context for her own. Although feminist artists and theorists have critiqued the usefulness of the Oedipal narrative for women, it constructs male artists' relation to their aesthetic and ideological fathers and, as such, is a constitutive and privileged element of patriarchal and patrilineal discourse. In addition to the perceived benefits to women of patrilineage, it may well be that many women shy away from openly admitting to conflict or competition with other women—with mothers, for instance—no matter how productive those relationships may be, both because these relations are less privileged in mainstream discourse, and because women have been traditionally trained to avoid conflict. If it is an egregious example of patrilineage to elide Connor and Hamilton from any contextualization of Antoni—given that these influences are so obvious, close, and privately acknowledged—one must wonder at the degree of complicity of the artist herself. Matrilineage can only begin when a woman artist risks foregoing validation via mega-fathers in favor of her own female teachers and contemporaries, or at least when she enriches the public's understanding of her work by a more balanced self-contextualization.[25]

Another recent example of the patrilineal unwriting of feminist history is particularly distressing because it is done in the service of a new breed of "angry" young women artists. After a divisive decade in which women artists were urged to steer clear of essentialist positions and nonappropriative methods, the antiessentialist discourse as a critical system seems to have collapsed altogether, as women working in sculpture and painting, depicting women in a very essentialized victim position, are receiving a great deal of attention. Many women were struck by the simultaneity of Kiki Smith's prone, featureless female creatures dragging feces across one gallery floor with Sue Williams's abused, beaten, and branded female figure laid out on another (Smith's *Tale,* at Fawbush Gallery, and Williams's *Irresistible,* at 303 Gallery, both in May 1992). These works are not analyzed for what they naturalize about women, nor in the context of the ideological battles that were so central to feminist discourse in the past decade. One even suspects that their popularity is partly based on the attractiveness to the mainstream of the female victim position. My comments, I must add, are not meant as a criticism of the works, which I feel are

strong, but as an analysis of the relationship among the work, its critical reception, and the manner in which certain ideas about women get produced and perpetuated.

The production of Williams's career is unfortunately built on an erasure of the history of two preceding decades of work by women, doubly unfortunate for the role that Williams herself may play in the process. Roberta Smith's *New York Times* feature on Williams ("An Angry Young Woman Draws a Bead on Men," 24 May 1992) provides an interesting example of such an erasure. Smith places Williams at CalArts at the same time as male art stars such as David Salle, Eric Fischl, and Ross Bleckner. Neither Smith nor Williams mentions that there was a groundbreaking and influential Feminist Art Program at CalArts at that time. Not all women in the art school joined that program by any means, and there were certainly tensions about being in or out, but the program provoked great curiosity among nonparticipating students, male and female, since it operated behind closed doors. Its presence constituted an unprecedented conscience-check on rampant machoism. It makes me sad, as a member of that program and as a feminist educator, that Williams wasn't able to avail herself of the personal support and empowering influence of this important educational experience but instead remembers CalArts as a "man's world then." This omission is galling to women who find Williams's work reminiscent of early Feminist Art Program class assignments emerging out of consciousness-raising, and to gay male artists who feel that the program gave them permission to deal with sexuality in new, non-Greenbergian forms.[26]

It should be noted that Smith and Williams were following a well-established path. The erasure of the CalArts Feminist Art Program was well under way as early as 1981, when a ten-year alumni show, curated by Helene Winer, included only two women artists and no one from the program but did include many of the aforementioned male art stars in whom the art world was building an investment. Thus, one artist's or one critic's work is not at fault or at issue here, but rather a particular process of career construction and its effect.[27] But the persistence of the patrilineal validation system and the participation in this process by women who do not wish to be associated with feminism does not serve the textual and formal development of art by women.

If women are denied access to their own past they always occur in history as exceptions, that is to say as freaks (Sue Williams's "self-destructive" personal history is useful to this type of mythmaking), and they are forced to rediscover the same wheel over and over, always already losing their place in the growth of culture. They are denied the critical mass of a history, with ancestors and even with Oedipal battles between generational rivals. If women themselves deny association with feminism, they are likely to be subsumed to male history no matter how exceptional they are. Women may feel they risk a lot by linking themselves to women progenitors as well as to men, but while the magazine review linking a woman artist to a male progenitor, either through a positive—or even negative—reference, may bring short-term career benefits, in the long term, experience shows that the art history textbook will name only the mega-father, and the artists who were described as "like" or "unlike" him will become simply, "and followers," among which women will be the last to be named.

It is a commonplace of history that it is written by the victors. Western civilization is so much a male "hommologue"[28] that it will always privilege a man's failure over a woman's success. It can barely consider accomplishments of women. They don't compute. To undo that process requires constant vigilance. Women must reexamine the very notions of success and failure in the light of their basis in a patriarchal value system. Yet women's fear of association with a "weaker" position remains a powerful force in the maintenance of patrilineage *by* women. Comments by individual women working in the new abstract painting suggest a distrust of any word beginning with *fem-*, rejecting the marginalization *fem-* might entail but, by the same token, rejecting the specificity of political/personal experience that might enliven their work and prevent its absorption into yet another "universalist," that is to say male, movement.

In "Patrilineage" I insist on the importance of a new, more gender-conscious form of studio-art and art-historical education. Patrilineage can only be dismantled by the conscious will to do so by women and men involved in the process of art production, criticism, and history. Women artists must identify women artists whom they admire, were influenced by, or even those they dislike or feel competitive with, revealing the *woman's world* many women artists now occupy in their daily aesthetic lives. An effort must be made by critics to not only be

aware of those influences, but even to search for them, and further, to posit the issue of gendered influence as a problematic of art. What does it mean for a woman to claim to be doing "universalist" work? Or to be clearly influenced by male artists, including, in some cases, misogynist ones? These questions must be critically addressed.

Patriarchy has a lot invested in the notion of universality and in the process of patrilineage. Property is what is inherited through legitimate lineage, and the possession of property—be it culture, history, or philosophy—is ultimately what is at the core of this art-historical mechanism. Artists and art writers, women in particular, have a stake in undermining traditional notions of property, value, and lineage. The method is really very simple: it will always be a man's world unless one seeks out and values the women in it.

TEACHING

On Failure and Anonymity

The most useful course that an art school could offer today would be one called "On Failure and Anonymity," for these are the truest conditions of the artist's life, all artists, even the great and famous ones.

Art schools are graduating hundreds of M.F.A.'s, thousands of B.F.A.'s a year; many of these graduates have their eyes firmly fixed on the youthful fame and financial success of a handful of exceptionally talented, ambitious, and lucky men. In one generation art has come from being considered a financially marginal occupation to being seriously thought of as a potential source of wealth.

This view is encouraged by the present confusion between the older values and romantic scenarios of "high" art and the contemporary art market, a confusion that roughly parallels the difference between the family farm and agribusiness. The long becoming of an artist, the lifelong search for meaningful form, is being interfered with by a huge influx of money and of media attention and influence. Artists are now pressured by considerations and expectations of immediate, youthful financial success, although the ratio of such successes has not significantly altered despite the change in emphasis.

The basic fact of the artist's existence remains that no one asks you to do whatever it is that you do, and just about no one cares once

you've done it. Art in our era is a self-generated activity, and the marketplace is for most artists just a transient delusion.

Which of these existences should art schools prepare students for? The fantasy of a retrospective at a New York museum before the age of forty or the lifetime of art practice? The answer some students give is distressing. A CalArts graduate presented a paper at a College Art Association conference some years ago in which she blamed the school for not having prepared her for the realities of the art market, specifically for not having provided enough of a postgraduate network of connections to help her market her work and herself. But the logical outcome of this emphasis on networking and salesmanship is hucksterism, self-commodification, packaging at the expense of content. The art precipitated by this imperative to "make it" tends to be fast work that can be sold easily and quickly. Even "angst" must be "lite." The transformative nature of artwork may be degraded into the distillation of "Raw Hype" into "Pure Hype," as depicted in a *New Yorker* cartoon.

In the last five years not a semester has gone by without a few, inevitably male, students bringing up how much money art is selling for. Only once in a while has a student, usually female, told me that she was in art school to "find out what this painting thing was about," and, even more significantly, looked to me with some concern and asked if, being a *woman* artist, I had a "life"?

Problems particular to gender aside, yes, I have a life. But the question is a crucial one. Expectations of glory veil the real life of the artist, and if being in the studio is the priority, the life is difficult.

Let us consider first the more obvious and predictably difficult life of the artist who is not a financial success (that is to say, the majority of artists). This is a life of total insecurity. The artist is a pre-Columbian sailor adrift on a flat ocean at whose edge is an abyss, just past the point when the rent money runs out. Jobs are boring, ill-paying, distracting, and exhausting. Or a more serious involvement with a "real" job threatens the continuity and ultimately the continuation of artwork. The committed artist risks being perennially broke, not to say penniless, a bum in fact. To be poor is to be infantilized in a country where adulthood is equated with financial independence. This life is grueling, ego-battering, embittering, filled with deprivation. I do not recommend it to anyone except to the artist for whom there is no other choice.

However, some artists are "successful" in the commercial sense. But that success may not come for years, it probably will not last if it does come, and it has unforeseen consequences. No matter how impervious the individual may feel to corruption, success can corrupt, erasing past ideas and ideals. The earlier it comes the more likely that is. Success is never enough; the need for more is insatiable. Success can lead to paranoia. Those young men everyone looks to as examples are all obsessed with those who might want to get at them, knock them down. Because of their success they see themselves as targets, as indeed they had targeted the previous generation, for the link between progress/success and forms of patricide is grafted onto the belief structure of Western civilization. Success can be paralyzing; approval can prevent change, because change risks the destruction of the desired commodity. Conversely, enforced, artificial "change" can become the commodity. Praise can be as intimidating as criticism. Both equally disturb the ecology of the life of the studio.

Real success is the ability to continue making art that is alive. For this the artist has to be educated to another set of values and a broader scope. Yet art schools underemphasize practical skills, liberal arts courses, and, worse yet, even their art history courses are often insufficient and cursory.

To survive the long run, to continue to function, someone ought to tell you that there is a long run. To survive, it is necessary to stand for something within yourself and yet always doubt your own deepest beliefs. It is necessary to have the agglomeration of terrors and hopes, delights and doubts that make up a soul. Perhaps a soul is culturally bound and determined, but it can be more than a slave to fashion. Follow fashion and be fifteen minutes late. Trends are fleeting. A lifetime of art cannot be built on a weather vane.

Real failure comes to those who accept their status quo, who do not press against their limitations. This seems to happen more or less to almost all artists, at some point down the path. The artist is an organism, genetically condemned to atrophy and death as all living organisms are. Only the persistence of dissatisfaction and struggle ensure a true form of success in the life of the artist.

The life of the work, the ecology of the studio is what I am interested in, when the doors are closed on the pressures of the marketplace. And in this life there is always failure, no matter how much money is made. For it is a given that there is always a gap between

what the artist wants the work to be and what it is, between the original goal and the weird paths that are taken. Life continues only as long as the blind chase down the path. There is tremendous fear on that chase because the relationship between artist and artwork is one of intimacy with the self, and intimacy is truly terrifying and can never be fully achieved. The closer one comes to something really intimate (which may seem really foreign), the faster one springs back, and thereby fails.

Despite the fear of intimacy and the impossibility of achieving completeness within and without, there can be a wonderful sense of anonymity in the practice of art. As at a noisy flea market, sometimes a silence and a slowness can overcome the busyness, and then small, insignificant treasures become distinct. In these moments you know no one and are no one. A friend of mine describes in terms of reverence and sexuality the rags she wears when she paints. Every layer discarded and replaced by street clothes is an added layer of anxiety and loss of intimacy with her self.

The greatest thing an art school could give a student is access to this anonymous life of the studio, recognition of its supreme importance to the inner survival of the artist and to the creation of meaningful art that transcends fashion and money.

Authority and Learning

What can be taught and what can be learned? What atmosphere is necessary for art students to expand their own original attraction to whatever it was they understood to be "art," to learn about their own instincts, tastes, and personal narratives, and locate these within the complex history and practice of art? How does one help those students flourish whose identities and proclivities might be marginal to the mainstream, stylistically and in its conception of the ideal artist persona? My early interest in teaching was simultaneous with my decision to "be an artist," and also with my belief, whether illusory or not, that traditional studio-art instruction had taught me little about how I make my own work. My commitment to teaching was also more conventionally rooted in my desire to right what I perceived as prevalent forms of abuse in art teaching, and my desire to transmit what I had experienced as life-allowing methods for thinking about being an artist.

To teach is to place oneself and to be placed by students into a position of *"knowledge* and *authority."*[1] Regardless of one's age or degree of knowledge or personal authority, the role "teacher" gives power. Abuse follows. Some of the abuses of authority that I encountered as an art student and that I have seen and heard of being perpetu-

ated to this day can loosely be grouped under the category of gender abuse, with a gendered imprint, as well as actual gendered narratives and players. Inasmuch as we think of hierarchy in gendered terms, existing as we do, willy-nilly, in a patriarchal system, then systems of authority in art institutions are patriarchal, even, occasionally, when women artists/educators are involved.

These abuses extend from the obvious form of actual sexual harassment, forced sex for grades or promotion—which one hopes is rare and is now more readily subject to legal recourse—to the more common story of apparently consenting sexual relationships among faculty and students, to those aspects of teaching whose gendered characteristics are occulted under the false rubric of "universality." This most pervasive and persistent form of teaching abuse is marked by the lack of specification of the positionality of the speaker. When critiques of student work and advocacy of particular aesthetics are uninflected by genuine qualification of the generational aesthetic and gendered reality of the teacher, when the position of the speaker is not rendered transparent, difference and multiplicity are ignored and denied.

One of the positions that I speak from is that of a feminist artist, not just a woman artist, among several positions and allegiances I embody as a teacher of art. From this position, the issue of seduction between male teachers and female students in art schools and art departments is a disturbing one, and it is verifiably persistent at the anecdotal level. This may seem like an unworthy subject for pedagogic inquiry, but it raises questions that are at the heart of any investigation of authority, of gendered abuse in teaching practices.

Male (usually) teachers colonizing female art students is about as newsworthy as dogs biting men.[2] So what's wrong with it? Certainly, ambitious women art students want power, or, as a first step, contact with power. Men still usually have the actual power and the appearance of power within the microworld of the institution (and the art world). From the other side, the temptation is great. Now that I'm . . . not quite so young, it is miraculously and perversely clear to me how sexual people in their late teens and early twenties are, whether they try to be or not. It is a tool they instinctively (and often unknowingly) use to get attention, since they have few other tools for power, lacking experience and political position. What is *wrong*—to use a term of morality or ethics—is that completing the drama of seduction fulfills

the traditional idea that woman's main trading chip within patriarchy is her sexuality, which is temporal and temporary. The woman student does perhaps gain closeness to power, but in this transaction she learns that her sexuality (or, more precisely, the newness of her sexuality) is more potent and valuable than her talent. What she wanted, what any student wants, is *attention*. If attention is paid to her *work* and to the quality of her mind instead of to her sexuality—even if she proffers the latter as a trading item—then another lesson is taught, focusing on capabilities she will have for longer than her youth— namely nonbiological productivity and intellect.

And what of the reverse situation, women teachers and male students? It just doesn't seem to happen as often. Fewer women faculty have as much institutional power, for one thing, so male students want contact of some kind with male faculty, too. Untenured women have more at stake, their job security rests on conformity and probity. And women risk being seen as ridiculous, "cradle robbers." The overarching gender hierarchies and conventions prevalent in society at large remain operative within a (woman) teacher/(male) student relationship, so that the woman risks *loss* of whatever power she has. Surely the mechanisms are similar in homosexual teacher/student relationships. No matter what the setup, rewarding students for using their sexuality as a principal tool, rather than paying attention to their minds beyond their sexuality, is abusive. Having shifted generations, I can to a greater extent than in my early years of teaching put myself into the shoes of all the male teachers I've known who have had affairs with students and, looking into the needy face of a younger person, understand the predatory nature of the trespass, the degree to which it is a betrayal of trust.

And yet, seduction is an important, even a necessary, aspect of teaching. Constance Penley, in her essay "Teaching in Your Sleep," notes "the extreme power of the transferential relation, of the narcissism underlying the demands of both students and teachers, or the basically eroticized nature of learning (the constant appeal for recognition)."[3] To keep the attention of a group of restless people, every acting skill is called for, and charm, humor, ardor, all help sustain focus. It is important that the teacher be alive and vibrant, and sexuality and seduction are important signs of life.

Beyond seduction, teaching techniques and philosophies com-

monly expressed and performed in art schools are suffused with the idea of abuse, plain and simple, as pedagogy—the kick-in-the-pants method of criticism. How many group crits involve a girl or two dissolving in tears? One sometimes feels that the (male) teachers are "counting coups," putting notches on their . . . paintbrushes. Crit the girls and make them cry. 2 Live Crew would be right at home on this range. Those tears are as often as not caused by anger and frustration at being bullied and silenced by the louder voice or dismissed as too disquieting. If the student changes in a manner consistent with the teacher's aesthetic, or even just fights back in what turns out to be a productive manner, then this pedagogy is deemed successful. The kick was for her/his own good. Abuse is self-perpetuating, as social research has shown, and this form of abuse is deeply self-perpetuating and ingrained in Western culture, as it forms part of the Oedipal narrative in which the father tries to kill the son, and then the son *does* kill the father, and the mother or sister conveniently kills herself.

Another difficulty in countering this pedagogy is the disconcerting fact that students crave the visible exercise of authority, indeed of brutality—even as they claim to rebel. Critiques that follow different models are not credited or understood. If a teacher tells you your work is full of shit, without elaborating his or her own position, motivation, or bias, he or she may not be helping you achieve self-criticality, but it is a *noticeable* commentary. In a time of conspicuous consumption, that is important. "I was told I was full of shit," or even, perversely, "I *cried!*" That the validation of brutality in teaching is pervasive emerges from a Hasidic tale:

> When Rabbi Yitzhak Meir was quite young he became a disciple of Rabbi Moshe of Koznitz, the son of the maggid of Koznitz. One day his teacher kissed him on the forehead because he had helped him solve a difficult problem with astonishing acumen. "What I need," said Yitzhak Meir to himself, "is a rabbi who rends the flesh from my bones—not one who kisses me."
> Soon after he left Koznitz.[4]

Clearly, rending flesh is sometimes necessary for growth. What is at issue is how to get to clean bone without brutality, and not for the sake of being destructive. How does one make it possible for someone to change "by him- or herself"? As a teacher I am never quite sure

of what I offer as an alternative to the "this work is full of shit" approach. I suggest choices to students—extrapolating from a painting several divergent possibilities for further work. While many students may wish me to say, this is good, this is bad, do this, don't do that, instead I say, this small spot in the painting seems alive—but understand that I may respond to this little thing because of something in my own work—and you could develop to the utmost this thing that is latent in your work, or you could develop to the utmost this totally opposite thing. This approach is less determinative and predictive. I urge students down paths suggested by their work and their conversation to an endlessly deeper path of investigation, which in itself is the core of art-making/thinking. This layered form of commentary apparently differs from the traditional voice of authority.

The problem-solving approach, so important in foundation teaching, poses similar problems, since a problem-solving exercise tends to hint at *a* solution. Clearly, all would pay lip service to the idea that it is just the working through any set of limitations that is useful about these exercises. Yet an art curriculum that depends heavily on problem solving tends to be oriented toward formalism, and thereby implies a set of correct solutions. This, in turn, is connected to the linear model of art history, which is a gendered construct, or rather, is a construct elaborated by a discipline that has orchestrated the elimination of the feminine from its pale.

These abuses of teaching, which I am suggesting have a gendered profile, are a mountainous obstacle for any student to get past. All students, and women students are particularly affected, must push their way past obstacles to learning about their own work that have been placed in front of them not "for their own good," as might be the claim, but for the good of the institution.

Despite these obstacles, and my delusion that no one had taught me anything notwithstanding, I *did* learn about making my own work. Some of how I learned cannot be recreated or proposed as a model: my parents were artists who worked at home. In college, I was mainly taught the ABCs of visual art in art history rather than studio classes. Thus, color, composition, form, and style, all the normalizing information one must pick up somehow were taken in either subliminally, in the intimacy of family, or at the useful distance from my own creative work that art history instruction provided.

There are aspects of my schooling, however, that can perhaps serve as suggested models for teaching and learning art making. I was a participant in the Feminist Art Program at CalArts in 1971–72, under the direction of Judy Chicago and Miriam Schapiro. The program undertook the dual project of critiquing male authority, specifically how art education had to that point dealt with its female students (who usually form the majority of the undergraduate art student body), and of trying to formulate presumably different and fairer authority structures that would not dispirit and destroy female creativity. Like many feminist activist groups at the time, there were immediately contradictory forces apparent, between any group's need for leaders, certain individuals' desire to lead, and a movement that ideally sought to undermine leadership as presently constituted. Penley notes the "contradictory demands around authority" inherent in feminist teaching:

> Ideally, she [the teacher in the feminist classroom] carries out a very deliberate self-undermining of her own authority by refusing to be an "authority" at all, or by insisting that the validation of knowledge issue not from her acquired grasp of the material but from the students' own experiences as women and through a collective working-through of the issues raised. Another demand, often just as conscious even when recognized as contradictory, conflicts with the demand that she relinquish her authority. The woman who is a feminist teacher is expected at the very least to be an exemplary feminist, if not a "role model."

Penley concludes this passage by noting that "Feminism, then, like psychoanalysis, is characterized by its willful reliance on nonauthoritative knowledge." [5]

No utopian solutions were found, within the Feminist Art Program. One might note that women unused to power perhaps exercised it awkwardly at times, divided within themselves by conflicting desires and beset by a fluctuating and delicate sense of their own right to any authority (an uncertainty bred into them by their acculturation within patriarchy). Moreover, women students, also acculturated within the same system, held women in slightly less awe than they did men, so there were overt debates, arguments, passionate efforts to rebel against the exercise of authority within the group. Within a separate and private space, women could analyze and learn to fight over power.

The program existed in the middle of an egalitarian educational project. The history of CalArts's early years has been reformulated by art history, as is its wont, into the house that John (Baldessari) built, contributing in a conveniently linear pattern such postmodern artists as David Salle, Ross Bleckner, Matt Mullican, Troy Brauntuch, Eric Fischl, Barbara Bloom, as well as Ashley Bickerton and Mike Kelley. The discipline of art history turns clover leaves into one-way streets. In fact, CalArts, perhaps for a brief period only, was distinguished by the inability of any one group or aesthetic to dominate over any other. No one group could consider itself the elite without recognizing that another elite existed down the hall: Post Studio/Baldessari, Feminism/Schapiro and Chicago, Late Abstract–Expressionism/Brach and Hacklin, Happenings/Kaprow, Fluxus/Knowles. Each ideology provided a liberating corrective to the others.[6] This variety of mostly avant-garde movements of different vintages and ideologies coexisted and cross-fertilized within a unified space.

The atmosphere, ideology, aesthetic, and sexuality of this era at CalArts is best expressed, not in the paintings of Salle or Bleckner, but in the colorful, silly, exuberantly gay, and utterly sweet confines of *Pee-wee's Playhouse* (Pee-wee Herman, a.k.a. Paul Reubens, a.k.a. Paul Rubenfeld, CalArts 1970–74). There is no one authority figure in *Pee-wee's Playhouse,* not Pee-wee, not Gumby, not the King of Cartoons. The secret word is not held by a single authoritarian figure or movement, but is a signal for a group of players to yell as loud as possible and have a lot of fun.

Sex, sexuality, and exhibitionism were rampant at CalArts at the time. The first day I arrived, a teacher was pointed out to me, "that's Ben Lifson, he took his pants off at the Board of Trustees meeting." Traditional demarcations of authority were eroded at the outset because students and faculty were united as rebels mooning the Disney family. But sexual abuse was subject to the political awareness caused by the presence of the Feminist Art Program.

The faculty at CalArts made the initial assumption that every student was an artist, positing at least the pretense of some equality between faculty and students, all artists together. When I began to teach, the first thing I had to adjust to was the obvious reality that most of my students were *not* artists and would not become artists. Even in an art school, not all students will go on to become professional artists, but a lot of studio teaching services computer majors, so there

can be no pretense of the equality of identity assumed by CalArts. Even CalArts's graduates could not escape statistics, nevertheless its utopian and communal premise was lived up to just enough to make every student feel that they had something valuable to offer the community (in some cases students in one area taught courses in a subject in which they had prior experience, such as a studio major teaching a course on economics), and just enough to destabilize the idea of centralized authority or knowledge limited to a privileged teacher.

Whether as an appropriate circumstance for this concept of knowledge and authority, or as a direct result of the basically egalitarian premise, traditional classroom teaching was overshadowed by other formats: gossip in the cafeteria; teachers disagreeing with each other publicly (undermining each other's unique claim to "knowledge"); apprenticeship; within the Feminist Art Program intensive projects such as *Womanhouse* (1972) worked on by faculty and students together; and, most importantly, shared lives for hours and days on end, more a ship of fools than a school. Wacky eccentricities marked the school: one teacher sat in the library and could be checked out like a reserve book![7]

In this atmosphere, I did *learn* about my own work, but very little was *taught* in anything resembling a linear transmission of information. It would be truer to say that I lived at CalArts for two years, than that I studied there. I could work within my own mind, undisturbed but constantly exposed to visual images and ideas, many of which challenged my assumptions not only of what art should be, but of what should *be*, period. That a group of people generally wilder than myself accepted me as an intrinsic thinker and producer made it possible for me to absorb and eventually adopt some of the dramatically opposite models of art they represented.

This permissive atmosphere also meant that seriously disturbed kids could wander the deserted building at midnight like so many drowned Ophelias without anyone noticing something wrong, but it was also an interesting antidote to the innate conservatism of young people who may have purple hair, wear nose rings, and listen to strange music but are still oppressed by pubescent fears of nonconformity and by institutionalized art teaching, which itself erases most forms of marginal production even while paying lip service to unbridled creativity.

CalArts had its share of crits where girls were made to cry, but undergraduates and graduates attended the same crits, and the traditionally rigid separation between drawing, painting, and sculpture was evaporated, leaving a freedom of access and movement for unformed artists. It boggles the mind that after all definitions of each of those disciplines have changed, particularly considering the expansion of what defines sculpture, many art schools and art departments within universities still metaphorically and geographically isolate the disciplines so that painting may be located in one building, while sculpture is taught in some troglodytic cave across campus where women students have to dress like loggers, under the direction of male sculptors of the type referred to as "tuskers" in Canada.

The ABCs of art were themselves redefined, from the accumulation of skills to the emphasis on context and content. Correct solutions to problems were less important than the reasons for being an artist, the personal narrative, the area of aesthetic intervention, or the political critique.

In this atmosphere, small bits of direct technical information were, not so paradoxically, especially memorable. One such incident took place within the Feminist Art Program: although we did learn a lot of factual material, from construction techniques to the reexcavated oeuvres of women artists of the past, the program was marked by intense psychodrama, wrenching moments of personal exposure within consciousness-raising sessions, painful lessons in every aspect of political organization. In the middle of all of that, Miriam Schapiro once said to me with a very serious expression on her face, "you know, you can put gesso on with a sponge [instead of with a brush]." Now here was something simple, not emotionally charged, a tiny practical hint at the variety of choices one had in materials and methods, a bit of the minutiae of daily life of the artist as *worker*. It was a "trivial" moment, yet one that expressed the deeper subtext of the relationship between a professional woman artist and the young woman for whom she wished the same life.

As a teacher my desires for my students vary wildly. Sometimes I want to throw a protective and all-encompassing cape over them like a Sienese Madonna of Mercy. I want to act like the great old European piano teachers you sometimes read about who also have their pupils to dinner, choose their clothes, and tell them who to marry. I want

IV

Bonnard's Ants

A family of words lace art-speak and art-think—simulation, simu-
lacrum, "simulacral discourse," irony, equivalence, distance, media-
tion, code, sign, signage, tactic, strategy, "commodity signification,"
exchange value/use value, art practice, reification, cultural produc-
tion, hyperreal, "hyperreal simulation," appropriation, and the pre-
fixes *de-* and *re-*. These words and the artworks they are used to but-
tress offer much of interest in their critique of contemporary culture.
Those artists who chose to remain ignorant of these words, ideas, and
works risk imperiling the validity of their own work. Yet, the overuse
of these systemizations of aesthetic thinking has become such that the
favorite derogatory terms of this language begin to turn against the
language itself: narcissistic, fetishistic, masturbatory.

This web of words forces a recognition of all that such discourse
has excluded, in this case—ambivalence, despair, anger, outrage, pas-
sion (love), remorse (tenderness), humility, transformation, transcen-
dence, search, mutability, failure, inconclusiveness, loss, struggle—
words that hover around an intangible element that one might call
the *Other* of "simulation."

And this "Other" takes its toll in a sort of psychic debt incurred
by those who wish its repression. For example, the paintings of Peter

Halley and the rapprochement to "individualistic" painting in Sherrie Levine's recent work are often cited instances of an infertile preoccupation with the non-integrity of representation and image in painting—that is, with a sort of "death wish" for painting. One wonders why, if painting is wished dead, must its most enthusiastic mourners do it the questionable favor of reenacting its death over and over again as if in a perpetual embalming.

Halley has succeeded in securing for his work the immediate obsolescence he blandly advocates in the realm of thought:

> The time has come to stop making sense—to replace History with myriad exaggerated theories of post-, para-, quasi-, and super-. History has been defeated by the determinisms of market and numbers, by the processes of reification and abstraction. These form the great juggernaut of modernity that has destroyed History by absorbing it, by turning each of History's independent concepts to serve its own purpose. Another kind of response is then called for: ideas that themselves change or dissipate as they are absorbed, *that are formed with the presupposition that they will be subject to reification . . . doubtful ideas that are not invested in their own truth and are thus not damaged when they are manipulated, or nihilistic ideas that are dismissed for being too depressing.*[1]

It is bad enough that our refrigerators are made to obsolesce! To momentarily transpose Halley's argument to another arena, if one applies Baudrillard's elaborations of the simulacrum, then Ronald Reagan might be described as a simulacrum—that is to say, an image that "bears no relation to any reality whatever"[2]—of presidentiality. But must one then freely campaign for the computer-generated "Max Headroom" next? Halley's paintings are themselves empty, etiolated by their dependency on obsolescing ideas. One is left before a blank page (or a page that does not even have the virtue of being blank), its rote text already forgotten.

Sherrie Levine has proceeded from photographs of photographs, to photographs of reproductions of "high art," to little watercolor reproductions of reproductions of "high art," to golden knotholes on plywood and decorator neo-geo stripes. At her first exhibition at the Mary Boone Gallery in 1987, the re-presentations *After Alexander Rodchenko,* shrunken, identically and ostentatiously matted and framed,

are relegated to the back room. Whatever "intellectual" honesty and avant-garde abrasiveness Levine's earlier work might lay claim to is lost to the corporate elegance and acceptability of the more recent work. The main rooms of the gallery contain Levine's new paintings, pretty, tame, and lame, while Rodchenko's work is no longer represented, it has been recuperated. Further, the dourness of her early work hints at the puritanical restrictions pertaining to the experience of "pleasure" in art, thus one is led to speculate on the degree to which the materiality of paint and the artisanal activity of painting in her newer work might be affording her just such an "incorrect" experience, without, apparently, leading her to an awareness of the interiority of painting.

These works' main source and reference is the art market (notwithstanding their claim as mediators of cultural representations): art flogged like a dead horse. There is nonapprehension of the noncommodity elements of the art that they negate, appropriate, or bracket, which pushes mediation toward autism. Instead of banging their heads against the wall, they bang art against the wall, past the point where that action might effectively, energetically release art, to the point of destitution.

The difficulty of summoning images, or realities—or irrealities for that matter—should not deny the power of these things, nor the power of the search for them and of its inevitable irresolution or failure. Despair about painting, art, or culture is not the unique province of the critical theorists of "simulation." Indeed, such despair is sometimes more deeply felt by those who chose to continue painting in the face of its alleged impossibility. One has only to follow geometry from "neo-geo" back to the "geometrics" of Jack Tworkov.

Tworkov's doubts about the validity of unconscious expression and gestural automatism inherent in the methods of abstract expressionism, which he had embraced in the late forties as one of the founders of the Eighth Street Club, led him in the early sixties to seek out mathematical formulations and geometrical form to contain the stroke of paint. In his late paintings, the beloved stroke, intuitively rendered with the utmost poetry, is subjected to a rigorous, even ruthless search for "neutrality." "For me geometrics, however simple and elementary, is a connection with something that exists besides, outside, myself. It is a small comfort, perhaps, indeed: but it is less hypo-

critical at the moment than the apparent ecstatic self-expression that a more romantic art calls for. Geometrics or any systemic order gives me a space for meditation, adumbrates my alienation."[3] At times, the artist's own project seemed to imprison him. But throughout, the struggle for rationality, Apollonian clarity, in counterpoint to a dark experience of despair for the condition of being a human, was joined with profound respect for painting, as well as acceptance of its difficulties. As Jack Tworkov writes,

> There is another quality in a painting that cannot be described: it is the residue reflected in the painting of the artist's pleasure in the making of it, especially the pleasure, the joy the artist experiences in the stages when the painting uncovers itself to his eyes. This is an internal experience of the artist which the attentive spectator can extract. It is something precious I get from a Cézanne, knowing very well he did not make it for me but it is there for me to have.
>
> Trueness and pleasure add up to the most fundamental quality in a painting. If the artist cannot paint himself out of a picture, if he is caught up in attention-getting devices, if he becomes concerned with his effects on the audience, he cannot achieve justness. You can admire his devices but you cannot live with them. You cannot draw joy from them. At their worst such artists exploit the same world as the advertising fabricators: clever, ingenious, eye-grabbing, but false.
>
> Am I stressing an esthetic morality? I am. It's what I get from Bach, Velázquez, Blake, Cézanne, Mondrian—and is rare in our present.[4]

It is the very hopelessness of the project of art making that imbues art with meaning. No element of art can be indifferent, meaning is masked by fear of intimacy, but everything has meaning, if only the meaning of loss. To continue to operate in the face of hopelessness, failure, and loss, there must be belief, but the declinations of irony and simulation at present rest on the denial of belief. For art to prevail, fear of content—even if the content is only loss—must be overcome and the "Other" of simulation, the noncommodity aspects of art, must be allowed to channel hopelessness into matter and into meaning.

Two drawings have recently compelled my attention. They are un-
pretentious, modest, relatively unimportant early steps in the devel-
opment by each artist of more major works, and these qualities are
precisely what strikes one at this art moment.

The first drawing, by Giacometti, is one of a chair in his studio.
The humble nature of the familiar subject clarifies that the drawing is
a non-art effort, an un-special daily activity, and an embrace of fail-
ure. What gradually emerges from the marks that build, frame, lose,
and refind the chair is that the artist does not feel he is superior to
the chair, nor is he superior to the act and art of drawing. The chair
is approached with humility, indeed with terror—as redoubtable as
a man, as is the space it inhabits. Giacometti wrote, "When I woke
up this morning, I saw my towel for the very first time: a weightless
cloth in a stillness which has never been perceived before, suspended,
as it were, in a terrible silence. There was no longer any connection
between it and the chair or the table, whose legs, barely touching the
floor, were no longer supported by anything; there was nothing link-
ing these objects, separated from each other by immeasurable voids. I
looked around my room in terror, and a cold sweat ran up and down
my spine."[5]

Drawing the chair is a battle ever to be joined, never to be won, be-
cause it cannot be—for it is a given that there is always a gap between
what the artist wants the work to be and what it is, between the first
goal and the weird paths taken—and because it should not be won.
Winning would only make it *look like art* and would signal the end of
the blind chase down the path, the atrophy of the organism artist.

One of the misapprehensions, or arrogances, of postmodernism is
the assumption by its practitioners that certain battles within the *field*
of painting and image were definitively fought and "won" between
1850 and 1970, and that an artist's reconsidering of certain basic prob-
lems within painting is a historicist and reactionary action. In other
words, the assumption is that there was one problem and one solu-
tion—modernism—and, now, postmodernism's response is the only
legitimate reading of "linear" art history.

The second drawing is by Pierre Bonnard. Its analysis necessitates a
preliminary digression to a series of serigraphs by Edward Ruscha of
INSECTS. An ad appeared in *Art in America* in May 1972 announcing
this work. The ad copy assured the prospective buyer of the durability

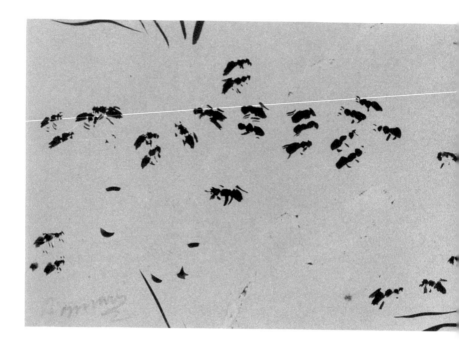

of the product: "A portfolio of six original silk screened prints, signed and numbered: three on 140 pound Classico glazed finish watercolor by Fabriano, and three on paper backed wood veneer. The edition is limited to one hundred portfolios. . . ."[6] Also announced was the marketing of the portfolio by its "simultaneous exhibition" in twelve galleries across the country (like the release of *Rambo*). The ad did not describe the wittiest element of this product: the actual portfolio containing the prints. Its cover is dirt (home of the insects) sandwiched between an inner layer of linen (material of old "high art") and an outer one of plastic (material of new "high art").

In one of the prints, photographically realistic ants congregate on a reddish background. They group in the center of the page (formalist concern for composition). On another, green-beige background, the ants cover the page to its corners (all-over composition, thereby art-historical reference). There are also smaller, black ants on pale wood bark (synthetic cubist material). These INSECTS *look like art.*

Bonnard's drawing is an unlikely candidate for marketing, even by today's standards. It is a little ink drawing, on paper without pedigree, of some ants. It is a drawing of not especially transcendent quality,

Pierre Bonnard, *Ants*, 1904, ink on paper, 2¾ × 7¾ ins. (7.0 × 19.7 cm.). (Courtesy The Phillips Collection, Washington, D.C.)

clearly one among many drawings, as are the ants among ants. Fifty-four ants to be exact, and thirteen blades of grass; the ants are loosely organized but clearly engaged in specific activities. These ants are doing something, the drawing is quite convincingly particular about that, and because of that the drawing makes clear that Bonnard does not consider himself or the act of drawing superior to the ants. It is a modest drawing of a humble detail of a planet inhabited by species of ants.

The activity of the formicarium may be a pitiful illusion, a historicist phantasm, a reactionary romanticism, it may be repetitive, anonymous, unoriginal, and futile, but it is always formidable.

Figure/Ground

Some people live by what they see with their eyes—light, darkness, color, form. Painters are compelled to express this continuous act of seeing and looking through the application of a liquid or viscous matter on a two-dimensional surface. Despite a barrage of criticism of painting and of representation, even painters who are cognizant of or complicit with this critique continue their preoccupation. I am one of these retinal individuals.

Criticism of the practice of painting emerging from a curious blend of modernist idealism and Marxism may be found in *October* or *Art After Modernism: Rethinking Representation*. While I am reluctant to give this loosely generalized school of criticism a name, "aesthetic terrorism" might describe its adherents's "fundamental commitment to the 'primacy' of 'objectivity'" and their use of "exclusion as one of their principal creative means."[1] In this discourse on art, painting has been described as peripheral, vestigial, an "atavistic production mode," and a "dysfunctional plastic category."[2]

According to this discourse, the linear progression of art history brought painting in the twentieth century to certain "logical" end points, namely abstraction and monochrome, after which representation is always a regression; new technologies emerging out of late

capitalism may be more suited to deal with its ideology; painterliness for its own sake, for the sake of visual pleasure, is narcissistic and self-indulgent.

Meanwhile, painting continues.

If painting needs defending, from these criticisms and from the paintings that may present justifiable targets for such a critique, what method is most effective for a painter to pursue?

I will momentarily defer from resorting to the transcendent, uto-pian, heroic statement of belief commonly proffered by painters as the ultimate defense of painting. For to argue the validity of painting on the ground of belief is a your-word-against-mine proposition, that is "your word" against "my work." On the ground of words, painting stands to be handicapped, often because a certain critical approach may have already devalorized an entire vocabulary. Another strategy for the painter then is to examine the critic's words — or perhaps, for the imaginary to reaudit the symbolic order.

Since painting can be most basically defined as the application of pigmented matter — which minimally can be understood as Figure — on a surface that is Ground, this reaudition takes the form of an examination of the figure/ground binarism and an analysis of the language used to critique, indeed to condemn, painting. However, I am not merely considering figure/ground as the deployment of posi-tive and negative space or the phenomenon of "push pull." It seems that the formalist concentration on this limited understanding of figure/ground has drained painting of its vitality, and has particularly affected the teaching of painting in this country. Hearing countless students mumble about "trying to push the space around," one *wants* to give up painting on the spot.

The history of avant-garde painting has been oriented toward a demystification of figure (narratives of religion and history, finally representation of any kind) and an emphasis and an amplification of ground: the flatness of the picture plane, the gallery space as a ground, finally the gallery space as Figure, a subject in itself. The history of modern painting — with the possible exception of surrealism and its progeny — is the privileging of ground.

In his examination of the windowless white-walled gallery space, *Inside the White Cube,* Brian O'Doherty develops the aesthetics and ethics of the "myth of flatness."[3] In the twentieth century both the

picture plane and the gallery space have been "vacuumed"[4] of ornament and incident until the wall and the entire square footage of the gallery space have become the ground for artworks, which as entities or events functioned as figure. "This invention of context initiated a series of gestures that 'develop' the idea of a gallery space as a single unit, suitable for manipulation as an esthetic counter. From this moment on, there is a seepage of energy from art to its surroundings."[5]

As ground/context are privileged, O'Doherty points to a change in the identity of the preferred audience: from the "Spectator" to the "Eye." "The Eye is the only inhabitant of the sanitized installation shot. The Spectator is not present."[6] The gallery wants to be alone.

O'Doherty points to the "hostility to the audience"[7] that marks modernism and avant-garde movements, and suggests the ultimate dissolution of the art/audience relationship: "Perhaps a perfect avant-garde act would be to invite an audience and shoot it."[8]

This (presumably) tongue-in-cheek proposal is metaphorically realized in a recent work that functions as a state-of-the-art index on the status of figure/ground, gallery context, and the inconveniently present spectator. Wallace and Donahue's *Buddy, Can You Spare a Dime? (Shooting the Public)* (1989), exhibited in the 1989 Whitney Biennial, is a big blue painting with a vertical row of very bright lights facing out to blind and disorient the viewer. As an element inserted onto the picture plane, this figure forces the viewer's eyes away from it and from ground. The audience has become the figure/subject of the painting, because the piece contains a surveillance camera focused on the public still foolish enough to expect to have a private individual experience of vision. The Spectator and the Eye's desire to *look*, to *see*, is now *scopophilia*,[9] which here is critically transformed into ideology; the viewer is a voyeur and the artwork is Big Brother.

The privileging of ground is consistent with the utopian ideal often expressed by modernist pioneers that painting, liberated from representation and reduced to its formal elements, will transcend its end and evaporate into architecture.

Some contemporary critics are astounded that painters have balked at this conclusion. For example, Benjamin Buchloh, in his signal essay "Figures of Authority, Ciphers of Regression," links returns to easel painting and to figuration with authoritarian ideologies, both in post-1915 works by Picasso, Derain, Carrà, and other cubists and futurists, and in recent painting movements such as German and Italian Neo-

Expressionism. The early-twentieth-century vanguard painters, and, by implication, all painters who subsequently replicate their historicist error, are indicted for their "incapacity or stubborn refusal to face the epistemological consequences of their own [earlier] work."[10] The consequence, in this discourse, is spelled out in the title of the essay following Buchloh's in the spring 1981 issue of *October:* "The End of Painting" by Douglas Crimp.

Buchloh's views of painting emerge from postwar German art; however, while the self-conscious flirtation with fascism in Anselm Kiefer's traditionally "heroic" paintings may indeed represent formal and political regression relative to, for example, the oeuvre of Joseph Beuys, Buchloh's frustration is engendered even by traces of mystifying notions about painting in, if not the works, at least the words of artists whose practice is said to (properly) confront the "despair of painting."[11] Excerpts from an interview between Buchloh and the German painter Gerhard Richter serve to recapitulate, in the mode of a Pinter play, what the critic of painting wishes and what the contradictory artist prefers:

Benjamin Buchloh [B]: . . . And that is really one of the great dilemmas of the twentieth century, this seeming conflict, or antagonism between painting's representational function and its self-reflexion. These two positions are brought very close together indeed in your work. But aren't they brought together in order to show the inadequacy and bankruptcy of both?
Gerhard Richter [R]: Bankruptcy, no; inadequacy, always.

B: The claim for pictorial meaning still exists. Then even your Abstract Paintings should convey a content?
R: Yes.
B: They're not the negation of content, not simply the facticity of painting, not an ironic paraphrase of contemporary expressionism?
R: No.
B: Not a perversion of gestural abstraction? Not ironic?
R: Never! What sorts of things are you asking?

R: When I think about contemporary political painting, I prefer Barnett Newman. At least he did some magnificent paintings.
B: So it's said. Magnificent in what respect?

R: I can't describe it now, what moved me there. I believe his paintings are among the most important.

B: Perhaps that too is a mythology which would have to be investigated anew. Precisely because it's so hard to describe, and because *belief* is inadequate in the confrontation with contemporary paintings.

R: Belief is inescapable; it's part of us.

R: They [Richter's paintings] have a normal seriousness. I can't put a name on it. I've always seen it as something musical. There's a lot in the construction, in the structure, that reminds me of music. It seems so self-evident to me, but I couldn't possibly explain it.

B: That's one of the oldest clichés around. People always have resorted to music in order to save the foundations of abstract painting.

B: . . . Why is your only recourse that to the metaphor of nature, like a Romantic?

R: No, like a painter. The reason I don't argue in "socio-political terms" is that I want to produce a picture and not an ideology. It's always its facticity, and not its ideology that makes a picture good.[12]

It seems possible that it is precisely its "facticity," its actuality, that is disturbing to those for whom painting is "dysfunctional" and "atavistic." "Aesthetic terrorists" mock "the metaphysics of the human touch"[13] on which defenses of painting depend. Buchloh adds an infantile and animalistic dimension to painting by calling for the "abolition of the painter's *patte*"[14] (French: paw), not just his/her hand but his/her *paw*. The painter's *patte* is an "atavistic production mode" and atavism is used incorrectly as a synonym of "dysfunctional" to signify a "morbid symptom."[15] But something atavistic is a still vital trait resurging from our deep past. Rubbing two sticks together to make fire when a match is handy may be dysfunctional, but the need for, and the fear of, fire are atavistic tropisms. Human mothers, like many mammals, still clean their children's faces with spit. They don't use their tongues, like lionesses, but they do the job roughly, with their "pattes," and the gesture has a function beyond the immediate and

pragmatic: it marks a bond, it is a process of marking whose strength is precisely its atavistic nature.

The desire for an art from which belief, emotion, spirit, and psyche would be vacated, an art that would be pure, architectural, that would dispense with the wetness of figure—Marcel Duchamp calls for "a completely *dry* drawing, a *dry* conception of art"[16]—may find a source in a deeply rooted fear of liquidity, of viscousness, of goo.

Whose goo is feared may emerge from a reading of *Male Fantasies,* Klaus Theweleit's analysis of members of the German *Freikorps,* mercenary soldiers who put down worker rebellions and fought border disputes in the years between the end of World War I and the advent of the Third Reich, and who were precursors, and often future members, of the Nazis. The "soldier male" (according to Theweleit's term) has never fully developed a "secure sense of external boundaries,"[17] a pleasurable sense of the membrane of skin. He fears the "Red floods" —of the masses, blood, dirt, "morass," "slime," "pulp,"[18] woman— which he perceives as constantly threatening to dissolve his "external boundaries." He also fears the liquid forces insecurely caged within his own body interior and unconscious. The "soldier male" resolves these conflictual fears by the construction of a militarized, regimented body, by incorporation into a desexualized phalanx of men, and by the reduction, through killing, of all outer threats back to the red pulp he imagines everything living to be. "He escapes by mashing others to the pulp he himself threatens to become."[19] The "uncanny" nature of the revolutionary mass, which the *Freikorps* were waging war against, with "its capacity for metamorphosis, multiformity, transformation from one state to another,"[20] is akin to the slithery properties of paint. This capacity for mysterious transformation, appearance, and disappearance "corresponds precisely not only to the men's anxiety images of the multiple forms and faces of the mass/Medusa they aim to subdue, but above all to their fears of uncontrollable, unexpected stirrings in their own 'interiors.'"[21] Against the unregimented flow of paint, some critics posit the mechanistic one, of architecture, or of language. Buchloh questions the importance of Newman's painting "because it's so hard to describe." If words fail, then the visually undescribable must be "investigated anew," or eliminated. Not surprisingly Buchloh favors the insertion of words into pictures, especially through collage, where the binding infrastructure mucilage, the

glue, is dried, clear, and hidden behind the image. Fear of flow also condemns Richter's analogy of painting to music, which, though invisible, is the quintessential flowing element through the ear, which offers no protection between interior and exterior.

A stated desire to "[purge] color of its last remnants of mythical transcendental meaning; by making painting completely anonymous through seriality and infinite repeatability,"[22] and a preference for photography over painting indicates that the problem for some critics is not with color but with pigment. Pigment is matter that interferes with the ideal of color. Its excremental nature makes any individualized manipulation of it distressing, and so it must be bleached out, cleansed, expurgated, photosynthesized onto a laminated sheet of paper on which color has been dematerialized.

Perhaps it is not surprising that many critics who would stop the amorphous flow of paint have most enthusiastically supported women artists who work in photography and video. Clearly, the ranks of postfeminists/postmodernists do include women who sometimes paint, Sherrie Levine, Wallace and Donahue, and Annette Lemieux to name but a few. But theirs is a strictly unsensual, depersonalized use of paint. Their material is always subsumed to mediation.

"We really don't directly experience anything anymore,"[23] says Lemieux. Lemieux's statements often reflect the literalism of the collage aesthetic (or ethic), so indicative of a generally held distrust of illusionism. "When one wants to talk about a helmet, it seems ridiculous to paint a helmet when one can acquire a helmet and present it. It would communicate better."[24] The degree to which painting is a sophisticated process of conceptualization is crystallized by this simplistic alternative.

Robert Pincus-Witten notes in a catalogue essay on Lemieux that "the sheer presence of oil upon canvas seemed too much like painting so Lemieux settled for the expedient of executing [both] works with her feet."[25] On the white ground of a long horizontal painting (*Pacing* [1988]) Lemieux has padded back and forth with black-paint-soaked bare feet. *This* instance of the painter's "patte" is acceptable because the painter's animal tracks are left on a vacated ground (the artist has walked away) for the sole purpose of averting the intentionality of painting (figure).

It is taken as axiomatic by some of its critics and apparently by

some painters as well that "painting's own recent history raises bar-
riers to the accessibility of a language with which to represent his-
torical or political fact."[26] This axiom puts two separate questions at
issue. Is painting in fact incapable of representing contemporary his-
torical reality? Do historical and political narratives exist *other* than
the ones painting has traditionally represented and that painting now
represents to its detractors?

The Neo-Expressionist movement, which spurred the particular
critique of painting discussed here, may well have participated in
a culturewide conservative reaction. For example, the sexual atti-
tudes displayed by David Salle were consistent with the backlash
against feminist activism that has permeated the eighties. Executed
with an aesthetic of nostalgia and cynicism, these works did success-
fully represent some aspects of contemporary reality. Conversely, the
"problem" with an artist such as Salle was not that he had soiled his
post-studio credentials by selling out via painting, but that he used
the format of painting to perpetuate a worldview wholly acceptable to
a reactionary establishment. Elaborating the same content in another
medium would hardly improve its politics. It is necessary to separate
painting from the rogue elephants whose practice *is* complicit with re-
gressive ideology.

There can be no question that many paintings refute Buchloh's
assertion that the return by painters to representation after cubism,
futurism, and suprematism constitutes "figures of authority, ciphers
of regression." The Mexican muralists Rivera, Orozco, and Siqueiros
combined communist activism and "mexicanismo" (non-European
identity) in a populist form of painting. In Germany the works of
Grosz, Beckman, and Dix held up an unflattering mirror to corrup-
tion and fascism. Currently, the flayed surfaces of Leon Golub's South
African racists catch the art audience in a web of complicity and repul-
sion. Watercolors from Nancy Spero's *War Series* allow no distantiation
between male body sexuality and militarist aggression and nihilism.
One can look to the peculiar activities taking place under Stalin's nose
in the impeccably and absurdly academic paintings by Komar and
Melamid. Ida Applebroog's paintings present sinister visions of past
and present violence to women, children, sanity, the earth, painted
from a waxy red-and-brown palette of toxic waste material and body
fluids. Works by artists such as Colescott, Coe, and Richter address

specific historical incidents and art history. In all these political inter-
ventions, narrative is coequal with formal or art-historical icono-
clasm. To say that they "advance" the language of painting would
accept the militarist rhetoric of aesthetic progress; one can assert that
the language of painting remains functional and mobile.

The evolution of looking into painting may not be able to single-
handedly dismantle ideology. But looking and painting practiced by
a politically engaged individual may filter into a politically active
stream. This is not to deny that looking and painting by a fascist
artist may reflect a fascist ideology. And if the reflective model of
painting is critiqued, how can it be argued that photo-collage tech-
niques are anything but reflective of contemporary media culture?
And perhaps, by virtue of its self-reflectiveness, of the individual-
ism of its *manu*facture, painting can occasionally provide an effective
Other within ideology. The existence of painting that does purvey
ideology supports the counterexistence of painting that erodes it.

There may be a gendered dimension to the critique of representa-
tion, the fear of narrative, since, historically, what must be excluded
from art discourse is tainted by femininity. Painting's presumed loss
of access to a language of historical and political representation must
be considered in its connection to the equally axiomatic "prohibition
that enjoins woman—at least in this history—from ever fancying, re-
presenting, symbolizing etc. (and none of these words is adequate, as
all are borrowed from a discourse which aids and abets that prohibi-
tion) her own relationship to beginning,"[27] as Luce Irigaray writes.
For "woman" one can insert "painter" as far as critical language is
concerned. Further, woman's presumed lack of subjectivity, of access
to self-representation, is the *ground* for the narrative of the One who
"must resurface the earth with this floor of the ideal."[28]

That ground was gendered female was never in doubt. Painting in
the high Italian Renaissance increasingly became a system for order-
ing and subduing nature, laying a grid on chaos (femininity), which
in the twentieth century became a process of razing and asphalting.
For if the ground began to move and "if the 'object' started to speak?
Which also means beginning to 'see,' etc. What disaggregation of the
subject would that entail?"[29] It might entail the death of the end-of-
painting scenario, which should have been played only once according
to late modernist critics, and which is to be endlessly resimulated by

postmodernists. The narrative of the death of painting is meant to jam the signals of other narratives, that is to say the narrative of the Other. According to Walter Benjamin, "Death is the sanction of everything that the storyteller can tell. He has borrowed his authority from death."[30] If ground begins to move, if figure rushes back onto evacuated ground, the sanction of death will reassert its authority over the narrative of the death of painting. In this patricidal narrative the artist inevitably sets *him*self up as the next duck in the shooting gallery: the narrative of traditional art history can only admit to a formalist attack on the pa(s)t(ernal). Further, an interdictory relationship to the past is constructed, in which artists are denied functional interaction with art that is not part of the linear "high Renaissance to modernism" art-historical progression. According to "aesthetic terrorists" one *cannot* claim a contemporary relationship to artists such as Sano di Pietro, Hugo van der Goes, or Chardin, only to prescribed artists such as Rodchenko, Duchamp, or Warhol. But, to European patriarchy's Others, patricide may be less of an option and a burden of guilt. The sons kill the fathers, and art history is a graveyard to which they expect and demand admittance. But may not the daughters (and for daughters read all Others in this system), so long denied, now freely roam the "cemetery" (museum), mining the ore of the past, forging different narratives (narratives of difference) on the anvil of painting?

In a melancholic tone, Walter Benjamin, in his essay "The Storyteller," discusses the "new beauty in what is vanishing," "the art of storytelling,"[31] an art of intimacy, of companionship. He notes the role of "boredom" in the transmission of the story, originally heard as people wove and spun. "The more self-forgetful the listener is, the more deeply is what he listens to impressed upon his memory." "Boredom is the dreambird that hatches the egg of experience."[32] This entails a flow, of the storyteller's words to the self, and of self outward to the teller. We have seen that the fear of flow underlies the wish for painting's end. The need to rid painting of all that is "human," the wish for a sanitized, unitary architecture is an attempt to close one's ears to a story or a musical theme—the "death thematic"[33] that has been embedded in femininity, the Other's untold story.

The story condemned and evaded is also the story of pleasure. Contemporary critiques of painting wage war on pleasure. Buchloh, for example, uses the French word *"peinture"*[34] to refer with contempt to

paint used mainly for sensual effect on artist or audience. Beyond sen-
suality, craft is suspect in this wording. Visual pleasure emerging out
of the materiality of paint is viewed to be politically incorrect. As the
prevailing school of Marxist-influenced art history focuses on social
construction and ideological phenomenology in painting of the past,
the individual art historian's experience of sensual pleasure is at best
a secret vice or an unfortunate relic of connoisseurship. And because
access to the past is regulated by concerns of historicity and histori-
cism, such criticism allows a contemporary painter only cold comfort
in the existence of great *"peinture"* of the past.

The contemporary emphasis on the ideological purposes of scopo-
philia neglects the subversive potential of visual pleasure. Visual plea-
sure does not rule out politically or psychologically charged narra-
tives. The "Cabinet" paintings by Goya are small, intimate renderings
of madness, witchcraft, and misery. In *Courtyard with Lunatics* (1793–
95) an eerie light of white paint presses down on a dark courtyard. In
a sense, this is a totally "abstract" painting in which enclosure is im-
plicit in the composition. Light is as bleak as darkness. The figures of
the imprisoned lunatics barely indicate scale. What is striking in this
painting and Goya's other paintings on witchcraft is the motility of
the brush, the gentleness of the paint strokes as they construct brutal
subjects. These little, soft brush-marks are seductive, but the pleasure
they give is the honey that traps the eye of the viewer, seduced by *"pein-
ture"* into looking at images of the most profound anxieties and evils.

However, the emphasis on technique in recent confections of
"beautiful" paintings by Ross Bleckner, Mark Innerst, Joan Nelson,
and their followers is curiously related to the belief, emerging out of
the critique of painting, that painting has become, or will be in the
future, a craft. In this country in particular, craft has such negative
connotations that there is almost no way of interpreting this fate so
that painting would retain intelligence and contemporaneity. And yet
easel and panel painting came out of the guild economy of the Middle
Ages. The great Sienese painters were craftsmen: Giovanni di Paolo is
said to have kept a model book of other artists' compositions, which
he freely borrowed from—an early instance of appropriation, or a
functional use of more advanced artists' ideas and a respect for his
elders. These craftsmen served their communities and respected their
discipline. At its best, "craft" might not be such a dread fate.

For a painter there is certainly tremendous pleasure in working out a thought in paint. It is a complete process in terms of brain function: an intellectual activity joining memory, verbal knowledge, and retinal information, is given visible existence through a physical act. But the value of painting cannot rest on any individual artist's private pleasure. Painting is a communicative process in which information flows through the eye from one brain, one consciousness, to another, as telemetric data speeds from satellite to computer, without slowing for verbal communication. Incidents of paint linger in the working mind of the painter as continuous thrills, as possibilities, like words you may soon use in a sentence, and—in a manner that seems to exist outside of spoken language—as beacons of hope to any human being for whom visuality is the site of questions and answers about existence. The black outline of a rock in a Marsden Hartley landscape, the scumbled white of a shawl in a portrait by Goya, the glaze of a donor's veil in the *Portinari Altarpiece,* the translucent eyelid of Leonardo's *Ginevra di Benci,* the pulsing red underpainting of a slave's toe in a Delacroix, the shift from shiny to matte in a passage of indigo blue by Elizabeth Murray, are only a few of a storehouse of details that are of more than professional interest to me.

In French, *terrains vagues* describes undeveloped patches of ground abutting urban areas, gray, weedy lots at the edge of the architectural construct of the city. *Terrains vagues,* spaces of waves, the sea of liquidity, where the eye flows idly and unconstructed, uninstructed. These spaces are vague, not vacant (*terrains vides*). In such interstices painting lives, allowing entry at just these points of "imperfection," of neglect between figure/ground. Between figure/ground, there is imperfection, there is air, not the overdetermined structure of perspectival space, or the rigid dichotomy of positive and negative space, not the vacuumed vacant space of painting's end, but the "self-forgetful" "boredom" of the area that glimmers around paint, sometimes only microscopic interactions within a color, sometimes the full wonder of the dual life of paint mark and illusionism. Paintings are vague terrains on which paint, filtered through the human eye, mind, and hand, flickers in and out of representation, as figure skims ground, transmitting thought.

Researching Visual Pleasure

This summer I had planned to sit on my tuffet like Little Miss Muffet and try to conclusively (!) theorize the state of visual pleasure in painting today. Needless to say along came the spider, or, in my case, the laughing gulls of Provincetown, and my resolve for this impossible task vaporized in the first whiff of salt-infused air. I was left with the books I had accumulated to help me write either by giving corroboration, legitimation, or resistance to my ideas.

In the general population visual literacy is centered on media images, rather than on paintings. Recent critiques of images, including those deployed in painting, have concentrated on sociopolitical readings whose purpose is to illuminate the operation of ideology within these images. For example, visual pleasure has been noted as an agent of male eroticism and fetishism, as power is circulated through the male gaze. In this critical economy, visual pleasure is a lost art.

Thus, the extremely *close* descriptions of painting found in Yve-Alain Bois's *Painting as Model* offer refreshing possibilities for visual investigation. In essays on Matisse, Mondrian, Strzeminski, Newman, and Ryman, Bois engages in deeply detailed, almost scientific or technological descriptions of individual works. The degree of attention is exhilarating, however, it can also induce a hypnotic state of excruci-

ating fatigue, which nevertheless offers much reward if one can stick with it.

Bois's essay on Barnett Newman and his comparative descriptions of *Onement I* and companion works is perhaps the most illuminating writing of this anthology. By following Bois's comparison of *Onement I,* painted in 1948, with somewhat earlier works such as *Moment* from 1946, the reader participates in the "dividing line"[1] in Newman's career that *Onement I* represents. Both paintings are vertically oriented, of nearly identical dimensions, and represent a field bisected by a vertical line. But whereas "in *Moment* we are confronted with a differentiated field that functions as an indeterminate background and is pushed back in space by the band—the band functions as a *repoussoir,*" so that what the artist had produced was "an *image,* something that was not congruent with but *applied* to its field,"[2] in *Onement I* the meaning of the central "zip" "lies entirely in its *co*-existence with the field to which it refers and which it measures and declares for the beholder."[3] Bois illuminates the sense of immediate and total space Newman sought to create when he states that "Like all previous paintings by Newman, *Onement I* is concerned with the myth of origin, but for the first time this myth is told in the present tense."[4]

In Bois's "Introduction: Resisting Blackmail," he admits that "any critical discourse is programmatic in part," and expresses the wish to "resist [the] pressures"[5] that are brought to bear on contemporary art historians—to be theoretical or to be antitheoretical; "the dogmatism of the chic" (theory fads); "antiformalism"; "*asymbolia.*" However, *Painting as Model*'s own ideological program affects its usefulness to a consideration of the *future* of visual pleasure in painting: Bois is relentlessly anti-space, anti-figure/ground. Bois has been one of the few postmodern critics to give painting any allowances, chiefly by promoting Hubert Damisch's theory of the "generic *game*" (painting) versus the "specific performance" or "*match,*" in both the essay "Painting: The Task of Mourning" in this collection and in the concluding essay, "Painting as Model." Through this strategic sleight of hand, "One can conclude that, if the match 'modernist painting' is finished, it does not necessarily mean that the game 'painting' is finished."[6]

Despite this allowance, I gradually felt compressed into the approximately eighth-of-an-inch maximum depth possible for painting within Bois's formulation. Painting must always be returned to the

question of flatness, to "the opposition between fictive depth (optical) and real depth (thickness)."[7] Throughout *Painting as Model* pictorial space of any kind comes under severe censure: Mondrian is said to have "finally *conquered* the *menace* of an illusionistic hollowing out of the surface"[8] in *New York City* (1942), his painting of "braided" strips of yellow, red, and blue on a white (forgive me) ground. I've never been a fan of perspectival space — Dürer's often-reproduced woodcut of an artist putting a grid over a woman's vagina points to perspectival space's intention to draw a straight line back to the womb and to draw an organizing grid over the chaos of a feminized nature — but reading Bois, *perspectival space begins to seem the most repressed element in twentieth-century painting.*

This repression of the space created by figure/ground is relevant to the question of visual pleasure, because Bois and the artists he discusses locate visual pleasure exactly in the spatial effects of figure/ground and see it as something that must be eliminated in order for the work to succeed. The differentiated background of Newman's *Concord* (1949) is "atmospheric" and "probably one of his most seductive canvases,"[9] and this conjunction of differentiated figure/ground and seductiveness is seen as a factor in the "failure" of the painting (Bois has the grace to put this in quotation marks).[10] The difficulty in eliminating figure/ground altogether is acknowledged somewhat ruefully in an anecdote related by Naum Gabo, in which Mondrian reworks a painting "because the white is not flat enough" and "a painting must be flat, and that colour should not show any indication of space."[11] Gabo argues: "You can go on forever, but you will never succeed,"[12] because, as Clement Greenberg pointed out, the minute you lay paint to canvas you inevitably create some illusion of a third dimension.

"The Limit of Almost," Bois's catalogue essay for the Ad Reinhardt exhibition at the Museum of Modern Art in 1991 recapitulates many of the themes of *Painting as Model,* while also providing an instructive analysis of Reinhardt's relationship, or rather, non-relationship with all the major movements he has been associated with, notably abstract expressionism and minimalism. Reinhardt's philosophy of negativity and negation are explored and the negative (or positive) of every assertion on Reinhardt's work is given: "Reinhardt . . . is the least optical painter (no push and pull, no shallow depth, no abstract land that the

eyes alone can visit), yet at the same time he could be called the *only* such painter."[13]

Indeed, visual pleasure rears its head in the catalogue, as it does in the work itself: despite Reinhardt's effort to eliminate any illusion of figure/ground by using the most matte paint surface possible, the paintings do provide visual pleasure. In fact, they make clear the distinction between "beauty" and visual pleasure, since many are hardly "easy on the eyes." Color in the late works is often not visible, although the reproductions in the catalogue capture distinctions in hue and value that the human eye cannot. Despite Reinhardt's wish to deemphasize the materiality of paint, the paintings exude an aura not just of color, but of pigment. The pigment seems imbued in the cloth, though much deeper and more profound than a stain.

Bois's essay is bracketed or framed by two images of the act of painting. In the first photograph, Reinhardt's hand holds a brush placing gleaming paint on a matte surface; in the second, the artist leans over a painting in a light-flooded studio. Those rigorously uncompromising (and almost ostentatiously) mystical paintings that seek to operate both in that eighth of an inch and at a religious level, perhaps (or not), were painted by a person painting. It is a thrill to be reminded of this simple fact.

One wishes for an essay that would consider what Reinhardt felt that painting could *not* contain (and what the exhibit and the catalogue force to the margins): the acerbic critique of the art world seen in his collages and the passion Reinhardt had for Islamic pattern and design, for the divine potential of decorative practice. This is not a call for ahistorical, anachronistic arguments, since clearly the artist himself felt that these interests must be kept separate from painting; however, for the future of painting, as opposed to the continuation of modernist discourse, it would be worthwhile to wonder why they continue to be so dichotomized and quarantined.

It is a welcome relief to read *Barnett Newman: Selected Writings and Interviews*. Putting aside for a moment the question of visual pleasure, it is a treat to get to know Newman, a one-man Guerrilla Girls of his time, who once ran a write-in campaign for mayor of New York City on a culture platform, and who combatively wrote no-words-minced letters to editors, art historians, and curators, in order to defend the integrity of his work, his views, and the historical moments he lived

through, and to put forward the work of other artists. His forthright language makes even old art-world skirmishes fresh and engaging.

Newman is totally uninterested in space: "what is all the clamor over space? . . . There is so much talk about space that one might think it is the subject matter of art. . . ."[14] Newman conjectures that critics' obsession with space is their way of being included in the work of art:

> They insist on having it because, being outside, it includes them, it makes the artist "concrete" and real because he represents or invokes sensations in the material objects that exist in space and can be *understood*.
>
> The concern with space bores me.[15]

Newman is opposed to the seductiveness of figure/ground and of atmospheric effects, he is anti-space, anti-beauty, anti-aesthetics, anti-sensuality, but his statements are set into the lived battles of his time, and he describes his paintings in a way that is eminently practical and accessible: "I don't manipulate or play with space. I declare it."[16] Newman further observes, "One thing that I am involved in about painting is that the painting should give man a sense of place: that he knows he's there, so he's aware of himself. In that sense he relates to me when I made the painting because in that sense I was there. And one of the nicest things that anybody ever said about my work is . . . that standing in front of my paintings [you] had a sense of your own scale."[17]

Newman writes and speaks in a mega-humanistic language. The texts and interviews over a nearly thirty-year span are extremely cohesive, indeed repetitive, reiterating in often identical words the same basic tenets. At first these seem somewhat quaint, yet once we enter into his language usage, they become very easy to grasp. In contrast to Bois's position, Newman's view of art making is surprisingly essentialist: "Modern painting is characterized by . . . a concern with—or more correctly, a return to—its primitive function, that is, its original function as a vehicle of human expression";[18] "We are reasserting man's natural desire for the exalted, for a concern with our relationship to the absolute emotions";[19] "The self, terrible and constant, is for me the subject matter of painting and sculpture."[20]

Newman was very concerned with surrealism: he gave the sur-

realists credit for reviving subject matter and for their "prophetic tableaux" of the "horror of war." Ultimately, surrealism failed because of "its use of old-fashioned perspective, its high realism, its preoccupation with the dream,"[21] or, returning to the question of perspectival space and illusionism:

> By insisting on a materialistic presentation of it rather than a plastic one, by attempting to present a transcendental world in terms of realism, in terms of Renaissance plasticity and Renaissance space, by, so to speak, mixing the prevailing dream of the modern artist with the outworn dream of academic Europe, they hoped to make *acceptable* . . . what they consciously knew was unreal. This realistic insistence, this attempt to make the unreal more real by an overemphasis on illusion, ultimately fails to penetrate beyond illusion. . . . they practiced illusion because they did not themselves feel the magic. . . . Realistic fantasy inevitably must become phantasmagoria, so that instead of creating a magical world, the surrealists succeeded only in illustrating it.[22]

Newman sees his generation as realizing some of the surrealists' unfulfilled goals. But his attention and respect for surrealism provides an important loophole in the modernist anti-space program, particularly since surrealist methods remain very popular and often viable among many Third World artists and many women artists.

The magic of illusionism, indeed of vision itself, is a consideration in seventeenth-century Dutch paintings, which perhaps influenced surrealist artists even more than did Italian Renaissance works. These paintings are the subject of Svetlana Alpers's *The Art of Describing: Dutch Art in the Seventeenth Century*, which I read this summer, perhaps as a corrective to the twentieth-century formalist texts I had chosen to read. If I was *searching for* visual pleasure, as well as researching it, I found it within the pages of this book.

The Art of Describing offers an alternative, almost an alternate, universe to the rigid policing of space whether through its pictorial organization or its formalist elimination. The theoretical economy found in seventeenth-century Dutch art challenges that of Italian art, which has so dominated Western art thought, for, as Alpers notes, "Since the institutionalization of art history as an academic discipline, the

major analytic strategies by which we have been taught to look at and to interpret images . . . were developed in reference to the Italian tradition."[23]

Perhaps not surprisingly, this different, Northern system is a system of difference and was given a gendered code by the dominant, Italian mode. Michelangelo is said to have described Flemish art as one that "will appeal to women, especially to the very old and the very young, and also to monks and nuns and certain noblemen who have no sense of true harmony" because it is "done without reason or art, without symmetry or proportion, without skilful choice or boldness and, finally, without substance or vigour."[24]

According to Alpers, Italian art is hierarchic and prescriptive; active and dynamic; it is (hu)man centered; it selects and organizes significant material; it proposes a unified field of vision, a substitute, idealized world; it finds portraiture inferior to works that engage "in higher, more general human truths";[25] it relies on and is validated by verbal access to classic texts; it is narrative; it is a progressive tradition. Alpers finds that Dutch art is nonhierarchic and descriptive; it is an art of existence and stasis; it decenters man as the measure of all things through, among other things, its embrace of telescopic and microscopic means of vision; it mirrors the visible world without imposing a "prior frame";[26] it privileges portraiture (whether of people or of mice, as the case may be) out of an interest and belief in individual identity; it is fragmentary; it emerges from a visual rather than textual culture; it is not a progressive tradition.

For the seventeenth-century Dutch, visual art is a method of pursuing knowledge and thus there are no prescriptions of what should or shouldn't be a subject for art, or what the format should be. Significantly, it is during this period, in the Netherlands, that the picture book was developed as a method of instructing children. Visuality was seen as "basic to education."[27] Dutch art is taxonomic, interested in describing as much of the visual world as possible. Thus, paintings may include elements from other forms of pursuing and promoting knowledge, such as maps and texts. Perspectival organization often impedes the full visualization of knowledge, so Dutch artists maneuver around or beyond it.

There is "extraordinary trust in the attentive eye."[28] At the same time, Alpers speaks of "a selflessness or anonymity that is also char-

acteristic of the Dutch artist," of the "passive" eye.[29] Dutch painting mirrors the seen world, rather than organizing it or idealizing it, and enjoyment of craft is seen in the luminous depictions of crafted objects as well as in the precise, polished surfaces of the paintings themselves. But the Dutch were well aware of the duplicity of sight both from a scientific point of view—the relativity and imperfection of the human eye and of the glass lens—and in its human, subjective dimension. Paintings such as Gerard Dou's *The Quack*, in which the painter, seen behind a quack selling his wares to a crowd who in their actions represent familiar pictured proverbs, alerts us "not only to the duplicity of the quack but also the painterly one."[30] And the enjoyment of the senses, including the sense of sight, takes place in the face of mortality, always indicated by some detail of decay, in the manner of a *Vanitas*.

Returning to the Italian/Dutch dichotomy, "a contrast can be made between such fragmentary beauty, a function of infinite attentive glances, and a notion of beauty that assumes the just proportion of a whole and thus admits to a prior notion about what makes an entire object beautiful."[31] (One might note that while Bois calls for an art that refers to no other space than its surface thickness, he brings to painting a "prior notion" of what a painting should be, an implicit totalizing impulse.)

The Art of Describing is as richly detailed and carefully crafted as the attentive paintings to which Alpers accords such equally attentive reading. In a typically nonhierarchic manner, a painting of a giant radish is almost as memorable as Vermeer's *The Art of Painting*, which is the centerpiece of the book. The narrative of visual pleasure as a vehicle for taxonomic knowledge is so absorbing that at the end of the book the introduction of Rembrandt seems like a barbaric intrusion. He "rejects the established practice of good craftsmanship appropriate to each medium: in his paintings, figure and ground are bound together and thus elided through the medium of paint."[32] (These words are nearly identical to Bois's description of what happens in *Onement I!*) Rembrandt ruptures the smooth surface of the painting and "settles for the materiality of his medium itself. His paint is something worked as with the bare hands—a material to grasp, perhaps, as much as to see."[33] Indeed, the surfaces of Rembrandt's late works, as he moved away from the tradition of crafted representation in order to

express what is *not* visible, "are the surfaces of a maker of pictures who profoundly mistrusted the evidence of sight. This point becomes the very subject of Rembrandt's art in his fascination with blindness."[34]

Alpers's text casts Bois's views about pictorial space in a new light. The compulsion to eliminate space is the flip side of the compulsion to organize it; thus, Bois can be understood as staying well within the constructs of the Italian tradition. And, given the pleasure of illusionism in the Dutch paintings, one wonders at the *fear* of illusionism that seems to be operative in the present devaluation and repression of visual pleasure—illusionism not necessarily referring to representational, figurative painting (or sculpture) but understood here as *any* concession to figure/ground.

The *model* of seventeenth-century Dutch painting—an "attentive eye" and hand, a respect for visual knowledge, and a nonhierarchic system—may suggest some possibilities for the reintegration of visual pleasure into a new erotics of painting.

seems to locate visual pleasure precisely in the figure/ground relationship but seems to limit the space for that interaction to about an eighth of an inch. Emotional or personal narratives in painting are ignored by these discourses.

These critiques of visual pleasure have a covertly gendered dimension: their language reveals fear of fluidity and bodily materiality, obsession with the control and delimitation of space, and elimination of the narrative and the personal. Yet, I do find these critiques useful. Painting as practiced in the wider art community rather than just at the edge of the postmodern avant-garde has suffered from its lack of contact with and understanding of critical theories. Many painters I know just don't think it is their concern. In my painting I do in fact try to work on the edge of figure/ground, and it does seem problematic to me that many paintings motivated by political concerns that I espouse, of gender and ethnicity, founder on their seeming lack of involvement with figure/ground and other formalist concerns.

The critiques of painting that have concerned me the most are the ones that directly circulate around the gendered ownership and role of visual pleasure in painting. Feminist art historians, critics, and artists have convincingly noted the uses of visual pleasure in painting to express and produce male eroticism while enforcing the repression of female subjectivity. One of the terms I enjoy speaking is Mary Kelly's description of painting, quoted by Griselda Pollock, as a domain of "culturally overdetermined scopophilia."[2] Yet, an analysis of misogynist impulses in the so-called great tradition of painting has become a blanket perception of visual pleasure in painting as a paraphilia, a psychosexual and political disorder. Women artists have been impelled to resist visual pleasure in painting, moving from investigations of mark making and from involvement with material toward a strictly instrumental use of imagery appropriated from other, presumably less lascivious media, or toward working in other media altogether; further, women artists are made to deny the implications of the appearance of visual pleasure if and when it occurs in their work despite their best intentional focus on other aspects of the work.

Lest anyone think that these feminist critiques are only applicable to nineteenth-century painting or some twentieth-century expressionism, then I would point to the almost sinister parallel between the feminist rejection of visual pleasure as male eroticism with continued

assertions *by* men of painting as the sole domain *of* men *because* of its connection to male eroticism or because of the *nature* of male eroticism. In this regard, I must quote the words of one of these strange bedfellows namely Peter Schjeldahl who only two years ago suggested the following:

> What there are now, after feminism's long march through the art culture, are more and more top women sculptors, photographic artists, and artists of installation and performance. . . . But no truly great painters. Is it biology? The very suggestion seems sexist, but what if it happens to be true? A theory lately in the air holds that male eroticism is concentrated in the sense of sight, whereas for women the erotic is distributed more evenly among the five senses. That would make painting, the medium of maximum physical control over the visual, naturally more intense in its pleasures for men than for women.[3]

This quote could be said to be the Rodney King video of the art world: you think you have seen the evidence, but then at least one committed feminist male artist curator has told me that this quote didn't mean what I thought it did, or that it didn't mean anything, and that basically I shouldn't pay it any mind.

This quote recalls the Freudian representation of the penis as being endowed with an eye, while relying on the notion that women are polymorphously perverse, so they get to do sculpture. Now, if you think about it a minute, this theory presupposes a heretofore unknown inner body part, a neuromuscular connection between the male optic nerve, the penis, and the hand.

Well, if that is so, then I would lay claim both to being polymorphously perverse, because after all why shouldn't *painting* benefit from the input of more than one sense, and also to having the very same body part, connecting my optic nerve and my hand to my sexuality, especially if sexuality is defined as not just the province of genital intercourse but as a profound life/death drive. It is in fact precisely this intersection of visuality, sexuality, and manual impulse that makes me a painter, and I would add something left out of this particular biological theory, that is, the connection of optic nerve, sexuality, and hand to intellect. In her recently published book, *My Enemy, My Love: Man-Hating and Ambivalence in Women's Lives,* Judith

Levine quotes one woman saying that "nature played a cruel trick on men. She gave them a source of pleasure, but the blood has to leave the brain for it to work."[4]

Needless to say, this biological theory also leaves out all the paintings by women that do engage in a painterly eroticism, an erotics of painting. What about Ljubova Popova, Hilma Af Klint, Paula Modersohn-Becker, Frida Kahlo, Remedios Varo, Florine Stettheimer, or Alice Neel, to name only a few of the usual suspects? And I chose only dead ones to avoid as much temporal controversy as possible. It seems silly to repeat these names, except that these painters are always left out of serious discourse on painting, no matter whose discourse, no matter if the critics may individually admire individual women painters, and it is a net loss for painting that this is so. The problem may be that the all-seeing penis eye only sees reflections of one thing, itself, and another eroticism, the eroticism of the Other, can't be seen by it even when this eroticism is perfectly visual, partly because of the Freudian rhetoric that considers female pleasure and subjectivity as impossible, invisible, and unrepresentable.

Given that what goes around comes around, I would expect that the contempt prevalent in the eighties for illusion, metaphor, and craft, and for painting as a vehicle of political content for women, would give way to a new conceptualization of visual pleasure, a re-gendered version of visual pleasure. At this moment, the question for me is what would a feminist erotics of visuality be? It is distressing for me, therefore, to note two recent trends in painting by women.

The first is a totally apolitical notion of femininity as a position available to men and women, a position beyond actual gender. This is the case for some women working in the area of the new abstract painting, if the rhetoric of the movement and comments by individual women are to be believed, some of whom seem disturbed by any word beginning with *fem-*, rejecting the marginalization *fem-* might entail, but, by the same token, rejecting the specificity of political/personal experience and content that might enliven their work and prevent its absorption into yet another "universalist" (that is to say, male) movement.

The second trend is toward bad painting and a teenage-girl style of drawing. We are expected to believe this is intentional, part of the feminist critique of visual pleasure. I'm not sure that it is completely

intentional, because this trend emerges from a generation trained at a time when traditional painting techniques, traditions, and values have been so maligned.

Such works also intersect and participate with Duchamp's critique of the retinal, which I see elaborated now in a profound fear of visual illusion of any kind and an obsession with the real, which in its contemporary incarnation means a simplistic literalism in which the object itself is always better than a representation of it through paint. This literalism, which is seen in much appropriative sculpture, painting, and scatter art, hints at the degree to which painting can be a sophisticated process of conceptualization.

Many works fall into clichés of literalism: for example, the idea that copying a photo of a famous lesbian poet, without altering the language of painting in the way that that poet herself altered the language of poetry, would make a painting an example of a lesbian erotics of visuality; or that merely copying a frequently married and frequently overweight movie-star's picture from a supermarket tabloid would automatically articulate social construction of gender. And certainly appropriating the styles and images of famous male artists doesn't necessarily constitute a subversion of these artists' values.

My own charge to myself is to bring a feminist analysis of my own body experience, of political events, and of art history, to painting, using visual language not just to illustrate temporal political battles but also to offer an empowered, expanded example of what a feminist gaze would produce. My charge is to continually evaluate my work in relation to several theoretical discourses and critiques of painting while engaging with the serious pleasure I get from the visual, not with the intent of making art that would look pretty or beautiful—in fact, one characteristic of much work by women painters that I am interested in is that they depict the underside of ideals of beauty but without contempt for paint itself—nor with the intention of presenting a positive, uninflected image of femininity, nor with the delusion that I can invent a new language of painting. I want to engage with the language of painting, with the metaphorically expressive possibilities of the materiality of painting, trusting in the complexity of visual language in painting, in order to reinvest painting with the energy of a different politics, a politics of difference, and a different eroticism than that of the monocular penis.

Course Proposal

Can a cure be found for P.I.S. (Painting Illiteracy Syndrome), which would also help alleviate P.D.S. (Painting Deprivation Syndrome), suffered by those who don't get their recommended daily allowance of painting?

A very bright, young art critic recently explained to me why painters today have a basic problem of reception for their work: the most intelligent of her generation of art critics, she said, do not understand painting, they don't know how to read it, don't understand color, and so on. This admission, at least honest and made in the spirit of trying to develop such an understanding, did not come as a surprise but, rather, confirmed what any practicing painter might already suspect from personal experience.

Certainly, as most writers about art, these bright young critics are interested in any artworks only insofar as they serve their own particular agendas—be it feminist, lesbian, or gay male identity politics—and theoretical/stylistic positions—such as appropriation or techno-culture. What is ultimately most important is how the art fits into what the writer wants to write. The same can be said of curators of shows such as the Whitney Biennial, whose current adherence to art that is "political," participatory, populist, and antiaesthetic (anti-

metaphorical via form or materiality) is surely an indication of their desire to stake out the proper position *for themselves*. The importance of being *perceived* as having the right position only highlights the degree to which the actual qualities of the art objects are secondary to the art workers' enterprise, which seems even more to be fashion when the art is political—to the detriment of the political and artistic constituencies at issue, just as painting was fashion before that, to the detriment of painting.

So how could one attempt to educate in painting critics, curators, and those young painters whose work they espouse, many of whom similarly may have no understanding of "painting"? Perhaps reeducate is more like it, not to say deprogram, because, of course, they are very educated in other aspects of cultural studies. P.I.S. is so resistant because its sufferers possess so much knowledge of what *seems* to be the same material. They know their art history—as a construct. When faced with a painting, they access their data on its sociopolitical valence. Even a Dada collage, such as Max Ernst's tiny *The Preparation of Bone Glue* (1921)—of a woman, lying on a sofa, dressed in the coils of a scientific contraption and threatened by the large head of a screwdriver—might elicit the Benjaminian or Brechtian meaning of collage as the only visual means to express the dissociative mechanisms of twentieth-century capitalism, or the Sadean sexuality of surgically remodeled femininity. But can the delicacy of the *manu*facture (not just the *fakture*) of the little slip of paper on which you cannot *see* the cut marks access other meanings? For, in such a work, meaning is carried not just in the image content (iconography) or in the deconstruction of linear logic (collage) but also in the tenderly seamless totality of the work whose poetic tendencies lead away from the idea of collage as a cog in the wheel moving art history inexorably toward entropy, to it as a thing made by a person with a variety of contradictory ideas and values, which may include a love of craft or even a nostalgic love for just what is being critically deconstructed. One can only imagine how hard it is for the P.I.S. generation to make the transition, in the 1993 exhibition at the Museum of Modern Art of Max Ernst's works from 1919 to 1927, from the rooms of photo-collages to the subsequent paintings in which similar de- and reconstructions return to oil paint, with some paintings' sources in early Renaissance painting and even folk art, as in the brilliantly colored oil on plaster

The Birds Cannot Disappear (1923), of a bird struggling not to drown in a smooth, blue-green sea.

The intractability of P.I.S. is above all based in hostility to much of the conceptual and sensual underpinnings of painting, as inculcated by avant-garde art education of the past decade. Aversion therapy has been practiced. Although available for superficial historical knowledge, image readability, and critique, in a sense painting is *never seen*.

Reeducation to perceive painting must be equally persistent. Since one is dealing with a type of blindness, I would suggest a kind of braille in which paintings are actually to be touched. Against the formalist imperative to see a painting from a safe distance, as a self-reflexive composition, a controlled disposition of space and iconography, marks of paint should not only fill the viewer's field of vision but that optical process must be bolstered by the sense of touch.

Rather than step around Sue Williams's plastic puddle of vomit at the 1993 Whitney Biennial, one might be immersed in the puddle of fatty, multicolored marks that make up the pudding face of a self-portrait by an aging Rembrandt, until the thought process that determined Rembrandt's progress through to the final resolution of the painting would be imbricated in your mind (rather than whatever fixed role Rembrandt plays in your idea of art history). The sense of touch is important, perhaps because it is at yet another remove from verbal language than the merely optical. And because, in the precise moment of actually painting, the painter, no matter how intellectual or conceptual, is engaged in a nonverbal activity. But if a Rembrandt isn't at hand, then at least step up to Williams's two paintings in the Biennial and note the difference between them: both carry overdetermined messages about rape and pornography, but in *Are You Pro-Porn or Anti-Porn?* (1992), the images and text are drawn and painted in black line with a great deal of overlapping and blurring between white-and-cream back and foreground. The mobile interaction between figure/ground, the carelessly skillful drawing and lush marks of erasure, offer a level of amusement beyond the linguistic jokes, more engaging than the effect of *It's A New Age* (1992), in which tons of text and images are simply plunked down on a flat, yellow ground.

Incidents of paint as the trace of thought are as important in non-objective paintings. The Mondrians in MoMA's permanent collection, for example, are notable for the crackling of paint from age and for

the little bristlebrush-marks that were Mondrian's tools in his efforts to eliminate the figure/ground relation. When seen up close, not as reproductions flattened by photography, shaken from their catalogued positions as utopian modernism, the paintings are almost embarrassingly, nakedly—paintings. What may be a flaw if the painting is dismissed or even admired for its historicity is, in fact, the hook that keeps the viewer in the painting long enough to absorb the radicalness of its struggle for figure/ground equivalence.

Because painting in the 1993 Whitney Biennial is a vestigial activity represented by less than a handful of painters, it is as good a place as any to apply the educational practice of braille for the sighted. For one thing, if "good" painting is suspect and unseen, then it might help to look at some bad painting just as closely. A comparison of representations of shit in works by Suzanne McClelland and Lari Pittman is instructive.

In McClelland's *Right* (1992) turdy smears of brown terra-cotta are affixed to the canvas by crusted blobs of a shiny, waxy synthetic polymer. These seem to be additive rather than the residue of a process, and they help locate the secret underpinnings of the painting in a kind of defanged late modernism. Take away the brown crusts and the pretense of involvement with language, and you're looking at the vast emptiness of a later Helen Frankenthaler.

Now consider the curling brown piles of cascading shit that are important iconographic elements in Pittman's immense and immensely detailed *Untitled #1 (A Decorated Chronology of Insistence and Resignation)* (1992-93). The painting insists on a physically close reading, because, simply from a technical point of view, it's hard to imagine how he does it at all. An incredible variety of images and delightful ornamentation compete for breathing room while each is rendered with demented precision. A red-rimmed asshole releases an elegantly curved, unified pile of shit painted in a flat brown, which is elegantly highlighted by delicate hatching of light naples yellow hair-thin brush-marks, in some spots tinged with crimson, all of this garlanded by swirling, tiny, raised white dots and a decorative green leaflike pattern. If touched these white dots would literally read as braille, while the dull blue and darker blue-grey that form the background of large areas are covered with large, silent teardrops of the same color, in tiered relief. The controlled sequestering of painterliness on a ground as intricately

detailed as *The Unicorn Tapestries* is but one method by which the painting speaks its iconography of "life, sex [and] death."[1] It may speak of death, but a celebratory love of painting is the metaphor of choice.

This course proposal does not call for a move away from cultural critique. Quite the contrary, the challenge is for the best and brightest young critics to hone their criticality of the appropriative, image- and media-oriented, linguistically based work in which they are fluent while recognizing that the art-ness, the painting-ness of painting can be a viable language to speak current ideas, just as painters need to sharpen their focus on the real.

Can this retraining be successful? At times painting illiteracy seems intractable and the ultimate futility of *The Wild Child*'s education in François Truffaut's movie comes to mind; in some scenes of that movie, such as when the doctor deliberately punishes his charge *un*justly to test if he has a sense of justice, education seems like child abuse, and in the end the child cannot be taught. On the other hand, forcing people into repeated and *close* encounters with painting's intimate details may achieve the nonlinguistically based knowledge similar to a great baseball player's understanding of the strike zone. Keith Hernandez's father would pitch balls to him for hours at the playground,[2] indicating which were strikes and which were balls, until the purely conceptual zone, an invisible cube of space, was a knowledge in the body.

Painting as Manual

Necrophilia

When one young painter recently asked me, in a tone and posture of more than half-serious mock desperation, "Why do we still want to paint?" another young artist, a sculptor, answered in passing, "necrophilia."[1] The idea that painting is fundamentally a craft reduced to an erotic preoccupation with traces of its dead past has been nurtured by the many theoretical and art-historical texts assigned and read in graduate seminars in art schools in America for the past ten years or so, which function as why-to-*not* paint manuals. While it must be noted that artists educated in schools with a less than avant-garde profile are equally handicapped by their education's disavowal or short-shrifting of contemporary concerns, including the methods and values of critical theory, artists emerging after the period of intense critique of representational strategies are very nearly paralyzed by ideological self-consciousness, boxed into a corner by a profound knowledge of why each direction they could take is always already compromised. They have had little instruction in either a practical or a conceptual sense for what painting could be in the present. Meanwhile, bookstores, video stores, and art supply stores are filled with how-to books and videos providing step-by-step instructions in spe-

cific techniques to produce paintings that fit into set genres—landscape, portraiture, still life, in pastels, acrylics, or oils—thereby furthering the status of painting as hobby and entertainment, established and immune to avant-garde thought.

So what would constitute useful painting manuals for our time?

Mr. Rogers's Studio

It is hard to imagine becoming a painter without ever having seen someone actually paint a picture. For many younger artists, the first person they ever saw paint was Bob Ross on his television program *Joy of Painting,* often aired on public television in the afternoon as a sort of semicultural after-school babysitter. In a soft voice, "so soothing that its effect was once compared to Demerol,"[2] Ross encouraged his viewers to "have a good time" as he demonstrated to them how to create simplistically illusionistic landscapes, in formulaic genres already buried under endless stratifications of kitsch, with little or no attempt to call the viewer's attention to his or her own specific visual surroundings. The effects were doubly magical: a specific (and profitably marketed) brush would always create the illusion of leaves, snow, grass, or clouds—"tiny little circles, tiny little circles . . . then fluff it"—at its lowest common denominator of representation, and in each program Mr. Ross would create what looked like the identical painting. There is an undeniable hypnotic fascination in waiting to see which cliché image Ross will put down next: Will there be a waterfall at the bottom of the blue mountains? Yes! "Happy little splashes." Yet it seems obvious, watching close-ups of these magically illusionistic effects as they appear, that, if ever seen "in person," the representation would disintegrate back into silly little marks.

The lulling quality and slow pace of Ross's speech was similar to that of the PBS kid-show host Mr. Rogers. Its message was: painting is easy, painting is safe. Painting in this neighborhood is the sum of a few tricks, and it is meant to be soporific, preventing troubling thoughts from disrupting the surface of the picture plane. Significantly, these paintings were only experienced as video images: the subtitle for Mr. Ross's *New York Times* obituary read, "Was Painter on TV."

Some artists will always dream of finding magic elixirs for success, and today's art students may look to their teachers for a rule book, given that the proliferation of possibilities offered in the postmodern moment are apparently so dispiriting that rules are craved if only for something to fight against. At the same time, the simplest of painting techniques, such as painting wet into wet or glazing, may appear as mysteries because they are not taught. This is because in more traditional schools compositional and spatial concerns overwhelm problems of color, light, atmosphere, and painterliness, not to mention subject matter, and in more advanced schools because such techniques reek of dated and fraught painting movements, especially abstract expressionism, whose humanist and existentialist ideologies appear so unsuitable to our time.

For seekers of secrets and tricks, Salvador Dali's *Dali: 50 Secrets of Magic Craftsmanship* offers hysterically detailed advice, as well as straightforward information of a stoutly traditional nature and some numinous descriptions of what painting once was:

> it is a rigorously objective fact: in 1948 a few persons in the world know how to manufacture an atomic bomb, but there does not exist a single person on the globe who knows today what was the composition of the mysterious juice, the "medium" in which the brothers Van Eyck or Vermeer of Delft dipped their brushes to paint. No one knows—not even I! The fact that there exists no precise recipe of that period which might guide us and that no chemical or physical analysis can explain to us today the "majestic imponderables" of the "pictorial matter" of the old masters, has often caused our contemporaries to assume and to believe that the ancients possessed secrets which they jealously and fanatically guarded. I am inclined to believe rather the contrary, namely that such recipes must in their time have been precisely so little secret, so incorporated in the everydayness of the routine life of all painters, so much a part of an uninterrupted tradition of every minute of experience, that such secrets must have been transmitted almost wholly orally, without anyone's even taking the trouble to note them down.[3]

This book, "a kind of culinary initiation to the Eleunisian mysteries of painting—[in order] to make translucid the most obscure technical secrets which would seem to require the art of magic in addition to the practice of painting itself," offers detailed instructions on how to hold a brush, as well as wonderfully poetic surrealist piffle about sea urchin eyes, the need for sleep and olive trees, and the importance of being married to Gala. A combination of absurdity and slightly cracked but serviceable practicality imbues Secrets 17 and 18, which deal with how to keep dust off of the painting surface: "Also every painter while he's working should wear a necklace of large amber balls which should be rubbed at length before he begins painting, so that it too will attract flying hairs. I have even noticed that long mustaches like those I wear are also useful to the painter to attract small particles, preventing them not only from attracting themselves to the canvas but also from entering your mouth or your nose. Regard this as Secret Number 18."[4] Dali concludes his book with a sober list of "permanent colors which can be used with confidence," which does not differ much from more recent artist's handbooks such as Ralph Mayer's *The Artist's Handbook*.

However, the latter expresses current concerns about toxicity of art materials. A few years ago there was a move in Congress to prevent the production and sale of cadmium-based pigments. Enough protestations from the art community spared art supplies from this act of environmental protection, but ecological (and conservatorial) concerns are now pervasive in the education of artists. This emphasis on the perils of lead and cadmium, the poisonous nature of raw umber as a dry pigment, and myriad other skulls and crossbones on traditional art supplies creates an atmosphere of fear. Now painting must be enacted and experienced through rubber gloves and a mask, reflecting the fear of sexually transmitted disease that has, in the 1980s and 1990s, imposed the use of the condom over the sexual freedom of the 1960s and 1970s. The fluid matter paint, whose fecal connotations and gooey female nature so appalled many early modernists and later conceptual artists and theorists, has now been scientifically proven to be medically dangerous. An atmosphere of risk permeates the unprotected production of a painting. Perhaps this will attract reckless youth to its cause, although that has not yet happened.

Virtual Painting

What better place to evade the contingent messiness of paint than in the light of virtual reality? Modernism's preoccupation with pictorial and illusionistic space is collapsed into the immaterial space of the video monitor and is expanded into the equally immaterial but "dimensionally" illusionistic space of virtual reality. On the computer the "painter" can scan, crop, morph, colorize, distort, flip, blur images — everything that could be done, and was done, before, by hand, using the imagination, paint, scissors, and glue, but now at great speed, in the computer. The invisible scissors of Max Ernst and the melting of solid forms in Salvador Dali are now available to anyone as generic effects at the stroke of a wand, at a mouse click. An image can be collected by scanner or digital camera, reorganized, restyled, and re-effected. Filters are designed to convert photo images into simulacra of painting surfaces and styles of brushwork: craquelure, mosaic, film grain, "impasto," "distorto," "drip," "Auto Van Gogh." Surrealism's conventions are appropriated by a more hallucinatorily speedy technology of representation. The technology facilitates but also complicates through its capacity for visual tricks, already established conventions of juxtaposition, collage, and alteration of images. The computer's speed and variety of options may well enthrall the painter. While the painter may consider the computer just a friendly tool for organizing and pre-transforming source images, the result may glow more vividly in the light of the monitor than when returned to the clotted substance of pigment and medium.

David Humphrey is a painter who uses computer manipulation of photographs and other images to develop source imagery for his paintings. He also produces prints created entirely through computer graphics. Distortions as well as evocative juxtapositions of images have always figured notably in his paintings. While his work within the "feedback loop"[5] of painting, which imitates the computer's imitations of painting, enhances these methods of representation, occasionally he seems to hit a wall created by the difference of speeds and materialities inherent to each medium. In the pigmentless glow of the monitor, images can be effected quickly and in infinite configurations. When the artist is tempted to *re*translate a particular computer image, arrived at through the computer's version of painting

effects, into the fixed materiality of physically present oil paint, simu-
lacral effects sometimes congeal into self-conscious sections of types
of painting, lacking the flow of Humphrey's computer images or his
less computer-dependent paintings.

These momentary glitches may represent only brief moments of
transitional awkwardness in one artist's significant advance into a new
process of hybridization of technologies and media. Yet they seem
symptomatic of the problems inherent to navigating between two
methodologies of representation: some of these problems are con-
tinuations of the still strained relationship between photography and
painting. These inter-media problems suggest a cautionary example
of modernist precepts about truth to materials. The computer may
offer barely developed new possibilities of visual art, but these may
best function within its specific space and language boundaries, as
painting does within its own.

But what is the best site for computer imaging? At present an image
exits the virtual space of the monitor either into the similar space of
the television screen, or onto the page, returning to graphics as we
already know it. New means, the same old flatness of paper. And if
the best, the most literally brilliant space is that of the monitor screen,
how will that affect the development of painters using paint in the
future? The August 1995 TV ad campaign for Microsoft's Windows 95
ended with a small girl, not more than three and a half years old, turn-
ing to us from her station at a computer: the threat to the consumer
is evident—your toddler can and will use this so you'd better get with
it. The threat to painting is there as well: what will happen to paint-
ing when kids don't finger paint except virtually, when they cathect
not to the textures and smells of gooey pigment and stubby markers,
but to the clicks and beeps of the computer and mouse? Children are
offered software games such as *Kid Pix Studio,* which is, significantly,
suggested for "kids ages *three* to 12" (my emphasis), and promises to
"make it easy for kids to add movement, video, sound effects and
music to any creation."[6] It sounds like a lot of fun. Why draw or paint
still images in silence, given options for music and moving pictures?
Yet, early play with paint and colored crayons develops eye-hand co-
ordination; presumably children's computer games do so as well, but
perception of deep and local shallow space, maybe the senses of smell
and touch as artistic triggers, may become underdeveloped in the
future.

While it is likely that even early painting play is influenced by art-historical image tropes, the computer increases the input of ideology since it trains the child to answer its commands and allows play only within each program's capacity for interactivity. The sociopolitics of painting-software designers, who are more committed to computer technology than to previous media, will affect the concept of art—as well as gender and other social positionalities.[7]

CD-ROMs that make art history accessible to children are equally dubious manuals for painting with paint, since no matter how clear the resolution of the detailed reproduction, no matter how fascinating it is as a visual experience, it is a poor substitute for the actual paintings represented, or, worse, instructed by the glow of the monitor and the color/contrast enhancements necessary for a vivid video picture, the child may find the actual work a poor substitute for its video image.[8]

Hope for the future viability of painting with paint may rest on the year or so when the child is too young to be trusted with expensive equipment but is coordinated and conscious enough to manipulate pencil and paint on paper. Judging from the approximate age of the child in the Windows ad, that window of opportunity is shrinking. However, perhaps a need for what Dierdre Boden calls "copresence" will persist.[9] In "The Compulsion of Proximity," Boden and her co-author Harvey L. Molotch argue that "copresence," the actual physical presence of human beings, is necessary to humans and will persist despite the increasing capabilities for rapid, virtual communications. "Copresence is 'thick' with information";[10] they note the importance of touch in ameliorating even business transactions, and also note that in business and political hierarchies, the more important the decision, the greater the necessity for actual physical meeting. The concept of "thick communication"[11] from copresent visual cues seems particularly relevant to the question of painting.

The Real as Manual

If virtual space is a future site for realizing the urge to create images, for which painting once provided the only field, in today's art world installation art dominates the expressive arena. Recent national and international exhibitions that nominally included painting among other media, foregrounded a variety of installations that employed

real objects and spaces along with video and text. In one week in the summer of 1995 two such exhibitions were written up in the *New York Times*. "Politics, This Is Art. Art, This Is Politics,"[12] described the exhibition, *Dialogues of Peace*, presented at the United Nations European headquarters in Geneva. Although it was noted that the show "[brought] together paintings, sculptures, video art and installations by 60 contemporary artists from around the world," with the exception of a series of serigraphs by Robert Rauschenberg and a room-sized sand painting (a painting that is also an object and a performance taking place in the real) by Joe Ben Jr., a Navajo artist, the article focused on sculpture or video installations, even when done by artists primarily identified as painters, such as Pat Steir. The following work sounded prototypical of an international style of installation art: "in the gardens, visible from the main building, the French artist Sophie Ristelhueber has placed 'Resolutions'—five white refugee tents, each carrying a phrase from some long-forgotten United Nations resolution—'a decision will be taken,' 'inadmissible attacks,' 'deeply worried.'"[13] So too Daniel Buren's "empty roofless room with its outside walls covered with mirrors, as if it were peopled by images of the world."[14]

"In Place of Prisoners, Reflections on Confinement" detailed "Prison Sentences: The Prison as Site/The Prison as Subject," an exhibition at the Eastern State Penitentiary in Philadelphia: all of the works described were on-site installations in the cell blocks of an early-nineteenth-century prison. Again, even artists identified as painters were described as doing installation/sculptures, such as "Bruce Pollock, an abstract painter from Philadelphia, [who] uses slabs of fallen plaster from the decaying prison to seal one cell's doorway."[15] A work by Beth B. offered visitors "a choice of being locked briefly in a cell or watching on television the reactions of those" who are locked in the cell.

Over the past ten years, installation art's hybrid strategy of representation has become familiar and formulaic enough to have entered into mainstream popular culture. Vividly prefiguring Beth B.'s prison cell, a room installation of mirrors and doors in which museum visitors are trapped by a computerized timer while their reactions are viewed on a video monitor figures in a recent murder mystery paperback aptly titled, *Death of a Postmodernist* ("Was it art or was it murder?" asks the cover subtitle).[16]

A conceptual mechanism has been set in place, as well as a recipe book of objects, texts, and spaces, which seems, both to the international curatorial class and to young artists, to be the best way for artists to interface with culture, perhaps because the emphasis on the real seems to answer concerns of accessibility of art to a broader, less elite audience. For instance, sculptors are less likely to employ handmade, "traditional" sculpture techniques than to use video monitors, new readymades such as women's cosmetics, found objects, and thrift store purchases, placing them in room or landscape environments, frequently depending on language to provide meaning for the viewer.[17] The metaphorical and illusionistic properties of painting seem to be liabilities and limitations when measured against the seduction of the tangible readymade and the bright glow of the virtual.

Craft and the Past

> Before going any farther, I want to show you in what fashion you should make the coals for drawing. Take a nice, dry, willow stick; and make some little slips of it the length of the palm of your hand, or, say, four fingers. Then divide these pieces like match sticks; and do them up like a bunch of matches. But first smooth them and sharpen them at each end, like spindles. Then tie them up in bunches this way, in three places to the bunch, that is, in the middle and at each end, with a thin copper or iron wire. Then take a brand-new casserole, and put in enough of them to fill up the casserole. Then get a lid to cover it, <luting it> with clay, so that nothing can evaporate from it in any way. Then go to the baker's in the evening, after he has stopped work, and put this casserole into the oven; and let it stay there until morning; and see whether these coals are well roasted, and good and black. If you find that they are not roasted enough, you must put the casserole back into the oven, for them to get roasted. How are you to tell whether they are all right?—Take one of these coals and draw on some plain or tinted paper, or on a gessoed panel or ancona. And if you find the charcoal takes, it is all right; and if it is roasted too much, it does not hold together in drawing, but breaks into many pieces.[18]

Equal amounts of careful craftsmanship, strange recipes, and patience were necessary to produce "plain or tinted" papers, panels, gesso, and

paints in fifteenth-century Florence. As Cennino Cennini says, in *The Craftsman's Handbook,* at the beginning of an account of how to make tracing paper, "if you do not find any ready-made."[19] Today, in addition to the proliferation of art supplies of all kinds packaged as "readymades," young painters use Elmer's Glue, play-doh, surveyor's tape, and foamy, extra-light acrylic paints, all in bright fluorescent colors, many of these materials purchased not in art supply stores but at hardware stores and the children's toy section of Wal-Mart. The idea that effort might be required, therefore motivation tested, in order to produce paintings is a lost concept; Cennini's recipes and homilies seem merely quaint.

And yet a sense that making art cannot be taken for granted emerges from reading this ancient manual, which may have resonance for today's painters, proposing an intervention into the prevailing atmosphere of speed, repetition, apathy, and entropy. It seems poignant that Cennini's mode of address—the use of "you" and the emphasis on the necessity of *seeing,* "if you do not see some practice under some master you will never amount to anything"[20]—is so similar to that of TV how-to hosts including Bob Ross, while Cennini's writings call one's attention to the picture plane in ways that are far more vivid and lovingly physical than the prescriptive descriptions of Clement Greenberg. The section on gessoing and what amounts to sanding, although that term is not used because sandpaper did not yet exist, creates in the mind's eye a perfect abstract painting or process painting: "Take a rag and some ground-up charcoal, done up like a little ball, and dust over the gesso of this ancona. Then with a bunch of hen or goose feathers sweep and spread out this black powder over the gesso. This is because the flat cannot be scraped down too perfectly; and, since the tool with which you scrape the gesso has a straight edge, wherever you take any off it will be as white as milk. Then you will see clearly where it is still necessary to scrape it down."[21] The tactile seductions of these details of craft are enhanced by precisely what seems the most quaint to the contemporary reader, namely the amount of time it takes to produce each material, surface, and effect. For instance, Cennini instructs, "Now you have to have a gesso which is called gesso sottile; and it is some of this same gesso, but it is purified for a whole month by being soaked in a bucket."[22] Or, "Then take some clear river or fountain well water, and grind this black for the space of half an hour, or an hour, or as long as you like;

but know that if you were to work it up for a year it would be so much the blacker and better a color."[23]

This ancient text forces one to consider how the computer places the artist into something of a time warp: operations that would have been inconceivable for Cennini to accomplish in a year, and that might have taken Max Ernst several days, now take a second, yet hours pass as minutes as the artist becomes mesmerized by the possibilities of speed and change or struggles with glitches. At the end of the day, all that has been effected may remain only present in an absent space. But even if the time were only fast, where would that get the artist? The philosopher Teresa Brennan suggests that, "[t]o make a profit, capital has to produce commodities at a faster rate than the time taken by living nature to reproduce itself. As the only substances out of which commodities can be produced are those supplied by living nature, this means that the profit factor tends to exhaust natural resources."[24]

Human thought is in itself a natural resource and the pace imposed by computer technology could well outpace the speed of human creativity's capacity to renew itself. While one cannot seriously recommend going back to scraping sheep gut every time you need a sheet of tracing paper,[25] Cennini's recipes emphasize for the contemporary reader the possibility even now of using different types of time and space in the production of an artwork.

Painting as Manual

Painting is still painting. It is a paint thing. The material "paint" is trapped within the word and the discipline "painting." There is no material called "sculpt" that remains at the essence of the discipline called sculpture, which is perhaps why, occupying and developing three-dimensional space, it was able to open its doors at a crucial moment, in the late 1960s, when the exclusionary formalism associated with Clement Greenberg succeeded in pushing too much content out of the picture plane of painting. It all rushed into the expanded and welcoming space of sculpture. Suddenly it seemed that *anything* that existed in space, time, or thought could be called sculpture. The possibilities attracted many artists, including feminist artists committed to integrating previously excluded and undervalued content into art.

The spatial cleansing of painting emerged from Greenberg's pre-

occupation with flatness as "more fundamental than anything else to the process by which pictorial art criticized and defined itself under Modernism. For flatness alone was unique and exclusive to pictorial art."[26] Although current Greenberg scholars take pains to stress the "catholicity" of his tastes,[27] his principal writings codified and further set into motion modernism's clearing out from painting sculptural, but also "representational or literary,"[28] elements that would "[dissemble] the medium."[29] The results were ultimately unfortunate for painting, though felicitous for sculpture. Yet it seems crucial now to effect a compromise between the rigorous self-critique of painting associated with an acute awareness of its elemental flatness, as propounded by Greenberg, and the content that pertains to our time: text, information, politics, gender, and sexuality.

If no one painting style or painting contains a totality or a synthesis of cultural information, neither does any other available medium. Such a totality is effectively interdicted by current philosophy and by the proliferation of information and media. All media, including current sculpture and photo/computer imaging, are infected by a network of predictable mechanisms and recipes for representation. It may seem that the readymade and the virtual are the most relevant arenas for investigating the questions of the moment, and yet they carry with them limitations and burdens of history that are rapidly becoming equal to those of painting. Yet if painters choose to continue making paintings using paint, then they have to take into consideration that they are making a painting that must be as much about some awareness of it being a painting as it is about anything else. This is particularly important for those who are working representationally and who may be using painting as a site for identity politics. If, as they struggle to refine and express their specific "story" content, they fail to think of the basic elements of painting—including, crucially, the relationship of illusionistic space to the real flatness of the surface—as also *the* content of any painting, they forgo the very qualities of metaphor inherent in these elemental aspects of painting that made them choose painting over other media in the first place. As a result, their work risks lapsing into a new cliché, kitsch genre of personal identity painting as pernicious as the ones codified in mass-market how-to manuals and TV shows.

The generation of painters about to enter the art world exer-

cises many possibilities for new painting. Some use neon-colored "toy" materials to refresh modernist formats by expressing computer-enhanced, MTV color/motion sensibilities within the traditional structure and surface of painting. Their aesthetic is influenced by popular culture but embraces the art-as-art of pure abstraction. Others, whose explorations of identity embed canny pastiches of media that influence or perpetuate these identities within cleverly corresponding painting techniques, carry on the self-reflexive process inherent in the modernist project. Looking back to 1960s and 1970s process and conceptual art, they often rely on conceptual systems in order to bypass sentimentality, but many seem to have put aside the ironic disbelief in painting that poisoned so much of the painting that took place during the 1980s.

Ultimately, the best painting manuals are paintings themselves seen in the "thickness" of "copresence," where the richness of visual information facilitates painting's conversation with painting as medium, space, substance, and history.

V

You Can't Leave Home without It

Sometimes I wish I could just phone home.

Recently a friend of mine couldn't enjoy an evening out until she called her five-year-old daughter. Another said that she understood completely: she sometimes longs to call up her cat. And I often wish that I could telephone my loft. In fact, my answering machine's remote features a room monitor. But would listening to the silence of my four walls satisfy my desire for their enclosure?

Hewing for a moment to traditional dichotomies, house has represented culture, the father, the building, the body public and political, the future, and modernity; home has stood for nature, the mother, the cave/womb, the body private and psychological, the past, and atavism. Home doesn't depend on a house. Those we call the homeless may not have a structured domicile of their own, but many attempt to recreate home: last Thanksgiving, some homeless men living in makeshift shacks under New York's West Side Highway roasted a turkey in a file cabinet and had some friends over for supper.

Home is also homeland, homeboy, homegirl; it is a mother tongue, the basis of an individual's identity in a sense of origin and place; home is where you come from, where your emotional nature is structured and protected, where you are best known and most anonymous.

As in baseball, once you leave it, the object of the game is to get home safely.

"A house is not a home," but to seek home in recent artworks, one first has to get past and inside the pictographic image of house that almost all of us drew as children. Perhaps we were indoctrinated to draw it by Dick and Jane books regardless of our actual circumstances. In any case, the little house, the square with a triangular roof, perhaps a few windows, a chimney, and a front door remains as ubiquitous in adult representation as in children's drawings. In contrast to the urban arena so central to nineteenth-century art, postmodernity emerges from the decentered isolation of suburban sprawl. Hello Levittown, good-bye Paree.

This pictographic house is always miniaturized and infantilized. Even when it is big enough for a person to stand up in, it is still the type of structure wherein the door takes up a disproportionate amount of the facade, like a doghouse. Joel Shapiro's little bronze houses on the prairie of the Paula Cooper Gallery's floor posit the artist both as the adult with a bird's-eye view of the childhood he has literally outgrown, and as the child playing with toy representations. Cabrita Reis's reprise of Shapiro's motif, small iron-and-fiberglass structures surrounded by cypress trees, walls, and chairs, is pervaded by a retrograde melancholia.[1]

The word "home" may itself conjure up a sentimental Victorian image of coziness and comfort, slippers by the fire, teakettles humming on the stove. However, much late-twentieth-century art presents a more dystopic vision, one I will trace in a brief tour through art, rooms, houses, and household objects of the past two decades, bringing along my middle-class background and my identity as a New Yorker. The concept of home is inevitably personal, even if the "home" of this essay is an agora of the international art world, *Art-Forum*.

The relationship between the house, the home, and the body, acted out in miniaturized environments, is evident in many of Vito Acconci's pieces dealing with private and public space. In early works such as *Trappings* (1971) and *Seedbed* (1972), Acconci retreated within claustrophobic "location[s] for regressive activity."[2] The home was cast as a hothouse of sexuality, and, implicitly, of sexual or gender dysfunction. Acconci calls attention to the sexual aspects of such

childhood games as "playing house," which often means acting out gender roles ("You be the mommy and I'll be the daddy"), or playing doctor; tree houses (gender bonding); houses created by a sheet drawn over a table (recreating the womb). His recent, more elaborate playhouses, such as *Houses Up the Wall* or *Making Shelter (House of Used Parts)*, both from 1985, reflect the "cold, manipulative order of the '80s."[3] The spectator is no longer a voyeur, but associative mental imaginings are cut off because interaction is organized into limited patterns: one is invited into a home, yes, then told to sit *here*, fit in *here*, squat *here*. The guest must conform to predetermined and cramped situations. Says Acconci, "This should be the kind of home that makes you a stranger inside it."[4]

Once entered, this ideograph of house readily becomes a prison. Lee Jaffe's series of *Cages for John Cage* (1990) are lead-and-steel walled with metal-fenced interiors. Repetitive sounds of laughing, crying, and sighing, with a bare light fixture overhead, propose the home as Riker's Island. Bruce Nauman's *Room with My Soul Left Out/Room That Does Not Care* (1984) is even bleaker, an interior without interiority, without even a substantial floor: metal-grate floors again recall the penitentiary. Other works by Nauman present the home as a chamber for surveillance: you walk down *Live Taped Video Corridor* (1970) toward the monitor but away from the camera, so that you are always viewed but frustrated in any attempt to see yourself. In this home the child is watched but never allowed to develop a sense of self free of the need for an outer mirror.

Such a state of surveillance is a factory for the production of narcissism. And mirrors are frequent appointments of the art home, reflecting only the glassy, gleaming surface of their own appearance rather than the child's. Roy Lichtenstein's mirrors of the late sixties and early seventies are impeccably self-absorbed; *they* are the fairest of them all. Similarly, Barbara Bloom has photographed elegant nineteenth-century mirrors that do not capture the image of the vampire artist—undead or unalive. "Une Mère de Glace," the title of an essay by the French psychoanalytic theorist Luce Irigaray, seems relevant to this blank reflector: mother of mirror, mother of ice (sea of mirrors, sea of ice).[5] The home is the site where the mother takes revenge on her children for having herself been the object of specularization, by denying them an accurate reflection of their own subjectivity. And,

in fact, much contemporary work that circulates around the concept of home conjures up an unloving or lacking mother, if one associates the basic security of home with child psychologist D. M. Winnicott's idea of the "good-enough" relation to the mother in early childhood.

In Richard Artschwager's house luxurious furnishings cannot ensure the stability of home: walls shimmer and vanish into the Celotex swirls of his many domestic interiors. In *Hanging Man/Sleeping Man* (1989) Robert Gober uses wallpaper, a debased pictorial mode, to suggest a societal nightmare: a sleeping white man (the image taken from an ad for a white sale) dreams a lynched black man. Since the image is ambiguous—whose nightmare is this?—Gober's walls are doubly destabilizing. In another 1989 installation by Gober, sink drains in the walls seem ready to absorb the nocturnal emissions of the penises, vaginas, and assholes sketched on the black wallpaper behind them.

Notwithstanding these rather literal imagings of "lack," there's a lot of furniture in the home. The nineteenth-century urban *flâneur* has been replaced by the couch potato, but this ever more passive spectator is denied a soft couch for analytic introspection. Chairs made of lava, granite, and Formica (Scott Burton and Artschwager) are resolutely unadapted to the human form and are guaranteed to hurt actual bodies.

"Go to bed now." At home one learns how to fall asleep. But Gober's *Pitched Crib* (1987) hints at parents reading Doctor Caligari instead of Doctor Spock. Other cribs by Gober are sterile cages that deny visual stimulation, that pen one in. Rona Pondick's *Lead Bed* (1987–88) will protect the sleeper's sexual organs from radiation, but infantile sexuality has laid a turd on the pillow. Milk- and blood-filled baby bottles prevent relaxation on her *Double Bed* (1989), which recalls the Darwinian urge to reproduce and the contingency of the female body, but whose surface would bruise a lover's skin. Want to have sex on a bed? Curtis Mitchell's is covered with so many condoms you'd either be intimidated into impotence or slide off the rubberized surface.

This home tour may appear random but no matter which other invitations might have been accepted, all corridors lead to the rec room of the suburban home,[6] as inevitably as the traffic patterns of the Museum of Modern Art dictate our passage through the history of modernism. Pruitt·Early live in *Saturday Night Live*'s "Wayne's

World," the basement where mother cannot descend; lots of beer cans there, with decal labels: "Shit," "Alien Sex Fiend," "Choose Death," and "Doctor Pecker" (*Sculpture for Teenage Boys [Pabst Pyramid 13 High]* [early 1990s]).

There are lots of shiny metal objects in the rec room: walkers, handcuffs, and more beer cans, Cady Noland's "skeletal tracings of cages, 'playpens' far more openly vicious than Gober's." Critics feel that she "evokes the homespun violence of the hearth."[7] It is said that her "focus may seem circumscribed in its preoccupation with a depiction of American pathology. But hers is no small task. She wants to show the tension between the standard way of looking at America and the reality of our banal lives."[8]

But frankly, this view of the American home and homeland as a bland, barren, generic factory for the production and dissemination of psychopathology *is* by now the "standard way of looking at America." Such a tarnished picture has long since replaced the earlier American myth of the innocent struggle for opportunity promulgated by Hollywood movies of the 1930s. A recent film, *Edward Scissorhands* (1990), offers, on the one hand, the bland, pastel suburban home as the domain of either ineffectual or brutal men and, for the most part, voracious witchlike females, and, on the other hand, the Gothic castle where a lonely and alienated artist recreates in ice (a suitably postmodern material, nontraditional and cold) the inhabitants of the suburban "wonderland" who have rejected him.

Edward's ice sculptures remain in the castle, but the "homey" objects described here are ultimately destined for art's home away from home, the "white cube" of the modernist and postmodernist gallery, that twentieth-century construct from which all Victorian concepts of home have been scoured. Even Gordon Matta-Clark's site-specific dissections of homes, so evocative in photographs, ended up safely ensconced in the white cube. Art itself is being produced in homes that have been made to look like the white cube. The art will be sold to another home that probably also has been made to look like a white cube. Today it is hard for an artist to be taken seriously if his or her studio does not mimic gallery conditions: white walls free of homey elements, and halogen lights, please. While it stands to reason that studios that are not prototypically "cubic" might produce work that strays from the given, as John Perreault has noted, "Most [artists]

have interiorized the likely conditions and allow these to determine how they work." [9]

If the white cube "hothoused the serial jettisoning of content," [10] *Womanhouse* (1972), a project of the Feminist Art Program at CalArts, sought to reinject into art and society the subject matter Virginia Woolf had intuited in *A Room of One's Own:* "For women have sat indoors all these millions of years, so that by this time the very walls are permeated by their creative force." [11] *Womanhouse* was produced within the confines of a single-family 1920s home in Hollywood and was experienced by the public as a house tour that began in Robin Weltsch, Susan Frazier, and Vicki Hodgetts's painted-foam breast and sunny-side-up-egg-encrusted pink kitchen. The bathrooms included Camille Grey's lacquered, deep red *Lipstick Bathroom* and Judy Chicago's pristinely white *Menstruation Bathroom* (stocked with packages of feminine hygiene products and featuring a wastebasket filled with "bloodied" tampons). Sandra Orgel's linen closet trapped a female mannequin between its shelves. A shoe closet by Beth Bachenheimer prototypically contextualized Imelda Marcos and Mary Boone, while Miriam Schapiro's *Dollhouse* played with traditional links between woman-and-child/woman-as-child.

Many of the artists who participated in *Womanhouse* were quite young, and their work expressed a sense of their mothers' frustrated domestic imprisonment more than their own personal experience. The confining aspects of the home for its female occupants/caretakers, counterposed to the liberatory aspects of the inner home of the body, were represented and enacted in direct, imaginative, theatrical, and emotive forms, far removed from the dictates of the white cube. The work hardly idealized the notion of home, yet its rooms resonated with a sense of visual *fullness* in full opposition to the prisonlike sensory deprivation given so much credence in the art world today.

Wonderland (1983), a more recent work by Schapiro, also suggests an imaging of "lack" modulated by the plenitude of feminine activity. Schapiro's celebration of traditional feminine domesticity raises the issue of a double standard in the art world's reading and acceptance of such gendered depictions. One might compare *Wonderland* to Mike Kelley's wall hanging of colorful afghans and toys, *More Love Hours Than Can Ever Be Repaid* (1987). Kelley's ironic and strategic use of kitsch gains him a place in "Wayne's World," the currently

favored venue of avant-garde art, the latest version of the white cube. Schapiro's genuine embrace of kitsch as an aesthetic consigns her to the unseen world of the Mother, the sewing room in the attic of modern art.[12] At the center of *Wonderland*'s colorful, active, quiltlike field, Schapiro has placed an embroidered objet trouvé: we are welcomed to the Artschwageresque home of a hauntingly insecure woman who leans tentatively to one side. Schapiro's central placement of this pathetic image is based on sympathy for the sorrows of the disappeared Mother; for its part, Kelley's work threatens to collapse into childishness. One may be ambivalent about the "feminine mystique" but, for Schapiro, this is no excuse for visual impoverishment.

Stuttering God (1989–90), a recent collaboration by poet Madeline Gins, painter Arakawa, and architect John Knesl, recalls *Womanhouse*'s focus on the interiority of the female body. Part of a larger work, *Building Sensoriums for determining how not to die (1973–90),* it constitutes the "inside" to the "outside" of *The Process in Question/Bridge of Reversible Destiny,* a forty-three-foot-long metal-and-wood bridge across the large main room of Ronald Feldman Fine Arts. This piece was phallic, metallic, and allowed progress along a linear, although often blocked, path. In contrast, *Stuttering God* was invisible and soft, a womb entered through two cloth slits in the back gallery wall, a dark birth canal crowding the viewer with net bags filled with sponges. In a sense it was a classic funhouse setup, with all the scary apparatuses visible. Yet the viewer/participant felt genuinely trapped, with only forward movement possible. A walled-off inner core offered peephole glimpses into vistas similar in construction to the piece outside (this was not the nature-bound body secreted in Marcel Duchamp's *Étant donnés*). Most participants, however, were so anxious to get out that they did not linger long enough to really peep, reemphasizing the gulf between inner and outer space. The work did not seem to rely on the gallery space as home, it almost shunned it.

Ilya Kabakov's radical erasures of the white cube in *Ten Characters* (1988) and *He Lost His Mind, Undressed, Ran Away Naked* (1990) emerge out of urban domestic arrangements specific to Soviet Russia. These abandoned but overcrowded rooms are places for narrative, and they continue the tradition of the Russian novel and drama. People lived in these spaces, they talked exhaustively (if only perhaps to themselves), and despaired passionately. Although Kabakov's "domestic

theatre"[13] is enacted within a system of Soviet oppression, it has parallels in American culture. Coming to the end of one of his poorly lit, seemingly endless corridor mazes, one could just as easily imagine emerging in the rabbit warrens of the Martinique Hotel (notorious former home for homeless New York welfare recipients) as in the deserted rooms of a Soviet communal apartment. These miserable and often messy homes are nevertheless as replete with human content as the rec rooms of the suburban home are empty.

Urban life positively spills from the Harlem tenement that is the

Miriam Schapiro, *Wonderland,* 1983, acrylic and fabric on canvas, 90 × 144 ins. (Courtesy Steinbaum Krauss Gallery, New York)

locus for Faith Ringgold's *Street Story Quilt* (1985). Its windows are a crucial intermediary between the public and the private: people proclaim their antiwar sentiment—"Hell No We Won't Go! Uncle Sam Don't Give A Damn" is scrawled on a torn window shade—or they hang out, observing the ongoing drama of the street, the narrative of daily events displacing the bricks of the building they live in. The story culminates in the perhaps ironic "happy" ending of *The Homecoming,* which envisions the protagonists' removal from this vivid homeland to Hollywood: "Ma Teedy leavin 222 West 146th Street in Harlem

today. She goin to live where the grass grows green 12 months out the year. And where the sky is clear blue. And the sun shines everyday. She goin to Beverly Hills in Hollywood where the movie stars live." But this artificial and empty paradise is not figured.

In his contribution to *Bedrooms,* a series of installations in 1991 at Snug Harbor on Staten Island, Thomas Lanigan-Schmidt also touched on some of the human content of the inner-city home. A bare, white, old-fashioned hospital bed was the focus of a pink-walled room, barely touched by anything resembling art or even artfulness: on the walls were taped letters and pictures from the life of a Hispanic neighbor who had died of AIDS. The loving support of a lower-class family home could not save its child from drugs and AIDS, despite religious faith and the poetic talents of the victim.

The difficulties of sustaining the concept of home as a secure and intimate place are real. Yet people everywhere—that is, most often women—are trying to "make a home," to infuse a sense of human connectedness into a house. In Maureen Connor's *Linens* (1980), a starched and ironed white organdy tablecloth spills over and beyond the legs of an elegant dining-room table. The transformation of a useful item into a decorative object, the continuum between woman's work—never done—and the ephemeral visual pleasure it can provide, are addressed without the ironic distance so devoutly adhered to in the contemporary art home. In fact, the piece had a suggestive complementarity to the unusual, noncubic space in which it was displayed. The marble mansion's appointments—linen-covered walls with ornate neoclassical plaster moldings and ceilings—brought to mind the world in which the servant girl, perhaps Irish, who had preserved these luxuries might have lived and worked. One can usefully compare this linen confection to Artschwager's *Table with Pink Tablecloth* (1964), where such niceties are frozen into Formica, or to Mitchell's tablecloths, despoiled with coffee and ketchup with a dispassion both scientific and aesthetically formal. Connor illuminates the momentary triumph of the desire most often enacted by the female, to transcend the imperatives of mere shelter, without erasing a sense of the labor involved in such extravagances. Visual pleasure and exploitation are interwoven.

Contemporary evocations of home, in works by Bloom, Noland, and Pruitt·Early among others, seem based on the reading and mis-

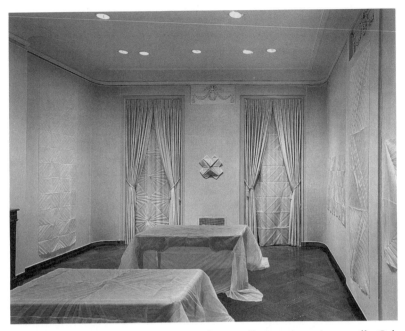

Maureen Connor, *Linens,* 1980, organdy, installation view, Acquavella Gallery, New York. (Courtesy of the artist)

reading of Walter Benjamin, especially his critique of aura and his belief in the radical potential of film and photographic technology. Would these works be different if graduate seminars required texts by Benjamin other than the ubiquitous "The Work of Art in the Age of Mechanical Reproduction"? Recognition of the intense disagreement over the notion of aura between Benjamin and his friends Theodor Adorno, Bertolt Brecht, and Gershom Scholem might complicate one's understanding of Benjamin's feelings. (Brecht wrote in his diary: "b[enjamin] discovered [the decay of aura] through the analysis of film, where aura disintegrates because of the reproducibility of artworks. it is all mysticism mysticism, in a posture opposed to mysticism."[14]) Benjamin's "Unpacking My Library, A Talk About Book Collecting" gives an almost refreshing glimpse of a man, who otherwise seems to have been a consummate schlemiel in practical affairs, outwitting a competitive bidder for a coveted book.[15] Shallow readings of "The Work of Art" ignore the cabalistic aspects of Benjamin's

relation to the material world, his understanding of text or object, be it ever so humble, to contain the potential for material and Messianic redemption.[16] Indeed, Benjamin's book collection was of such deep personal importance to him, recalling his Berlin childhood and providing him with a sense of identity and place (even when he and it were displaced to Paris), that some feel he committed suicide because, in fleeing to Spain, he had had to leave it behind. These objects were finally as meaningful to him as his life.

Benjamin's obvious attachment to auratic objects oozes out of his every (auracular) word. A luminous fragment from his essay "One-Way Street" bears upon the implications of aura in representations of home:

> If the theory is correct that feeling is not located in the head, that we sentiently experience a window, a cloud, a tree not in our brains but, rather, in the place where we see it, then we are, in looking at our beloved, too, outside ourselves. But in a torment of tension and ravishment. Our feeling, dazzled, flutters like a flock of birds in the woman's radiance. And as birds seek refuge in the leafy recesses of a tree, feelings escape into the shaded wrinkles, the awkward movements and inconspicuous blemishes of the body we love, where they can lie low in safety. And no passer-by would guess that it is just here, in what is defective and censurable, that the fleeting darts of adoration nestle.[17]

I find particular pleasure in wandering through the deserted backwaters of museums where objects once used in the home stand overcrowded in glass vitrines. Most of these objects are premodernist, removed from the Museum of Modern Art's scientifically designed prototypes and arranged in a manner distinctly unlike Haim Steinbach's ironic tableaux. Gleaming collections of silver teapots, crackled ironstone platters, red-and-yellow earthenware bowls, porcelain teacups, and majolica dishes recall my hearth and warm my white-cube-frozen heart.

Looking at the rows of ever so slightly dusty chairs and tables hung up for study in the Henry R. Luce Center for the Study of American Art at the Metropolitan Museum of Art, I'm not sure that love even rests in the object's flaws. The harder we try to see the beloved, the more fugitive its image becomes; one might as well try to freeze in

time the flow of one's own blood. Domestic security rests precisely on being spared, at least briefly, any sense of closure, loss, mortality. You don't *see* your home unless it is threatened, just as you don't notice your skin unless it is injured. The difference between house and home is evident when a house is emptied of its possessions. The structure remains, but the concept of home has now fled to the moving van; it has gone with the end table that was perhaps never really perceived until it was withdrawn. The empty hallway awaits reinvestment with hominess, but the table contains it, even when it is displayed in a period room or put on a pedestal like an art object. Art objects about home cannot shake their link to the agora, while objects made for use in the home retain the auratic history of their *human* usage.

Representation takes place in the gap between absence and desire. But that doesn't mean that the desired never existed, was never glimpsed; what is lost may not have been lacking. My mother, for whom English is a fourth language, once wrote to me, "I love you with all my hearth." While such emotion may occasionally be confining, its glow is not imaginary and it illuminates, for me, representation's *effort* to reattain the desired home. The suburbanoid permutations of much contemporary art only focus on absence and the futility of effort. Why not focus instead on the fullness of what was desired and the heroism of the effort to slide safely into home?

Afterword: Painting and Language/
Painting Language

My early career ambitions did not include following in the tradition of artists who write about art. In fact, my first important choice after college was to pursue studio art and to *not* pursue art history, my college major. Increasingly, I had found myself identifying with the "wrong" side of the slide projector, questioning how my teachers could possibly claim to know what the artists had intended. However, my preliminary training in art history did convince me of the importance of all manner of documentation in the preservation and reception of art, and my student involvement at the inception of feminist art history underlined the special importance of self-documentation and commentary by women artists.

Although writing as a visual image was an important subject of my artwork during the seventies, I came to critical writing more slowly. I was led, like many of my illustrious artist/writer predecessors, through a fairly typical sequence of circumstantial events: you feel strongly about something happening in the world, no one is writing what you think, you find you are able to express your thoughts in words, you write them down for your own gratification and clarification, and then one thing leads to another. In my case, I founded a journal and got my writing published and then wrote regularly about

art. While it was difficult for me to get "Appropriated Sexuality" published, once I got going it seemed relatively easier to get art writing published than to get art exhibited: within four years of my first published essay, I had written a cover essay for *ArtForum*.[1] For a moment at least, the idea bank *seemed* more accessible than the image bank.

Barnett Newman's often quoted aphorism, "An artist paints so that he will have something to look at; at times he must write so that he will also have something to read,"[2] is instructive as to the varied implications of a dual practice: according to this formula, painting comes first, writing is more sporadic ("at times"), and yet is felt as a necessity ("he *must* write"; emphasis added). If s/he *must*, it is an unstated given that s/he *can* paint *and* write. But this ability is fraught and many of the artists who have it make sure to underline their ambivalence about writing in order to ward off the intense distrust the art world has of the artist/intellectual. Artists often demur after the fact, emphasizing that their writing careers came about by default[3]— it's a dirty job, but somebody had to do it; or that they did it for the money[4]—which is particularly improbable considering the pay scale. Certainly, they stop or slow down the writing as soon as it has served one of its purposes, namely, to act as a career lifeboat transporting the artist, her work and ideas, from obscurity into public view. At a certain point the demands of their art practice take precedence, and sometimes the generation gap makes their critical views less accurate or less relevant to a new discourse.

In fact, artists are moved to make the case for the movement they feel they belong to, or because no one else will or can make the case for their own aesthetic any better.[5] Rather than being detrimental to the development of their art, writing has often proved itself a very useful element in the process of staking out aesthetic positions, clarifying ideas, and tempering creative impulses. Writing is a space in which to work out ideas about one's own work.[6] In my case, the relationship between what I write and what I paint is often even closer than I am consciously aware: it was obvious to me that my research for "Representations of the Penis" was simultaneous with my own efforts at such representation in my work, but I did not immediately understand the degree to which my review of Barnett Newman's writings indicated a turning point in my painting toward greater flatness and simplification. Finally, the artist's words pose the ultimate challenge

to his or her visual art, that of living up to the standards you yourself have set in your critique of other artists.

Adding critical writing to my art practice made me feel more complete as a person and affected my process in the studio in a positive manner. In fact, I began to write and became an editor at the same time that I began to paint in oil on canvas and linen after years of working with pastel, dry pigment, and gouache on paper. These earlier media didn't allow much change from one's first action, whereas oil allows for endless transformation, and, similarly, writing almost by definition must be rewritten. This trait of text interacted synergistically with the mutability of oil painting. Each process gave me courage to be more ruthless with my original idea in either practice.

The disadvantages of writing, for an artist, are subtle but definite, beyond the purely social spectacle of other artists engaging in behavior that clues you in to what never to do or say to a writer! There is a deep suspicion in the art world of artists who are intellectuals—at the same time as they are exploited for their usefulness to the discourse and dissemination of new art ideas.[7] Growing up in the art culture of the New York School, this prejudice was as deeply inculcated into my consciousness as were those against intellectually ambitious women: "men don't make passes at girls who wear glasses," "those who can, do, those who can't, teach," and "stupid like a painter" all operate in the same cultural frame. This was particularly true in the fifties, when a formalist aesthetic prohibited literary references and artworks were by rule and necessity restricted to their own materials, forms, and disciplinary confines. The eighties' emphasis on theoretical substructures, linguistic representations, and public-accessible museum labeling shifted the prejudice perhaps too far away from the primacy of visual form, but now it seems the tides are shifting again and some new version of the old rules and prejudices is reemerging.

Critics are territorial about their own discipline and power position and see you as an interloper. They may be fearful, either because, if they admire you in both capacities, they may feel inadequate to the task of reviewing you because they fear you'll be critical of their writing, or because they know you have the ability to retaliate for bad reviews in kind by writing about them. Ultimately, they resent the fact that while some artists can be critics, "at times," most critics can

never be artists.[8] Curators too are threatened by artists who claim to know as much as they do and might want to participate, that is to say interfere, in the presentation and contextualization of their work. There is sometimes a prejudice against people who can do more than one thing well. Therefore, it has been insinuated into the general culture that it isn't possible to do both equally well. This is the same suspicion that befalls people who are bilingual. Can a person be truly fluent in two languages? Can s/he navigate between the two? This is true if the languages are French and English, or verbal and visual. The issue of bilingualism and translation are relevant to my experience on both grounds and touches on more personal reasons for my assumption of a public voice in writing about art.

I am a first-generation American (although a third-generation painter). English is my mother tongue, but not my mother's mother tongue. Because of that it also seems like my adoptive tongue as well. Born in Poland, living in Paris before the Second World War, my parents Ilya and Resia Schor settled in New York City in 1941, as refugees from Hitler's Europe. They spoke Polish, Yiddish, French, and English at home. Their friends were multilingual, usually fluent in their native Russian or Polish and in the language of their *first* emigration — Polish, German, or French. Their English was heavily accented, amusing, and remarkably effective. My sister Naomi and I were sent to the Lycée Français de New York. My sister writes eloquently of the ramifications of these linguistic multiplicities in her book *Bad Objects.*[9] She chose French for her professional and even her affective life. I chose the visual language of drawing and painting for my professional and affective life, and, also, I embraced English, to the point of becoming an avid Anglophile and of shedding fluency in spoken French with almost pathological speed after receiving my Baccalauréat.

I was born at a later stage of my parents' assimilation into American society. My significant linguistic memories include my father and a fellow refugee playing Scrabble every night, gleefully accusing each other of cheating as they consulted *Roget's Thesaurus* and my mother reading the *New York Times* daily from cover to cover. When any event strikes her as really important, any injustice in need of redress, she says, "somebody should write an article" (preferably in the *New Yorker*). Yet, despite their gradual integration into American life, fundamentally my parents remained strangers. They were not native

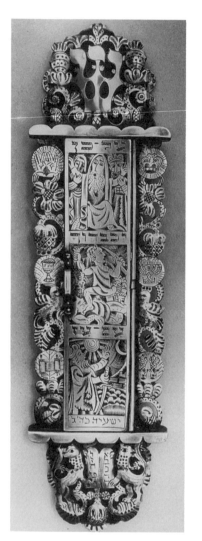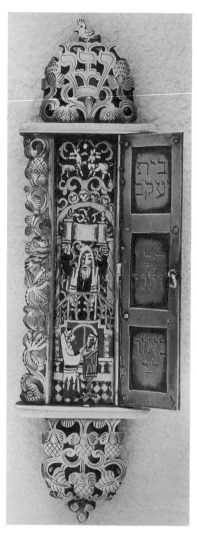

Ilya Schor, *Mezuzahs,* early 1950s, silver, gouache, and gold leaf on parch-
ment, 7 × 2½ ins. (dimensions approximate). (Courtesy of the Ilya Schor
Estate)

Resia Schor, *Mezuzah,* 1976, brass, plexiglass, mezuzah text, and gouache on paper, 12 × 6½ ins. (Courtesy of the artist)

speakers. They went to art school at the Warsaw Academy of Fine Arts, not Black Mountain College; my sister went to Yale, I went to CalArts. The child of an immigrant is traditionally the family interpreter: if someone were to write an article, it was going to have to be my sister or me. We were the primary translators. Thus, writing has a special importance for me, as a form of family obligation. But a trace of my parents' strangerhood, their Europeanness, infiltrates my ideology: the Hasidic belief in the possibility of redemption inherent to the most humble detail of daily life, inherited through my father's artwork in Judaica, haunts my ability to assume the ironic stance of my schoolmates and generational cohort. And, often, lunching in a New York coffee shop with my mother, I have peered over my burger deluxe and Coke at my mother's egg salad sandwich and hot tea and thought, "What is this woman doing here, in America, in New York City?" That question calls up another, "What am I doing here?" To the necessity to write *for* my parents is added the slight cultural duality and displacement that allows me to see my art world from the oblique angle I noted in my preface.

Language takes on its deepest meaning for me at the level of its appearance as an aesthetic image. The visualization of text was at the physical and spiritual core of my parents' work. My parents were artists, making jewelry and objects of Judaica, as well as paintings. I love all their work but of consistent interest to me are their silver and gold mezuzahs: not only did they engrave and delineate Hebrew letters on each mezuzah—letters that I could *only* appreciate as images, because I do not read Hebrew—but an unseen talismanic text was secreted inside these small sculptured treasures, behind a small door and a gilded illumination. In my mother's work, a certain iconoclastic and more modernist impulse led her to sometimes display the small text openly and even cut it up into separate word fragments.

Language has been an important visual and conceptual element in my own work in different ways, which repeat the graph of my writing: personal (pre-theory), polemic (political content and the visual appearance of theory language), and, most recently, language as self-referential sign (post-theory).

In the seventies I used the elegant undecipherability of my handwriting as an image and metaphor of female thought. In works such as *Book of Pages* (1976), made of rice-paper pages heavily laden with

Mira Schor, *Dress Book,* 1977, mixed media
on rice paper, 63 × 15 × 7 ins. (Courtesy
of the artist)

medium, dry pigment, paint, and ink writing, I created an archetypical woman's diary in which the muse, traditionally female, was cast as a mute male Sphinx. Writing covered the translucent rice-paper layers of person-sized double-V-shaped Dress Books hung on the wall at body level (1977–78): you could go up to the "woman"/artwork, turn its pages, trying to read *her* text (which was personal and autobiographical).

In the late eighties, I returned to representations of language of a more political nature. In *War Frieze* (1991–94), an approximately three-hundred-running-feet by one-foot-wide painting done in discrete eight- to twenty-foot sections, the transmission of power in society is represented by the flow of language as body fluid from sexual body part to body part—language embedded into the body of oil paint. The language was no longer that of the secret diary or the obsessional love letter. It was public, often appropriated from the news, such as the phrase "Area of Denial," which was a type of weapon used during the Gulf War, or "Undue Burden," part of the wording of a Supreme Court abortion decision.

In these paintings I used the careful cursive script in which I was taught to write at the Lycée. I chose this rather than the ubiquitous helvetica font of media culture because I had cathected to the physical and aesthetic pleasure of writing out a letter as I was instructed to do, putting my weight into a thicker downstroke, lifting my wrist for a delicate upstroke. In the beginning, there was the beauty of the letter *a*.

My use of language as image reflects the degree to which I was immersed in theoretical texts at the time: so many words were intercut with slashes (virgules) or parentheses in order to reveal their ideological underpinnings. In a sense, "the language" served as a still-life element for my paintings. Painting text led to painting punctuation marks, especially the semicolon seen as the true G-spot: these paintings imagined a gynecological examination in which it would be discovered that there was language in there!

Recently the letters in my paintings are in my handwriting again, presented with, and in contradistinction to, the cursive script of public instruction. My subject is writing itself, as in *Personal Writing Software* (1994), a multicanvas installation in which very old tech—handwriting and painting—and low tech—xerox enlargement of handwriting—

Mira Schor, *Light Flesh* ;, 1994, oil on canvas, 12 × 16 ins. (Courtesy of the artist)

are used to imagine what personalized script software fonts might look like. Other works depict the words for colors—green becomes yellow intersects with black as letters cross paths in a giant, Scrabble-like installation. Again, I'm trying to literally embed the gap between visual and verbal languages within each other's materiality and meaning. I still own my father's copy of *Roget's International Thesaurus* (from 1955). I always loved the entry for "redness," turning the words and the colors in my mind simultaneously: red, scarlet, vermillion, crimson, hellebore red, Persian earth, carminette, carmine, lake, madder, carnelian, ruby, sanguine, claret, incarnadine . . . I dreamed of having flowing locks of, not red, but "Titian red" hair. The visual fulfillment of these early readings, my current paintings use language as a necessary but also vestigial "subject" for an exploration of oil paint as the ultimate body that, historically, any painter must engage, male or female. And, strangely, the more I want to only "paint paint," the more I am tied to language as my image and my conceptual anchor.

The title of this book, *Wet,* was at first chosen in jest, as a sexier re-

placement for *Figure/Ground,* a more pithy but accurate encapsulation of what that essay was about—the "goo" of femininity and of painting as opposed to the unitary, hard dryness of the modernist ideal and the dematerialized virtuality of postmodern space. It reflects my position within the great divide between painting and language. I welcome linguistic analysis of painting and femininity, I try to bring my writing as close to the visual art object as possible, but I would not reject painting in the name of language. At the risk of engaging in the same pattern of self-protective ambivalence that I have noted in other artist/writers, while I enjoy, indeed, thrive on the complexity of a dual practice, my heart rests in the ultimately nonlinguistic, ineffable pleasure and deep meaning of the figure/ground interaction, of the visual language of paint.

Notes

Preface

1 I note this problem in the most recent work of feminist art criticism I have encountered, *New Feminist Art Criticism,* ed. Katy Deepwell (Manchester and New York: Manchester University Press, 1995); cf., also, note 5, below. Rather than miring myself in an umpteenth rehearsal of these terms, which I also feel would overemphasize the importance of this discourse to this collection as a whole, I would refer readers who are unfamiliar with the discourse to the many excellent books on the subject, including the recently published *The Essential Difference,* ed. Naomi Schor and Elizabeth Weed (Bloomington: Indiana University Press, 1994); *Engaging with Irigaray: Feminist Philosophy and Modern European Thought,* ed. Carolyn Burke, Naomi Schor, and Margaret Whitford (New York: Columbia University Press, 1994); and *Essentially Speaking: Feminism, Nature, and Difference* by Diana Fuss (New York: Routledge, 1989); as well as older texts that were central to the circulation of these French feminist philosophies in the United States, *New French Feminism: An Anthology,* ed. Elaine Marks and Isabelle de Courtivron (New York: Schocken Books, 1981) and *Sexual/Textual Politics: Feminist Literary Theory* by Toril Moi (London and New York: Methuen, 1985).

2 *Womanhouse,* exhibition catalogue, CalArts Feminist Art Program, 1972.

3 Cf. Mira Schor, "Backlash and Appropriation," in *The Power of Feminist Art,* ed. Norma Broude and Mary D. Garrard (New York: Harry N. Abrams, 1994), 248–63.

4 Cf. Elizabeth Hess, "The Women," *Village Voice,* 8 November 1994, 91, 93, and Lilly Wei, "Feminists in the Art World," *Art in America,* January 1995, 35, 37.

5 For example, in Katy Deepwell's introduction to the recent collection of essays on feminist art in Britain, *New Feminist Art Criticism* (Manchester and New York: Manchester University Press, 1995), I noted with interest the description of one of the essays: "Christine Battersby's piece argues that the adoption of psycho-analytic terms and models, specifically from Luce Irigaray, may prove fraught for feminist art practice if we do not address these writers' own analyses of the place of painting" (4). My hopeful anticipation latched on to the word "paint-ing" in relation to Irigaray's philosophy. But the essay itself, "Just Jamming: Irigaray, painting and psychoanalysis," devoted its first five pages to Irigaray's theoretical divergences from Lacanian orthodoxies; these are cogently expli-cated, but they have been before. Irigaray's analysis of the work of Unica Zürn, an artist who was also Hans Bellmer's mistress and model, is alluded to, but, disappointingly, Battersby does not describe Zürn's less-familiar work, nor is it reproduced. I have never heard of this artist. She is not mentioned, for example, in Whitney Chadwick's very complete work, *Women Artists and the Surrealist Move-ment* (Boston: Little, Brown, 1985). One possible strategy to create theory from the visual would be to organize an essay around a close analysis of the artwork of this artist, foregrounding the art as a locus and maybe a source for the theory. At the very end of the essay, works by Kay Sage and Ithell Colquhoun are briefly described and illustrated. One comes away with a thoughtful rehearsal of Iri-garay's somewhat underinformed efforts to theorize a female gaze but very little sense of the value of women artists' actual efforts in that direction.

6 Piet Mondrian, *The New Art—The New Life: The Collected Writings of Piet Mon-drian,* ed. and trans. Harry Holtzman and Martin S. James (New York: Da Capo Press, 1993), 336.

Appropriated Sexuality

I researched and wrote the first draft of this essay in the spring of 1984. The Art Index entries under SALLE, DAVID were then, and are now, composed almost totally of supportive presentations and exegeses of his position. Articles critical of him are few and timid in their scope. There are none that are critical from a clearly feminist point of view. My article could be endlessly updated to include analyses of recent writings on Salle, but the balance of opinion is unchanged.

Some have questioned my use of the word "cunt" to describe female geni-talia. I do so advisedly. It is the word that best describes what Salle paints, and it is a word that he himself does not shun.

I have limited my focus to Salle's depiction of women and to the treatment of that depiction by critics, that is to say, I have scrutinized only his subject matter. I have not addressed myself to issues of quality or style. If the question is asked, "Is David Salle a 'good' artist?" I can answer that I feel that he is very good at what he does, which is the manipulation and juxtaposition of appro-priated images and styles. It is crucial to offer a critique of his imagery because he is so effective in his presentation of it, because he is a critical and a financial

success, and because his work and his career have epitomized a system of art practices and theories that have dominated the decade of the 1980s.
—October, 1986

1 Muriel Rukeyser, *The Collected Poems of Muriel Rukeyser* (New York: MacGraw-Hill, 1982), 484.

2 Carolyn Donahue/David Salle/Joan Wallace, "The Fallacy of Universals," *Effects—Semblance and Mediation*, no. 1 (summer 1983): 4. (It was impossible to ascertain to whom this quote should be correctly attributed, thus all three names.)

3 David Salle, as quoted in Georgia Marsh, "David Salle. Interview by Georgia Marsh," *Bomb* 13 (fall 1985): 24.

4 David Salle, as quoted in Robert Pincus-Witten, "Pure Pinter: An Interview with David Salle," *Arts* (November 1985): 80.

5 Pincus-Witten, "Pure Pinter," 80.

6 Sherrie Levine, "David Salle," *Flash Art*, no. 103 (summer 1981): 34.

7 Carol Duncan, "Virility and Domination in Early Twentieth-Century Vanguard Painting," in *Feminism and Art History: Questioning the Litany*, ed. Norma Broude and Mary D. Garrard (New York: Harper and Row, 1982), 308.

8 Pincus-Witten, "Pure Pinter," 81.

9 Robert Pincus-Witten, "Entries: Big History, Little History," *Arts* (April 1980): 183.

10 Ibid.

11 Robert Pincus-Witten, "David Salle: Holiday Glassware," *Arts* (April 1982): 58.

12 Ibid.

13 Donald Kuspit, "Reviews: David Salle," *Art in America* (summer 1982): 142.

14 Thomas Lawson, "Reviews," *ArtForum* (May 1981): 71. In checking quotes for this republication, I find that the full quote is worth noting here because Lawson reworks this passage in "Last Exit: Painting," published in *ArtForum* in October 1981, with significant differences. In the May 1981 review he writes: "Most often his [Salle's] subjects are objectified women. At best these representations of women are cursory and off-hand; at worst they are brutal and disfigured. His women are made ridiculous or ugly through juxtapositions with containerlike objects, such as furniture. These juxtapositions disturb on a deeper level than one might at first imagine" (71). In "Last Exit: Painting" he writes: "Often his subjects are naked women, presented as objects. Occasionally they are men. At best these representations of *humanity* are cursory, offhand; at worst they are brutal, disfigured. The images are laid next to one another, or placed on top of one another. These juxtapositions prime us to understand the work metaphorically, as does the diptych format Salle favors, but in the end the metaphors refuse to gel. Meaning is intimated but *tantalizingly* withheld" (42; emphasis added). This version is significantly more favorable to Salle: he states, misleadingly I believe, that Salle also represents men, although he doesn't make clear whether he does so in the same manner or to the same degree of objectification, which allows him to shift from writing of representations of *women* to representations of *humanity*, a much vaguer and forgiving category; and he

now gives the technique of juxtaposition a more positive value as determining a metaphorical reading, rather than as making the women more "ridiculous or ugly," as in his first version. Also significant is the change from, "Meaning is intimated, but *finally* withheld," ("Reviews," 71) to the sexier, "*tantalizingly* withheld," ("Last Exit: Painting," 42), emphasis added.

15 Thomas Lawson, "Last Exit: Painting," *ArtForum* 20 (October 1981): 45.

16 Lawson, "Reviews," 71.

17 Kuspit, "Reviews: David Salle," 142.

18 David Salle, "The Paintings Are Dead," *Cover* 1, no. 1 (May 1979): unpaginated. A revised version of this statement is reprinted in *Blasted Allegories: An Anthology of Writings by Contemporary Artists,* ed. Brian Wallis (New York: New Museum of Contemporary Art; Cambridge, Mass.: MIT Press, 1987), 325–27.

19 Simone de Beauvoir, *The Second Sex,* trans. H. M. Parshley (New York: Bantam Books, 1961), 136.

20 Kuspit, "Reviews: David Salle," 142.

21 Salle, "David Salle. An Interview with Georgia Marsh," 20.

22 D. C. Muecke, *The Critical Idiom #13 — Irony and the Ironic* (London and New York: Methuen, 1970), 48.

23 Carter Ratcliff, "David Salle and the New York School," in *David Salle* (Rotterdam: Museum Boymans-van Beuningen, 1983), 36.

24 Ibid., 35.

25 Ibid.

26 Ibid.; emphasis added.

27 Linda Nochlin, "Eroticism and Female Imagery in Nineteenth-Century Art," in *Women as Sex Objects: Studies in Erotic Art 1730–1970,* ed. Thomas Hess and Linda Nochlin (New York: Newsweek, 1972), 9.

28 Ibid., 14.

29 Carol Duncan, "The Esthetics of Power in Modern Erotic Art," *Heresies 1: Feminism, Art and Politics,* January 1977, 46.

30 Carol Duncan, "Virility and Domination," 296.

31 Eva Hesse, quoted by Cindy Nemser, "Interview with Eva Hesse," *ArtForum* 8, no. 9 (May 1970): 59.

32 David Salle, "The Paintings Are Dead," unpaginated.

33 Michael Krüger, *David Salle,* trans. Martin Scutt (Hamburg: Ascan Crone, 1983), 8.

34 Meyer Schapiro, "The Apples of Cézanne—An Essay on the Meaning of Still-Life," in *Modern Art—19th and 20th Centuries: Selected Papers* (New York: Georges Braziller, 1978), 33.

35 Ibid., 30.

36 Ibid.

37 Laura Mulvey, "Visual Pleasure and Narrative Cinema" (reprinted from *Screen* 16, no. 3 [August 1975]), in *Art after Modernism: Rethinking Representation,* ed. Brian Wallis (New York: New Museum of Contemporary Art; Boston: David R. Godine, 1984), 361.

38 Harold Rosenberg, *Discovering the Present—Three Decades in Art, Culture and Politics* (Chicago and London: University of Chicago Press, 1973), 46.

39 E. B. White cartoon caption: "It's broccoli, dear."/"I say it's spinach, and I say the hell with it."

Representations of the Penis

This essay is a revised version of a slide talk first presented at M/E/A/N/-I/N/G's Artists Talk series at the Sorkin Gallery, New York City, on 3 May 1988.

1 Jane Gallop, *The Daughter's Seduction: Feminism and Psychoanalysis* (Ithaca: Cornell University Press, 1982), 22.

2 Ibid., 95.

3 Ibid., 96.

4 Victor Burgin, "Tea with Madeleine," *Wedge*, no. 6 (winter 1984): 43.

5 Luce Irigaray, *Speculum of the Other Woman* (Ithaca: Cornell University Press, 1985), 135.

6 Jane Gallop, *Thinking through the Body* (New York: Columbia University Press, 1988), 126–27.

7 Irigaray, *Speculum*, 135. Cf. Irigaray, 47: "So Freud will see, without being seen? Without being seen seeing? Without even being questioned about the potency of his gaze? Which leads to envy of the omnipotence of gazing, knowing? About sex/about the penis. To envy and jealousy of the eye-penis, of the phallic gaze? He will be able to see that I don't have one, will realize it in a twinkling of an eye. I shall not see if he has one. More than me? But he will inform me of it. Displaced castration? *The gaze is at stake from the outset.*"

8 Kenneth Clark, *The Nude: A Study in Ideal Form* (New York: Doubleday Anchor Books, 1956), 35.

9 Ibid., 42.

10 "As K. J. Dover has shown, the Athenian taste in male genitalia ran to small and taut. Our modern stag party jokes of 'well-endowed men' would have been lost on the Athenians. Large sex organs were considered coarse and ugly, and were banished to the domains of abstraction, of caricature, of satyrs, and of barbarians." Quoted from Eva C. Keuls, *The Reign of the Phallus: Sexual Politics in Ancient Athens* (New York: Harper and Row, 1985), 68. Keuls's study of the phallocratic regime of fifth-century Athens as evidenced on vase paintings of the period contains much that is relevant to the works discussed in my essay, and illuminates the phallocratic and misogynist underpinnings of Western representation and discourse.

11 Cf. Clark, *The Nude*, 72, 73, 79, 82 as examples. Note also the ethnocentric howler/critique of sexual, or sexy, representation: "The soft, nerveless, and extravagant shapes of Indian art emphasize by contrast the taut, resolute, and economical forms of the Greek. We feel in every line of their purposeful bodies a capacity for endurance and self-sacrifice for which the word moral is not in-

appropriate" (52). Phallic language ("taut," "resolute"), morality, and desexualized representation are here neatly linked.

12 Clark, *The Nude*, 200.

13 Ibid., 225.

14 Leo Steinberg, *The Sexuality of Christ in Renaissance Art and Modern Oblivion. October 25* (Cambridge, Mass.: MIT Press, 1983), 1.

15 Lea Lublin, "Painters' Wee Wees or the Confoundations of Painting," *Wedge*, no. 6 (winter 1984): 32.

16 Steinberg, *Sexuality*, 46.

17 Ibid., 9.

18 Albert Elsen, *Rodin* (New York: MoMA, 1963), 21.

19 John Berger, *About Looking* (New York: Pantheon Books, 1980), 184.

20 Frederic Grunfeld, *Rodin* (New York: Henry Holt, 1987), 372.

21 Berger, *About Looking*, 184.

22 Irigaray, *Speculum*, 38.

23 Max Kozloff, "Pygmalion Reversed," *ArtForum* 14, no. 3 (November 1975): 37.

24 *Vito Acconci: Poetry, Activities, Sculpture, Performances, Installations, Video*, compiled by W. M. H. Kaiser, Amsterdam, 1977, unpaginated.

25 *Vito Acconci*, ed. Judith Russi Kirschner (Chicago: Museum of Contemporary Art, 1980), 15.

26 Kozloff, "Pygmalion," 35.

27 Arthur Danto, in his *Nation* review of Robert Mapplethorpe's exhibition at the Whitney Museum (26 September 1988), makes the similar comparison: the only artist he summons to his discourse, in his consideration of Mapplethorpe's 1980 self-portrait as a girl, is Duchamp: "One cannot but think of Marcel Duchamp's self-representation in *maquillage*, wearing the sort of wide-brimmed hat that Virginia Woolf might have worn with a hatband designed by Vanessa, with ringed fingers and a fur boa. Duchamp even took on a feminine alias, Rrose Sélavy. ('Eros c'est la vie.')" (249).

28 Catherine Elwes, "Floating Femininity: A Look at Performance Art by Women," in *Women's Images of Men*, ed. Sarah Kent and Jacqueline Morreau (London: Writers and Readers Publishing, 1985), 188.

29 Indirectly, Benglis's ad was responsible, according to some accounts, for *October*, which Krauss and Michelson founded after they quit *ArtForum*, the Benglis incident having been a last straw.

30 Lawrence Alloway, Max Kozloff, Rosalind Krauss, Joseph Masheck, Annette Michelson, "To the Editor," *ArtForum* 13, no. 4, (December 1974): 9.

31 Ibid.

32 Cf. Clark, *The Nude*, 286: "It is curious how seldom the male nude (except in the form of satyrs) appears in Rubens' finished paintings. His men are all draped or dressed in armor, often, no doubt, to provide a contrast with the shining nakedness of his women. Moreover it seems that he was reluctant to accept the convention by which male figures are nude when the subject does not warrant it." Needless to say, the subject always warrants women being nude. Fischl's representations of naked men are to be seen in relation to this convention.

33 Gerald Marzorati, "I Will Not Think Bad Thoughts. An Interview with Eric Fischl," *Parkett*, no. 5 (1985): 13.

34 Sarah Kent, "Looking Back," in *Women's Images of Men*, 60.

35 Duncan Fallowell, "Gilbert and George Talked To/Written On," *Parkett*, no. 14 (1987): 26.

36 Ibid., 29.

37 Robert Mapplethorpe died of AIDS in 1989.

38 Sarah Kent, "The Erotic Male Nude," in *Women's Images of Men*, 91.

39 Ibid., 86.

40 Ibid., 90.

41 Virginia Woolf, *A Room of One's Own* (New York: Harcourt, Brace and World, 1957), 35–36.

42 *Pornament Is Crime* is reproduced and annotated by Joyce Kozloff, with an introduction by Linda Nochlin, in *Patterns of Desire* (New York: Hudson Hills Press, 1990).

43 Patricia Hills, *Alice Neel* (New York: Harry N. Abrams, 1983), 49.

44 Irigaray, *Speculum*, 119.

45 Ibid., 240.

From Liberation to Lack

1 This three-part schema is derived from Julia Kristeva's "Women's Time," as summarized by Toril Moi in *Sexual/Textual Politics: Feminist Literary Theory* (London and New York: Methuen, 1985), 12.

2 Linda Nochlin, "Courbet's *L'Origine du Monde:* The Origin without an Original," *October* 37 (summer 1986): 77–86.

3 *Specular (specularized, specularity)* is a key word used extensively by the French psychoanalyst and philosopher Luce Irigaray to describe the mechanism whereby the instrument (the speculum) that man uses to see and represent woman is a mirror in which he sees only his own reflection (a "return of the same"). "[Woman is] a mirror in which the 'subject' sees himself and reproduces himself in his reflection." This quote is from Irigaray's *Speculum of the Other Woman*, translated from the French by Gillian C. Gill (Ithaca: Cornell University Press, 1985), 240. With its echoing of words such as *spectator* and *speculation*, it is a very useful term in feminist theory.

4 Irigaray, *Speculum*, 124.

5 Ibid., 47.

6 Moi, *Sexual/Textual Politics*, 57.

7 Irigaray, "Ce Sexe qui n'est pas un" ["This Sex Which Is Not One"], in *New French Feminism: An Anthology*, ed. Elaine Marks and Isabelle de Courtivron (New York: Schocken Books, 1981), 103.

8 Sandra M. Gilbert and Susan Gubar, *The Madwoman in the Attic* (New Haven: Yale University Press, 1979), 98.

9 Rozsika Parker and Griselda Pollock, *Old Mistresses: Women, Art and Ideology* (New York: Pantheon Books, 1981), 167.

10 Luce Irigaray, *Le Corps à corps avec la mère* (Montreal: Les Editions de la Pleine Lune, 1981), 86: my translation.

11 Irigaray, quoted by Moi, *Sexual/Textual Politics,* 147.

12 Moi, *Sexual/Textual Politics,* 139.

13 Irigaray, *Speculum,* 33.

14 Naomi Schor, "This Essentialism Which Is Not One: Coming to Grips with Irigaray," in *The Essential Difference,* a book from *differences,* ed. Naomi Schor and Elizabeth Weed (Bloomington: Indiana University Press, 1994), 42–43.

15 Susan Rothenberg, as quoted by Eleanor Heartney, "How Wide Is the Gender Gap?" *Art News* 86, no. 6 (summer 1987): 140.

16 Cynthia Ozick, *Art & Ardor* (New York: E. P. Dutton, 1984), 177.

17 Donald Kuspit, "Dorothea Tanning's Occult Drawings," *Art Criticism* 3, no. 2 (1987): 47.

18 Irigaray, *Speculum,* 50.

Medusa Redux: Ida Applebroog and the Spaces of Postmodernity

1 Griselda Pollock, *Vision & Difference: Femininity, Feminism and the Histories of Art* (New York: Routledge, 1988), 84.

2 Ibid., 71.

3 See Karen Petersen and J. J. Wilson, eds., *Women Artists: Recognition and Reappraisal from the Early Middle Ages to the Twentieth Century* (New York: Harper and Row, Colophon Books, 1976), 77.

4 Pollock, *Vision & Difference,* 158.

5 Ibid., 163.

6 Ibid., 164–65.

7 Laura Mulvey, "The Oedipus Myth: Beyond the Riddles of the Sphinx," in *Visual and Other Pleasures* (Bloomington: Indiana University Press, 1989), 197.

8 Ibid.

9 Mary Kelly, quoted in Pollock, *Vision & Difference,* 198.

10 It's worth noting that up until the construction of Paris's Musée D'Orsay, these three paintings, with others, were assembled in one room of the Louvre, to represent the pinnacle of the grand tradition of French painting.

11 Pollock, *Vision & Difference,* 156.

12 Kelly, quoted in Pollock, *Vision & Difference,* 188.

13 *The New Encyclopedia Brittanica* (Chicago: William Beaton and Helen Hemingway Beaton, Encyclopedia Brittanica, 1988), 14:610.

14 Teresa de Lauretis, "Desire in Narrative," in *Alice Doesn't: Feminism, Semiotics, Cinema* (Bloomington: Indiana University Press, 1984), 109.

15 Ibid., 110.

16 See Sandra M. Gilbert and Susan Gubar, *The Madwoman in the Attic: The Woman Writer and the Nineteenth-Century Literary Imagination* (New Haven: Yale University Press, 1979). Although in the internecine debates within critical feminism, between so-called essentialism and deconstruction, this book is generally seen to

fall into the discredited essentialist camp, the issue of female creativity as monstrously rebellious within patriarchy is tenacious and often useful in considering the works of women artists who are generally only discussed as deconstructionists.

17 Cf. "Figure/Ground"; this volume, 144–55.

18 Marcel Duchamp's stated wish for a "completely *dry* drawing, a *dry* conception of art" is more poetically cast in his earlier note:

arrhe is to art as
shitte is to shit

$$\frac{arrhe}{art} = \frac{shitte}{shit}$$

grammatically:
the arrhe of painting is feminine in gender.

See *The Writings of Marcel Duchamp,* ed. Michael Sanouillet and Elmer Peterson (New York: Da Capo Press, 1989), 24. A republication of *Salt Seller: The Writings of Marcel Duchamp* (Oxford: Oxford University Press, 1973). And Tristan Tzara presents a similar conflation of animal female sexuality and oil painting: "And farther down, sex organs of women, with teeth, all-swallowing—the poetry of eternity, love, pure love of course—rare steaks and oil painting." See Robert Motherwell, ed., *Dada Painters and Poets: An Anthology,* 2d ed., (Cambridge, Mass.: Harvard University Press, Belknap Press, 1989), 84.

19 Dan Cameron, "Reverse Backlash: Sue Williams' Black Comedy of Manners," *ArtForum* (November 1992): 71.

20 Ibid., 73.

"Just the Facts, Ma'am"

1 Quoted by Patricia Lynden, "The Art of Protest," *New York Woman* (September 1987): 11. A look at Castelli's roster proves that he puts his money where his mouth is. In the *Art in America Annual Guide to Museums, Galleries, Artists, 1990–91,* for example, Castelli listed sixteen male artists and no women; in the 1995–96 *Annual Guide,* of the sixteen artists, two are women; a gallery printout of "Artists Represented by Leo Castelli Gallery" given to me in March 1996 listed twenty-three artists of whom three are women.

2 Virginia Woolf, *A Room of One's Own* (New York: Harcourt, Brace and World, 1929), 51.

3 Quoted by Paul Taylor, "Where the Girls Are," *Corporate Culture* (April 1987): 178.

4 Quoted by Lynden, "Art of Protest," 11.

5 The Guerrilla Girls were awarded a grant by Art Matters, Inc., 1986; Honorable Mention in the Visual Arts, Manhattan Borough President's Award, 1987; a New York Foundation for the Arts Grant, 1988; and a National Endowment for the Arts grant in 1989/90.

6 See Alice Echols, *Daring to Be Bad: Radical Feminism in America* (Minneapolis: University of Minnesota Press, 1989).

7 Quoted by Mark Woodruff, "Artspeak: Monkey Business," *Taxi* (April 1989): 45.

8 Teresa de Lauretis, *Technologies of Gender: Essays on Theory, Film, and Fiction* (Bloomington: Indiana University Press, 1987), 23–24.

9 Lynden, "Art of Protest," 11.

10 "Queen Kong," *Playboy* (July 1989): 15.

11 Only my hairdresser knows for sure.

12 Joyce Kozloff, "From the Other Side: Public Artists on Public Art," *Art Journal* 48, no. 4 (winter 1989): 339.

13 Patricia C. Phillips, "Temporality and Public Art," *Art Journal* 48, no. 4 (winter 1989): 332.

14 Ibid., 334.

15 Deborah Wye, *Committed to Print* (New York: Museum of Modern Art, 1988), 8–9; emphasis added.

16 Arlene Raven, "ABC No Lady," *Village Voice*, 19 June 1990, 116.

17 Quoted by Myriam Weisang, "Guerrilla Girls Unmask Sexism in the Art World," *Mother Jones* (August–September 1987): 13.

18 The Guerrilla Girls members who appear at public lectures vary in order to fairly distribute honoraria. Therefore, presentations differ in clarity and acuity depending on the performative abilities of individual Girls. I witnessed an excellent presentation at the "Matrilineage: Women, Art, and Change" symposium program at Syracuse University in November 1991.

19 Roberta Smith, "Waging Guerrilla Warfare Against the Art World," *New York Times*, 17 June 1990, C1, C31.

20 Roberta Smith, "So Big and So Dressed Up, New Galleries Bloom in Soho," *New York Times*, 11 May 1990, C1.

21 Since I first wrote this essay, the Guerrilla Girls have addressed issues both within and outside the art world, using several different arenas and formats, and with similar patterns of success and "failure." For example, in 1991 and 1992 their posters addressed homelessness, abortion rights, the Clarence Thomas hearings, and the Gulf War. Gulf War posters included the question, "DID SHE RISK HER LIFE FOR GOVERNMENTS THAT ENSLAVE WOMEN?" under a photo of a female soldier standing in front of camels. Another poster sandwiched a news photo, of a policeman prodding a homeless person sleeping on a subway bench with his nightstick, between the following blocks of text: "Q. What's the difference between a prisoner of war and a homeless person?" and "A. Under the Geneva Convention, a prisoner of war is entitled to food, shelter and medical care."

The location of posters has been problematic: when the subject of the posters is the business of the locale in which they appear, such as art world–aimed posters plastered all over SoHo, there is a successful sense of purpose. Posters with broader political goals require broad distribution in similarly apt locations: the steps of the U.S. House of Representatives or Wall Street. Logistical and safety concerns prevented such purposefully targeted placement. On the other hand, a poster recently appeared announcing the arrival of the Guerrilla Girls on the Internet: "The Internet was 84.5% male and 82.3% white Until now—Guerrilla girls have invaded the world wide web—Join us—http://www.voyagerco. com/gg e.mail: guerrillagirls@voyagerco.com." True, the posters were in

SoHo, but Web surfers will find them and anything is possible. Also, the Guerrilla Girls started a newsletter in 1993, *Hot Flashes,* which moves their art world critique to that always effective method of distribution, direct mail. A book compilation of their work, *Confessions of the Guerrilla Girls,* appeared in 1995, published by HarperCollins.

22 Woolf, *Room of One's Own,* 118.

Patrilineage

1 Claudia Hart, "Reviews: Louise Lawler," *Artscribe International,* no. 67 (January–February 1988): 70.

2 Charles Hagen, "Reviews: Rebecca Purdum," *ArtForum* 28, no. 5 (January 1990): 134; Lois E. Nesbitt, "Reviews: Judy Ledgerwood," *ArtForum* 28, no. 3 (November 1989): 151.

3 Quoted in Donald Kuspit, "Reviews: Robert Morris," *ArtForum* 28, no. 1 (September 1989): 140.

4 Christopher Lyons, "Kiki Smith: Body and Soul," *ArtForum* 28, no. 6 (February 1990): 102.

5 Ibid.

6 Ibid., 105.

7 Tricia Collins and Richard Milazzo, *Pre/Pop Post/Appropriation,* exhibition catalogue (New York: Stux Gallery, 1989), unpaginated.

8 Ibid.

9 Ibid.

10 Brian Wallis, ed., *Art After Modernism: Rethinking Representation* (New York: New Museum of Contemporary Art; Boston: David R. Godine, 1984).

11 Griselda Pollock, *Vision & Difference: Femininity, Feminism and the Histories of Art* (New York: Routledge, 1988), 157.

12 Ibid., 169, 170, 199.

13 When I first wrote this essay, my wish was to choose names of women that were very well known, in order to establish their seemingly obvious availability as spiritual mothers to a woman artist, indeed to any artist. In order to be dispassionate, I did not place myself in the most personally relevant matrilineage and sorority: my mother, Resia Schor, is an artist whose answer to widowhood was to further develop her own art and her capacity to support herself and her family rather than seeking the help of a man; my sister, Naomi Schor, a distinguished feminist scholar, laid a path for me to follow, through "women's lib" and French feminist theory. Beyond these two most important female models, I live in a sisterhood of artists, former students, colleagues, friends all, whose work is of primary concern to me: Maureen Connor, Nancy Bowen, Susanna Heller, Susan Bee, Ingrid Calame, Robin Mitchell, Faith Wilding, Portia Munson, Rona Pondick, Jeanne Silverthorne, among too many others to list.

14 Peter Schjeldahl, "Introduction: The Oracle of Images," in *Cindy Sherman* (New York: Pantheon Books, 1984), 9.

15 Ibid., 8.

16 Carolee Schneemann, in an interview with Andrea Juno, in Andrea Juno and V. Vale, eds., *Angry Women Re/Search #13* (San Francisco: Re/Search Publications, 1991), 72.

17 Melissa Harris, "Karen Finley at the Kitchen and Franklin Furnace," *ArtForum* (September 1990): 159.

18 Faith Wilding, *By Our Own Hands* (Santa Monica, Calif.: Double X, 1977), 106 n. 12.

19 Ibid., 68.

20 Karen Finley, in an interview with Andrea Juno, in Juno and Vale, *Angry Women*, 48.

21 Ibid.

22 Lois E. Nesbitt, "Janine Antoni at Sandra Gering Gallery," *ArtForum* 30, no. 10 (summer 1992): 112.

23 Rowan Gaither, "A Sculptor's Gnawing Suspicions," *New York Magazine,* 9 March 1992, 24.

24 These include several sculptures from 1991 in which Connor created impossibly skinny figures out of black stretch lingerie material, and *Taste 2* (1992), exhibited a couple of months before Antoni's *Gnaw*. In *Taste 2* a bathroom scale rests on a low platform that has been covered with a white bath mat. Inside the scale a tiny monitor has replaced the numbers that usually reveal one's weight. It plays a tape loop of the artist stuffing herself with various foods in a random order. Suddenly her bulimic ritual of frantic bingeing ends as the monitor plays, in reverse, the images we have just seen so that the foods fall out of her mouth and become reconstituted. By the end of the tape they magically reappear on their plates completely intact and ready to be consumed and purged again in an endless cycle.

25 Such self-contextualization may be foiled by institutional forces beyond the control of the woman artist and invisible to the average reader of art publications. In writing about the relationship between Antoni's and Connor's work, I was relying on brief comments by Antoni and on my knowledge that Antoni had briefly been Connor's student at the Rhode Island School of Design (RISD). I did not give much thought, in regard to questions of influence, to the fact that I too had been Antoni's teacher, also for a one-semester graduate sculpture seminar at RISD. Since I had taken her to task for failing to publicly acknowledge any debt to Connor, I was somewhat abashed to learn, shortly after the publication of this version of "Patrilineage" (in Joanna Frueh, Cassandra L. Langer, and Arlene Raven, eds., *New Feminist Criticism* [New York: HarperCollins, 1994], 42–59), that she had credited me as a feminist mentor in an interview for *Flash Art* with Laura Cottingham but that this reference had been deleted by the editors, in favor of artists with greater name recognition:

> Laura Cottingham: Your work is so much indebted to feminist art of the 70s: the autobiography, your use of your own body as both process and subject/object, your reliance on the specificity of female experience as content, the performative work that accompanies your process.

Janine Antoni: The 80s artists, Kruger, Levine, Holzer, Sherman, are his-
torically important and really influenced me. They made it possible for me
to do the work I'm doing now.

(Laura Cottingham, "Janine Antoni: Biting Sums Up My Relationship to Art
History," *Flash Art*, no. 171 [summer 1993]: 104.)

Apparently, even a woman artist's (and a feminist art critic's) good faith effort
to credit a specific woman mentor may be occulted by a generic reference to the
usual suspects, although at least in this case they are female.

26 Tom Knechtel, a student at CalArts in the early 1970s, at the same time as Sue
Williams, took Williams to task for her "reimagining the history of Cal Arts,"
including the occulting of painting from its history, as well as such signifi-
cant women painting teachers as Elizabeth Murray, Pat Steir, and Vija Celmins,
and the elision of the Feminist Art Program. As Knechtel significantly notes,
"Even those women and men who didn't participate in the program could not
escape its influence." See Tom Knechtel, "The Total Picture at Cal Arts," let-
ter to the editor, *New York Times*, Arts and Leisure section, Sunday, 21 June
1992.

27 While Smith's ignorance of the history of early feminist art may be understand-
able in this instance, given the way the culture as a whole has dealt with that
history, her recent choices for inclusion and exclusion in a new category of
"angry" (young) women is less so. In "Women Artists Engage the 'Enemy'"
(*New York Times*, Sunday, 16 August 1992, sec. 2, p. 1), Smith is more obviously
market driven, even as her choices help shape that market, and as such her
choices, her premise, and even her conclusions, are more open to question.

She points to (and helps establish) a new mini-movement of women involved
with appropriation of male artists such as Richard Serra, Andy Warhol, and
David Salle. In that effort, she names Rachel Lachowicz and Janine Antoni.
Lachowicz's use of lipstick as an art material is, like Antoni's, a direct appro-
priation of Maureen Connor's work—Lachowicz was in an exhibition at Jack
Tilton Gallery in the summer of 1991, which included Connor's *Ensemble for Three
Female Voices,* and her first lipstick sculptures surfaced a few months later. Smith
does not consider other appropriations of male artists, for example, Connor's
subversive riffs on Marcel Duchamp's bottle-racks.

Consideration of appropriations among women artists would deepen Smith's
argument for this group of artists as a new feminist movement. Further, the
conclusion of her article undermines the status of the works Smith has pre-
sumably set out to boost when she states that "imitation is the highest form of
flattery. Except for Sue Williams and Janine Antoni, these women have not yet
achieved the originality of the feminist photographers of the early 80s, or of the
male artists they parody. [Deborah] Kass's work wouldn't be nearly as engaging
if it didn't incorporate the visual inventiveness of Salle or Warhol." If that is the
case, then why does Smith consistently, in what appears to be a series of articles
on these "angry" women, ignore women artists who *are* working originally: Ida
Applebroog might be a more outstanding example of an angry (older) woman

who appropriates, subverts, and invents imagery far more critical of cultural iconography and modernist syntax.

28 Luce Irigaray, *Speculum of the Other Woman* (Ithaca: Cornell University Press, 1985), 240. Irigaray speaks of the "phallosensical hommologue" of Western civilization.

Authority and Learning

In addition to the formative role played by the CalArts Feminist Art Program and the CalArts School of Art under the deanship of Paul Brach, this essay owes much of its underlying attitude toward teaching to the benevolent influence of Stephan von Huene, my mentor at CalArts.

1 Constance Penley, "Teaching in Your Sleep: Feminism and Psychoanalysis," in *The Future of an Illusion: Film, Feminism, and Psychoanalysis* (Minneapolis: University of Minnesota Press, 1989), 166.

2 Sometimes a teacher's assumption that such relationships are normal are so blatant as to be laughable. My intro painting teacher (in 1968), during a tutorial in his office, asked me how old I was, and when he discovered that I was under the age of consent so that, I suppose, he would be subject to the Mann Act if he took me over state lines, he shook his head, chucked me under the chin, and chuckled that I was "too young." Too young for what?

3 Penley, *Future,* 174.

4 Martin Buber, "The Malcontent," in *Tales of the Hasidim: The Later Masters* (New York: Schocken Books, 1948), 303.

5 Penley, *Future,* 174.

6 Many students were aware of the workings of power that made this coexistence possible: all of these people had been hired by Paul Brach, the Dean of the Art School, who by making no bones of his disagreement with most of them yet encouraging their difference, taught an important lesson in the *proper*ties of authority.

7 Jeremy Shapiro, 1972–73. This deftly underscored the recognition that he did have knowledge, and yet gave the students temporary command.

8 Recently two words intrude into my classrooms, where the institutions I work for impose physical and pedagogic limitations: *"Giant Meatball."* I remember that a class at CalArts baked as giant a meatball as could fit in an oven, had a party, and ate it. I tried to track down that giant meatball. I thought this might have happened in a class given by Emmett Williams, a Fluxus artist and poet, so I looked up "Food" in the elaborately cross-referenced index of the *Fluxus Codex* (Jon Hendricks, *Fluxus Codex* [New York: Harry N. Abrams, 1988]). I found a list including "fish jello," "liquid white glue eggs," and, almost what I was searching for, "giant bread filled with sawdust," (141). There was the "giant," now where was the meatball? I finally found one on the elegant frontispiece of *The Mythological Travels of a modern Sir John Mandeville, being an account of the Magic, Meatballs and other Monkey Business Peculiar to the Sojourn of Daniel Spoerri upon the Isle of Symi, together with divers speculations thereon* (Daniel Spoerri, "New York City, by the Park-

ing Lot of the Chelsea Hotel," [Something Else Press, 1970]). "For lunch I made *dolmates,* which in Symi are also called *yaprakia,* a variation of *keftedes* (in Symiotic, *pitaridia*), and are meatballs wrapped in grape leaves" (200–1). The recipe follows.

Bonnard's Ants

1 Peter Halley, "Notes on Abstraction," *Arts* (summer 1987): 35; emphasis added.
2 Jean Baudrillard, "The Precession of Simulacra," in *Art After Modernism: Rethinking Representation,* ed. Brian Wallis (New York: New Museum of Contemporary Art; Boston: David R. Godine, 1984), 256.
3 Jack Tworkov quoted by Richard Armstrong in his significantly titled catalogue essay "Jack Tworkov's Faith in Painting," in *Jack Tworkov: Paintings, 1928–1982* (Seattle and London: Pennsylvania Academy of Fine Arts in association with University of Washington Press, 1987), 28.
4 Tworkov, "By Jack Tworkov," in *Jack Tworkov: Paintings, 1928–1982,* 145.
5 Alberto Giacometti quoted in Charles Juliet, *Giacometti* (New York: University Books, 1986), 63.
6 *Art in America* 60, no. 3 (May–June 1972): 36.

Figure/Ground

1 Klaus Theweleit, *Male Fantasies,* vol. 2, *Male Bodies: Psychoanalyzing the White Terror,* trans. Erica Carter and Chris Turner (Minneapolis: University of Minnesota Press, 1989), 418.
2 Benjamin H. D. Buchloh, "Figures of Authority, Ciphers of Regression," *October* 16 (spring 1981): 59.
3 Brian O'Doherty, *Inside the White Cube: The Ideology of the Gallery Space* (Santa Monica, Calif.: Lapis Press, 1986), 20.
4 Ibid., 36.
5 Ibid., 69.
6 Ibid., 42.
7 Ibid., 73.
8 Ibid., 76.
9 That *scopophilia,* the love of looking, sounds like a psychological disorder (along with *necro-* and *pedo-*) seems related to its ubiquity in recent critical texts.
10 Buchloh, "Figures of Authority," 42.
11 Benjamin H. D. Buchloh, *Gerhard Richter: Abstract Paintings* (Eindhoven: Van Abbemuseum, and London: Whitechapel Art Gallery, 1978), 20.
12 Benjamin Buchloh, "Interview with Gerhard Richter," trans. Stephen P. Duffy, in Roald Nasgaard, *Gerhard Richter Paintings,* ed. Terry A. Neff (London and New York: Thames and Hudson, 1988), 21, 24, 26, 28, 29.
13 Douglas Crimp, "The End of Painting," *October* 16 (spring 1981): 77.
14 Benjamin H. D. Buchloh, "The Primary Colors for the Second Time," *October* 37 (summer 1986): 51.

15 The epigraph to "Figures of Authority, Ciphers of Regression" is a quote from the *Prison Notebooks* of Antonio Gramsci: "The crisis consists precisely in the fact that the old is dying and the new cannot be born; in this interregnum a great variety of morbid symptoms appears."

16 Marcel Duchamp, *The Writings of Marcel Duchamp*, ed. Michael Sanouillet and Elmer Peterson (New York: Da Capo Press, 1989), 130. A republication of *Salt Seller: The Writings of Marcel Duchamp* (Oxford: Oxford University Press, 1973).

17 Theweleit, *Male Fantasies*, vol. 2, 213.

18 Klaus Theweleit, *Male Fantasies*, vol. 1, *Women, Floods, Bodies, History*, trans. Stephen Conway (Minneapolis: University of Minnesota Press), 385–409.

19 Theweleit, *Male Fantasies*, vol. 2, 274.

20 Ibid., 35.

21 Ibid., 37.

22 Buchloh, "Primary Colors," 48.

23 *Annette Lemieux*, March 18–April 15, 1989, Josh Baer Gallery, New York.

24 Jeanne Siegel, "Annette Lemieux: It's a Wonderful Life, or Is It?" *Arts Magazine* (January 1987): 78.

25 Robert Pincus-Witten, "Alien Nature or Art once esoteric and banal or Painting as mise-en-scène or WITHOUT MOVING YOUR LIPS, possible titles for an essay on Annette Lemieux," in *Annette Lemieux* (New York: Josh Baer Gallery, 1989).

26 Benjamin H. D. Buchloh, "A Note on Gerhard Richter's *October 18, 1977*," *October* 48 (spring 1989): 103.

27 Luce Irigaray, *Speculum of the Other Woman* (Ithaca: Cornell University Press, 1985), 83.

28 Ibid., 140.

29 Ibid., 135.

30 Walter Benjamin, *Illuminations* (New York: Schocken Books, 1969), 94.

31 Ibid., 87.

32 Ibid., 91.

33 Buchloh, "Interview with Gerhard Richter," 20.

Buchloh: But if one looks at your iconography in the 1960s, I find it difficult to construct a continuous death thematic. . . . It seems to me completely absurd to want to construct a traditional iconography in your painting.

Richter: Perhaps it's just a little exaggerated to speak of a death thematic here. But I do think that the pictures have something to do with death, with pain.

34 Buchloh, "Figures of Authority," 59; also, Richter and Buchloh agree on this usage in the interview quoted above, p. 20.

Researching Visual Pleasure

1 Barnett Newman, as quoted in Yve-Alain Bois, *Painting as Model* (Cambridge, Mass.: MIT Press, an *October* Book, 1990), 190.

2 Yve-Alain Bois, *Painting as Model,* 192.

3 Ibid., 193.

4 Ibid.

5 Ibid., xi.

6 Ibid., 242.

7 Ibid., 162.

8 Ibid., emphasis added.

9 Ibid., 201.

10 Bois first speaks of Newman's "failure," in his discussion of paintings done the year after *Onement I,* such as *Dionysius* (1949), in which Newman can be seen trying "to find a shortcut to liberate himself from the 'plea' of bilateral symmetry." Bois continues, "(In a sense, however, it is absurd to speak of a 'failure' here: not only is the 'failure' entirely relative, but Newman's attempt was both logical and necessary—for what it foreclosed and what it opened in the future of his art. For the sake of brevity, though, let us keep the word 'failure,' but between quotation marks.)" (196). Later, in his analysis of another Barnett Newman painting, from 1949: "Unfortunately, although *Concord* is probably one of his most seductive canvases (and maybe partly because of that, as Newman was always opposed to hedonism), I would say that he 'failed' (note again the quotation marks)." (201).

11 Piet Mondrian, as quoted in Naum Gabo, "Reminiscences of Mondrian," *Studio International* 172 (Dec. 1966): 292, in Bois, *Painting as Model,* 168–69; 304, n. 31.

12 Gabo, as quoted by Bois, 169.

13 Yve-Alain Bois, "The Limit of Almost," *Ad Reinhardt,* exhibition catalogue (Los Angeles: Museum of Contemporary Art; New York: Museum of Modern Art, 1990), 28.

14 Barnett Newman, *Barnett Newman: Selected Writings and Interviews* (New York: Alfred A. Knopf, 1990), 175.

15 Ibid.

16 Ibid., 249.

17 Ibid., 257.

18 Ibid., 89.

19 Ibid., 173.

20 Ibid., 187.

21 Ibid., 95.

22 Ibid., 101–2.

23 Svetlana Alpers, *The Art of Describing: Dutch Art in the Seventeenth Century* (Chicago: University of Chicago Press, 1983), xx.

24 Michelangelo, as quoted in Svetlana Alpers, *The Art of Describing,* xxiii, and again, 223.

25 Alpers, 78.

26 Ibid., 27.

27 Ibid., 95.

28 Ibid., 76.

29 Ibid., 83, 36.

30 Ibid., 116.
31 Ibid., 85.
32 Ibid., 225.
33 Ibid.
34 Ibid., 227.

The Erotics of Visuality

This essay was delivered as part of a panel talk on 6 May 1992 at the Great Hall of the Cooper Union. The panel was moderated by Lenore Malen, and its participants included Peter Schjeldahl, Leon Golub, Candida Alvarez, Brice Marden, Eleonor Heartney, and myself.

1 Benjamin H. D. Buchloh, "Figures of Authority, Ciphers of Regression," *October* 16 (spring 1981): 59.
2 Mary Kelly, quoted in Griselda Pollock, *Vision & Difference: Femininity, Feminism, and the Histories of Art* (New York: Routledge, 1988), 198.
3 Peter Schjeldahl, "On Cindy Sherman," *7 Days*, 26 March 1990; reprinted in *Village Voice*, 10 April 1990.
4 Judith Levine, *My Enemy, My Love: Man-Hating and Ambivalence in Women's Lives* (New York: Doubleday, 1992), quoted in Eunice Lipton, "Justify my Hate . . . ," *Women's Review of Books* 9, no. 8 (May 1992): 16.

Course Proposal

All painting descriptions found in this essay are based on notes taken in the presence of the actual artworks or from memory of more than a single viewing — not from reproductions.

1 Lari Pittman, wall statement accompanying the paintings at the Whitney Museum of American Art's 1993 Biennial.
2 Keith Hernandez and Mike Bryan, *If At First: A Season with the Mets* (New York: McGraw-Hill, 1986), 55: "After every one of the thousand of pitches he threw to me as a kid, he told me where it was, if there was any question at all. Outside, Keith. On the corner, too close to take with two strikes. On the corner but low. Just high. The importance of the strike zone was drilled into me. *Drilled in.*"

Painting as Manual

I am grateful to David Humphrey for his articulate comments about the relationship between painting and computer graphic technologies, for demonstrating what seemed like magic tricks to me on his computer, and for generously letting me see some of his computer-related paintings in progress. I would like to thank ten-year-old Emma Bernstein for showing me how she uses a computer painting program. And, finally, I would like to thank the young artists at the Skowhegan School of Painting and Sculpture in the summer of 1995 for pro-

viding me with a living laboratory in which to test some of the ideas expressed in this essay.

1 Maria-Elena Sanchez, summer 1995.

2 "Bob Ross, 52, Dies; Was Painter on TV," obituary, *New York Times*, 13 July 1995, B11.

3 Salvador Dali, *Dali: 50 Secrets of Magic Craftsmanship* (New York: Dial Press, 1948), 14.

4 Ibid., 101.

5 David Humphrey, interview with Elaine A. King, in Elaine A. King, *David Humphrey: Paintings and Drawings 1987–1994* (Cincinnati: Contemporary Arts Center, 1995), 11.

6 J & R Computer World, *Multimedia and CD-ROM Spring/Summer 1995 Product Guide*, 20.

7 That gendered biases are built into the corporate structure of software design and the personal subculture of computer programmers is one of the premises of Allucquère Rosanne Stone's *The War of Desire and Technology at the Close of the Mechanical Age* (Cambridge, Mass.: MIT Press, 1995), cf., for example, 158–62.

8 "Cyberscope: Teaching Young Eyes to See," *Newsweek*, 26 June 1995, 8. This is a review of Voyager's "With Open Eyes" CD-ROM, which "presents 212 objects from the Art Institute of Chicago's collection in a clever framelike graphical interface, and lets children examine and have fun with art through various activities."

9 This hope was suggested to me during a telephone conversation about this question with Susan Bee: she interrupted herself to admonish her three-year-old son, Felix: "Don't do that!" What was he doing? Sticking a magic marker in his nose. Why? "Because I want to smell it." A few months later, he is already making a beeline for her computer, but at least some tropism for manipulating old-fashioned drawing tools has been established.

10 Dierdre Boden and Harvey L. Molotch, "The Compulsion of Proximity," in *NowHere: Space, Time, and Modernity*, ed. Roger Friedland and Dierdre Boden (Berkeley: University of California Press, 1995), 259.

11 Ibid., 276.

12 Alan Riding, "Politics, This Is Art. Art, This Is Politics," *New York Times*, Thursday, 10 August 1995, C11, C15.

13 Ibid., C11.

14 Ibid., C15.

15 Michael Dorman, "In Place of Prisoners, Reflections on Confinement," *New York Times*, Sunday, 13 August 1995, Arts and Leisure section, 29.

16 Janice Steinberg, *Death of a Postmodernist* (New York: Berkley Prime Crime, 1995).

17 Often, verbal descriptions of such works contain most of their interest, transmitting as they do the conceptual impact of their subjects and materials. It's like radio: the description works best in your mind's eye while in actuality such works often offer a somewhat shallow viewing experience, although they are usually impeccably produced. Cf., for example: "By the early 1990's, for ex-

ample, Mr. [Damien] Hirst had floated a dead 14-foot shark in a tank of formaldehyde; Marc Quinn had made a portrait bust of himself in frozen blood (his own); and Rachel Whiteread had cast the room of a Victorian house in plaster, titling it 'Ghost, . . .'" Quoted from Roberta Smith, "Some British Moderns Seeking to Shock," *New York Times*, 23 November 1995, C11.

18 Cennino d'Andrea Cennini, *The Craftsman's Handbook* (New York: Dover, 1960), 19.

19 Ibid., 13.

20 Ibid., 64.

21 Ibid., 74.

22 Ibid., 71.

23 Ibid., 21.

24 Teresa Brennan, *History after Lacan,* (London and New York: Routledge, 1993), 18.

25 Cennini, *Craftsman's Handbook,* 13.

26 Clement Greenberg, "Modernist Painting," in *Clement Greenberg: The Collected Essays and Criticism,* vol. 4, in *Modernism with a Vengeance 1957–1969,* ed. John O'Brian (Chicago and London: University of Chicago Press, 1993), 87.

27 Introductory comments by John O'Brian, moderator of "Greenberg Reconsidered," a panel discussion held at the Whitney Museum of American Art, 2 May 1995, which also included statements by Yve-Alain Bois, Peter Plagens, Caroline Jones, and Irving Sandler.

28 Greenberg, *Modernism,* 88.

29 Ibid., 86.

You Can't Leave Home without It

1 An exhibition catalogue for a show of work by Cabrita Reis is, in fact, entitled *Melancolia* (New York: Bess Cutler Gallery, 1989).

2 Vito Acconci, quoted in Max Kozloff, "Pygmalion Reversed," *ArtForum* 14, no. 3 (November 1975): 35.

3 Kate Linker, "Vito Acconci's Address to the Viewer Or, How Do I Work This Chair?" in *Vito Acconci: The House and Furnishings as Social Metaphor,* exhibition catalogue (Tampa: University of South Florida, USF Art Galleries, 1986), 6.

4 Vito Acconci, "Home-Bodies (An Introduction to My Work, 1984–1985)," in *Vito Acconci: The House and Furnishings as Social Metaphor,* exhibition catalogue (Tampa: University of South Florida, USF Art Galleries, 1986), 8.

5 Luce Irigaray, *Speculum of the Other Woman* (Ithaca: Cornell University Press, 1985), 168–79.

6 The rec room—for recreation—can also be read as a *wreck* room.

7 Daniela Salvioni, "Cady Noland: The Homespun Violence of the Hearth," *Flash Art,* no. 148 (October 1989): 129.

8 Jeanne Siegel, "The American Trip: Cady Noland's Investigations," *Arts* 64 no. 4 (December 1989): 45.

9 John Perreault, *Bedrooms,* exhibition pamphlet (New York: Newhouse Center for Contemporary Art, Snug Harbor Cultural Center, Staten Island, 1991), n.p.

10 Brian O'Doherty, *Inside the White Cube: The Ideology of the Gallery Space* (Santa Monica, Calif.: Lapis Press, 1986), 80.

11 Virginia Woolf, *A Room of One's Own* (New York: Harcourt, Brace and World, 1957), 91.

12 Although, in another double standard, if a Third World artist embraces kitsch and color in a similar manner, it's now considered OK.

13 Ilya Kabakov, *Ten Characters,* exhibition catalogue (London: Institute of Contemporary Arts, 1989), 35. Kabakov writes about "The Person Who Describes His Life Through Characters": "Most of all, though, the 'albums' are like a type of 'domestic theater,' not contemporary theater where the action takes place in darkness in order to hold more strongly the viewer's attention and envelop him in what is happening on stage, but more like old theatre conducted in a town square in broad daylight where the viewer is free to promenade physically and mentally in evaluating the action."

14 Bertolt Brecht, quoted in Susan Buck-Morss, *The Origin of Negative Dialectics: Theodor W. Adorno, Walter Benjamin, and the Frankfurt School* (New York: Free Press, 1977), 149.

15 Significantly, the prize Benjamin won was Balzac's *La Peau de chagrin,* a novel that links an antiquarian's treasure with desire, fulfillment, suicide, and death.

16 For a more complete analysis of the role of cabalistic tradition in Benjamin's thought, see Susan Buck-Morss, "Is This Philosophy?" in *The Dialectics of Seeing: Walter Benjamin and the Arcades Project* (Cambridge, Mass.: MIT Press, 1989), 216–52.

17 Walter Benjamin, "One-Way Street," in *Reflections: Essays, Aphorisms, Autobiographical Writings,* trans. Edward Jephcott (New York: Schocken Books, 1986), 68.

Afterword: Painting and Language/Painting Language

1 "Medusa Redux: Ida Applebroog and the Spaces of Postmodernity." That this was the cover feature of the March 1990 *ArtForum* issue is entirely a tribute to Applebroog's work and to *ArtForum* editor Ida Panicelli's wisdom, but I was honored to participate.

2 Barnett Newman, *Barnett Newman: Selected Writings and Interviews,* ed. John P. O'Neill (New York: Alfred A. Knopf, 1990), 160.

3 In her introduction and introductory chapter notes to *The Collected Writings of Robert Motherwell* (New York and Oxford: Oxford University Press, 1992), Stephanie Terenzio stresses Motherwell's ambivalence about his role as a spokesperson for abstract expressionism: "That Motherwell's writings have not been collected earlier may be surprising to some readers, given the influence he exerted on his times and his importance among theorists of abstract art. Ironically, it is the artist himself who resisted such a book. Over the years, he often told me that he would have been better off if he had not written a single word

about art, and considered it (in a characteristic hyperbole to ensure emphasis) the *tragedy* of his life that he had written as much as he did. This, I think, is because the broad cultural dimension he brought to his early essays and editorial work caused him painful alienation from many fellow artists in bohemian Manhattan, a milieu that in general was critical of an artist with intellectual or extra-painterly pursuits. The attitude was characterized in a comment later related to him by a colleague about his appearance on the New York art scene in the early 1940s: 'We artists were getting along just fine until Motherwell came along with a sense of history' " (vi); "It was an extraordinary convergence of elements and events that led Robert Motherwell to his life's work. What he achieved in his painting—and, consequently, in his writing, editing, lecturing, and teaching—was lastingly fired by a decision that was as much the result of circumstance and chance as of talent and choice. Why he soon after also chose to write and otherwise express himself publicly—or, more precisely, why he acceded to a role thrust on him—is bound up with that moment when he accepted his destiny as a painter" (3–4). Finally, Motherwell's ambivalence is revealed through disparate comments by the artist himself: "Yet I do not regret my innocence in supposing that an artist might be something of a scholar and a gentleman" (8), can be contrasted with, "I have written hundreds of thousands of words during my life, though I loathe the act of writing, its lack of physicality and sensuality . . ." (12).

4 "The job with *Arts* provided most of my money until the last year. I wrote criticism as a mercenary and would never have written it otherwise." Quoted from Don Judd, "Introduction," in *Donald Judd: Complete Writings 1959–1975* (Halifax, Nova Scotia: The Press of the Nova Scotia College of Art and Design; New York: New York University Press, 1975), vii.

5 "Because he had few if any defenders during most of his career as an artist (younger critics did not begin writing favorably about him until the sixties), Reinhardt was forced to become his own polemicist, explicating and defending an aesthetic only recently beginning to be understood. . . . Because he was isolated and misunderstood, Reinhardt's writing is devoted to explaining his own point of view and the way in which on one hand it continued the purist tradition, while on the other hand rejecting the tenets of geometric art to explore new possibilities of form and function." Quoted from Barbara Rose, "Introduction," in Ad Reinhardt, *Art as Art: The Selected Writings of Ad Reinhardt* (Berkeley and Los Angeles: University of California Press, 1991), xii.

6 "We know Newman best as the artist-painter, but there were moments in his career when writing may have been his more rewarding activity, particularly during the early and mid-1940s. At that time he produced a number of intense speculative essays, while his painting, however searching and innovative, seemed inadequate to him. Newman was always an effective writer. His striking verbal refinement and concise manner recall the manner of his painting." Quoted from Richard Schiff, "Introduction," in *Barnett Newman: Selected Writings and Interviews*, xiii. The importance of writing for Piet Mondrian is stressed by his friend Harry Holtzman: "The increasing complexity of each painting demanded great concentration of time and energy, but he never ceased making

notes for further essays." Quoted from Harry Holtzman, "Piet Mondrian: The Man and His Work," in Piet Mondrian, *The New Art—The New Life: The Collected Writings of Piet Mondrian,* ed. and trans. Harry Holtzman and Martin S. James (New York: Da Capo Press, 1993), 2. Mondrian explains the vital role of writing to the creative (visual) practice:

"For *consciousness* in art is another new contemporary characteristic: the artist is no longer a blind fool of intuition. *Natural feeling* no longer dominates the work of art, which expresses *spiritual feeling*—that is, *reason-and-feeling in one.* This spiritual feeling is inherently accessible to understanding, which explains why it is self-evident that, besides the action of emotion, the action of intellect becomes prominent in the artist.

"Thus the contemporary artist has to work in a double field; or rather, the field of activity, which was formerly vague and diffuse, is now becoming clearly determinate. Although the work of art grows spontaneously, as if *outside him,* the artist has to cultivate the field—before and after growth. . . . Clarification demands strenuous effort, but at the same time it furthers one's own development. Explaining means that one has reached clarity along the path of feeling and intellect by working and thinking about what has been achieved. Explaining means gaining consciousness, even through clashing thoughts—through conflict. Thus *explanation* about plastic expression indirectly makes it more profound and more precise." Quoted from Piet Mondrian, "The Rationality of the New Plastic," in *The New Art,* 40–41.

7 Cf. note 2, above, as to the New York art world's feelings about Motherwell. Similarly: "[Thomas] Hess observed that Newman's colleagues distrusted him as a painter because of his reputation as an intellectual and a writer; his works could be dismissed as some kind of extreme demonstration of a theory. Newman the writer had often been asked to speak on behalf of other painters and their interests, yet the very fact of his capacity to verbalize discredited his visualizing." Richard Schiff, "Introduction," xxv; cf. note 16, p. xxviii.

8 Cf. Barnett Newman, "For Impassioned Criticism," in *Selected Writings,* 131: "I suppose it is as presumptuous for a painter to tell art critics what criticism is or what kind of criticism they ought to write as it is for a critic to tell a painter what painting is and what to paint. However, the inherent natures of the two activities are such that the painter can be excused. When a painter talks about art criticism or about critics, he becomes at that moment, by that act alone, ipso facto, a critic. . . . The converse, however, is not true. No matter how much the critic may persevere in telling artists what painting is, what and how the painter should paint, the critic never becomes a painter. He is always the outsider. This is because the painter and the critic are involved in doing two irreconcilable things.

"Since I am emulating Baudelaire, I suppose I have the artist's advantage and should feel exultant. Yet I do not relish this new role of critic."

9 Naomi Schor, *Bad Objects: Essays Popular and Unpopular* (Durham and London: Duke University Press, 1995), "Preface," ix–xx, and "Théme et Version," 63–70.

Bibliography

Abject Art: Repulsion and Desire in American Art. Exhibition catalogue. New York: Whitney Museum of American Art, 1993.

Vito Acconci. Ed. Judith Russi Kirschner. Chicago: Museum of Contemporary Art, 1980.

Acconci, Vito. "Home-Bodies." In *Vito Acconci: The House and Furnishings as Social Metaphor*. Exhibition catalogue. Tampa: University of South Florida, USF Art Galleries, 1986.

Vito Acconci: Poetry, Activities, Sculpture, Performances, Installations, Video. Compiled by W. M. H. Kaiser. Amsterdam, 1977.

Alloway, Lawrence, and Max Kozloff, Rosalind Krauss, Joseph Masheck, Annette Michelson. "To the Editor." *ArtForum* 13, no. 4 (December 1974): 9.

Alpers, Svetlana. *The Art of Describing: Dutch Art in the Seventeenth Century*. Chicago: University of Chicago Press, 1983.

Ida Applebroog. Exhibition catalogue. Derry, Northern Ireland: Orchard Gallery, 1993.

Ida Applebroog. Exhibition catalogue. Ulm, Bonn, and Berlin, Germany: Ulmer Museum, Bonner Kunstverein, and Realismus Studio de Neuen Gasellschaft fur Bildende Kunst, 1991.

Ida Applebroog. Exhibition catalogue. New York: Ronald Feldman Fine Arts, 1987.

Ida Applebroog: Nostrums, Belladonna. Exhibition catalogue. New York: Ronald Feldman Fine Arts, 1989.

Armstrong, Richard. "Jack Tworkov's Faith in Painting." In *Jack Tworkov: Paintings, 1928–1982*, 17–30. Seattle and London: Pennsylvania Academy of Fine Arts in association with University of Washington Press, 1987.

Art in America Annual Guide to Museums Galleries Artists 1990–1991. Art in America 78, no. 8 (August 1990).

Art in America Annual Guide to Museums Galleries Artists 1995–1996. Art in America 83, no. 8 (August 1995).

Bad Girls. Exhibition catalogue. New York: New Museum of Contemporary Art; Cambridge, Mass.: MIT Press, 1994.

Battersby, Christine. "Just Jamming: Irigaray, painting and psychoanalysis." In *New Feminist Art Criticism: Critical Strategies,* ed. Katy Deepwell, 128–37. Manchester and New York: Manchester University Press, 1995.

Baudrillard, Jean. "The Precession of Simulacra." In *Art After Modernism: Rethinking Representation,* ed. Brian Wallis, 253–81. New York: New Museum of Contemporary Art; Boston: David R. Godine, 1984.

Benjamin, Walter. "One-Way Street." In *Reflections: Essays, Aphorisms, Autobiographical Writings,* trans. Edward Jephcott. New York: Schocken Books, 1986.

———. "The Storyteller." In *Illuminations,* 83–109. New York: Schocken Books, 1969.

———. "The Work of Art in the Age of Mechanical Reproduction." In *Illuminations,* 217–52. New York: Schocken Books, 1969.

Berger, John. "Rodin and Sexual Domination." In *About Looking,* 177–81. New York: Pantheon Books, 1980.

———. *The Sense of Sight.* New York: Pantheon Books, 1985.

———. *Ways of Seeing.* London: BBC and Penguin Books, 1972.

Bernheimer, Charles. "Penile Reference in Phallic Theory." *differences* 4, no. 1 (spring 1992): 116–32.

Bernstein, Charles. "I don't take voice mail." *M/E/A/N/I/N/G,* no. 16 (November 1994): 55–61.

Blistène, Richard. "Francis Picabia: In praise of the contemptible." *Flash Art,* no. 113 (summer 1983): 24–31.

Boden, Dierdre, and Harvey L. Molotch. "The Compulsion of Proximity." In *No-wHere: Space, Time, and Modernity,* ed. Roger Friedland and Dierdre Boden, 257–86. Berkeley: University of California Press, 1995.

Bois, Yve-Alain. "The Limit of Almost." In *Ad Reinhardt,* 11–33. Exhibition Catalogue. Los Angeles: Museum of Contemporary Art; New York: Museum of Modern Art, 1991.

———. *Painting as Model.* Cambridge, Mass., and London: MIT Press, an *October* Book, 1990.

Brennan, Teresa. *History After Lacan.* London and New York: Routledge, 1993.

Broude, Norma, and Mary D. Garrard, eds. *The Power of Feminist Art: The American Movement of the 1970s, History and Impact.* New York: Harry N. Abrams, 1994.

Bryson, Norman. *Looking at the Overlooked: Four Essays on Still Life Painting.* Cambridge, Mass.: Harvard University Press, 1990.

Buber, Martin. "The Malcontent." In *Tales of the Hasidim: The Later Masters,* 303. New York: Schocken Books, 1948.

Buchloh, Benjamin H. D. "Figures of Authority, Ciphers of Regression." *October* 16 (spring 1981): 39–68.

————. *Gerhard Richter: Abstract Paintings.* Eindhoven: Van Abbemuseum; London: Whitechapel Art Gallery, 1978.

————. "Interview with Gerhard Richter," trans. Stephen P. Duffy. In Roald Nasgaard, *Gerhard Richter Paintings,* ed. Terry A. Neff, 15–30. London and New York: Thames and Hudson, 1988.

————. "A Note on Gerhard Richter's *October 18, 1977.*" *October* 48 (spring 1989): 88–109.

————. "The Primary Colors for the Second Time: A Paradigm Repetition of the Neo-Avant-Garde." *October* 37 (summer 1986): 41–52.

Buck-Morss, Susan. *The Dialectics of Seeing: Walter Benjamin and the Arcades Project.* Cambridge, Mass.: MIT Press, 1989.

————. *The Origin of Negative Dialectics: Theodor W. Adorno, Walter Benjamin, and the Frankfurt School.* New York: Free Press, 1977.

Burgin, Victor. "Tea With Madeleine." *Wedge,* no. 6 (winter 1984): 40–47.

Burke, Carolyn, Naomi Schor, and Margaret Whitford, eds. *Engaging with Irigaray: Feminist Philosophy and Modern European Thought.* New York: Columbia University Press, 1994.

Butler, Judith. *Gender Trouble: Feminism and the Subversion of Identity.* New York: Routledge, 1990.

Cameron, Dan. "Reverse Backlash: Sue Williams' Black Comedy of Manners." *ArtForum* 31, no. 3 (November 1992): 70–73.

Carter, Angela. *The Sadeian Woman and the Ideology of Pornography.* New York: Pantheon Books, 1978.

Caught Looking: Feminism, Pornography & Censorship. Ed. f.a.c.t. book committee, Kate Ellis, Nan D. Hunter, Beth Jaker, Barbara O'Dair, Abby Talmer. New York: Caught Looking, Inc., 1986.

Cennini, Cennino d'Andrea. *The Craftsman's Handbook.* New York: Dover, 1960.

Chadwick, Whitney. *Women, Art, and Society.* New York: Thames and Hudson, 1990.

————. *Women Artists and the Surrealist Movement.* Boston: Little, Brown, a New York Graphic Society Book; London: Thames and Hudson, 1985.

Chave, Anna C. "Minimalism and the Rhetoric of Power." *Arts Magazine* 64, no. 5 (January 1990): 44–63.

Chicago, Judy. *The Dinner Party: A Symbol of Our Heritage.* New York: Anchor Press, 1979.

Cixous, Hélène, and Catherine Clément. *The Newly Born Woman.* Minneapolis: University of Minnesota Press, 1986.

Clark, Kenneth. *The Nude: A Study in Ideal Form.* New York: Doubleday Anchor Books, 1956.

Collins, Tricia, and Richard Milazzo. *Pre/Pop Post/Appropriation.* Exhibition catalogue. New York: Stux Gallery, 1989.

Maureen Connor: Discreet Objects. Exhibition catalogue. Essays by Amelia Jones and Andrew Perchuk. New York: Alternative Museum, 1994.

Cottingham, Laura. "Janine Antoni: Biting Sums Up My Relationship to Art History." *Flash Art,* no. 171 (summer 1993): 104–5.

Crimp, Douglas. "The End of Painting." *October* 16 (spring 1981): 69–86.

Dali, Salvador. *Dali: 50 Secrets of Magic Craftsmanship.* New York: Dial Press, 1948.

Danto, Arthur. "Robert Mapplethorpe." *Nation,* 26 September 1988, 246–50.

de Beauvoir, Simone. *The Second Sex.* Trans. H. M. Parshley. New York: Bantam Books, 1961.

Deepwell, Katy. "Introduction: Feminist art criticism in a new context." In *New Feminist Art Criticism: Critical Strategies,* ed. Katy Deepwell, 1–12. Manchester and New York: Manchester University Press, 1995.

Deepwell, Katy, ed. *New Feminist Art Criticism: Critical Strategies.* Manchester and New York: Manchester University Press, 1995.

de Lauretis, Teresa. "Desire in Narrative." In *Alice Doesn't: Feminism, Semiotics, Cinema,* 109–10. Bloomington: Indiana University Press, 1984.

———. "The Essence of the Triangle or, Taking the Risk of Essentialism Seriously: Feminist Theory in Italy, the U.S., and Britain." *differences* 1 (summer 1989): 3–37.

———. *Technologies of Gender: Essays on Theory, Film, and Fiction.* Bloomington: Indiana University Press, 1987.

Dickson, Jane. *Hey Honey Wanna Lift?* New York: Appearances Press, 1981.

Difference—On Representation and Sexuality. Exhibition catalogue. New York: New Museum of Contemporary Art, 1984.

Donahue, Carolyn/David Salle/Joan Wallace. "The Fallacy of Universals." *Effects—Semblance and Mediation,* no. 1 (summer 1983).

Dorman, Michael. "In Place of Prisoners, Reflections on Confinement." *New York Times,* Sunday, 13 August 1995, Arts and Leisure section, 28–29.

Drucker, Johanna. *The Alphabetic Labyrinth: The Letters in History and Imagination.* New York: Thames and Hudson, 1995.

———. "The Future of Writing." *M/E/A/N/I/N/G,* no. 16 (November 1994): 62–64.

———. "Visual Pleasure: A Feminist Perspective." *M/E/A/N/I/N/G,* no. 14 (May 1992): 3–11.

Duchamp, Marcel. *The Writings of Marcel Duchamp.* Ed. Michael Sanouillet and Elmer Peterson. New York: Da Capo Press, 1989. Republication of *Salt Seller: The Writings of Marcel Duchamp.* Oxford: Oxford University Press, 1973.

Duncan, Carol. "The Esthetics of Power in Modern Erotic Art." *Heresies 1: Feminism, Art and Politics* (January 1977): 46–50.

———. "Virility and Domination in Early Twentieth-Century Vanguard Painting." In *Feminism and Art History: Questioning the Litany,* ed. Norma Broude and Mary D. Garrard, 292–313. New York: Harper and Row, 1982.

Echols, Alice. *Daring to Be Bad: Radical Feminism in America.* Minneapolis: University of Minnesota Press, 1989.

Elsen, Albert. *Rodin.* New York: MoMA, 1963.

Elwes, Catherine. "Floating Femininity: A Look at Performance Art by Women." In *Women's Images of Men,* ed. Sarah Kent and Jacqueline Morreau, 164–93. London: Writers and Readers Publishing, 1985.

Endgame—Reference and Simulation in Recent Painting and Sculpture. Exhibition catalogue. Boston: Institute of Contemporary Art; Cambridge, Mass.: MIT Press, 1986.

Fallowell, Duncan. "Gilbert and George Talked To/Written On." *Parkett*, no. 14 (1987): 24–29.

Faludi, Susan. *Backlash: The Undeclared War Against American Women*. New York: Anchor Books, 1991.

Felstiner, Mary Lowenthal. *To Paint Her Life: Charlotte Salomon in the Nazi Era*. New York: HarperCollins, 1994.

Feminist Art Program. *Anonymous Was a Woman: A Documentation of the Women's Art Festival; A Collection of Letters to Young Women Artists*. Valencia, Calif.: Feminist Art Program, California Institute of the Arts, 1974.

———. *Womanhouse*. Exhibition catalogue. Valencia, Calif.: Feminist Art Program, California Institute of the Arts, 1972.

Finley, Karen. "Karen Finley." In *Angry Women Re/Search #13*, ed. Andrea Juno and V. Vale, 41–49. San Francisco: Re/Search Publications, 1991.

"Flash Art News: Francis Picabia and David Salle." *Flash Art*, no. 115 (January 1984): 31.

Foster, Hal. *Recodings: Art, Spectacle, Cultural Politics*. Port Townsend, Wash.: Bay Press, 1985.

Foster, Hal, ed. *The Anti-Aesthetic*. Port Townsend, Wash.: Bay Press, 1983.

Frueh, Joanna, Cassandra L. Langer, and Arlene Raven, eds. *New Feminist Criticism: Art, Identity, Action*. New York: HarperCollins, IconEditions, 1994.

Fuss, Diana. *Essentially Speaking: Feminism, Nature & Difference*. New York: Routledge, 1989.

Gaither, Rowan. "A Sculptor's Gnawing Suspicions." *New York Magazine*, 9 March 1992, 24.

Gallop, Jane. *The Daughter's Seduction: Feminism and Psychoanalysis*. Ithaca: Cornell University Press, 1982.

———. *Thinking through the Body*. New York: Columbia University Press, 1988.

Gilbert, Sandra M., and Susan Gubar. *The Madwoman in the Attic: The Woman Writer and the Nineteenth-Century Literary Imagination*. New Haven: Yale University Press, 1979.

Glaser, Bruce. "Questions to Stella and Judd." In *Minimal Art—A Critical Anthology*, ed. Gregory Battcock, 148–64. New York: E. P. Dutton, 1968.

Greenberg, Clement. *Clement Greenberg: The Collected Essays and Criticism*. Vol. 1, *Perceptions and Judgements, 1939–1944*. Ed. John O'Brian. Chicago and London: University of Chicago Press, 1986.

———. *Clement Greenberg: The Collected Essays and Criticism*. Vol. 2, *Arrogant Purpose, 1945–1949*. Ed. John O'Brian. Chicago and London: University of Chicago Press, 1986.

———. *Clement Greenberg: The Collected Essays and Criticism*. Vol. 3, *Affirmations and Refusals, 1950–1956*. Ed. John O'Brian. Chicago and London: University of Chicago Press, 1993.

———. *Clement Greenberg: The Collected Essays and Criticism*. Vol. 4, *Modernism with a Vengeance, 1957–1969*. Ed. John O'Brian. Chicago and London: University of Chicago Press, 1993.

Grunfeld, Frederic. *Rodin*. New York: Henry Holt, 1987.

Guerrilla Girls. *The Banana Report—The Guerrilla Girls Review the Whitney.* Exhibition catalogue. New York: Guerrilla Girls, 1987.

———. *Confessions of the Guerrilla Girls.* New York: HarperCollins, 1995.

Guilbaut, Serge. *How New York Stole the Idea of Modern Art: Abstract Expressionism, Freedom, and the Cold War.* Trans. Arthur Goldhammer. Chicago: University of Chicago Press, 1983.

Guilbaut, Serge, ed. *Reconstructing Modernism: Art in New York, Paris, and Montréal 1945–1964.* Cambridge, Mass., and London: MIT Press, 1992.

Hagen, Charles. "Reviews: Rebecca Purdum." *ArtForum* 28, no. 5 (January 1990): 134.

Halley, Peter. "Notes on Abstraction." *Arts* 61, no. 10 (summer 1987): 35.

Harris, Ann Sutherland, and Linda Nochlin. *Women Artists: 1550–1950.* Exhibition catalogue, Los Angeles County Museum of Art. New York: Alfred A. Knopf, 1977.

Harris, Melissa. "Karen Finley at the Kitchen and Franklin Furnace." *ArtForum* 29, no. 1 (September 1990): 159–60.

Hart, Claudia. "Reviews: Louise Lawler." *Artscribe International,* no. 67 (January–February 1988): 70–71.

Hawthorn, Jeremy. *A Glossary of Contemporary Literary Theory.* London: Edward Arnold; New York: Routledge, Chapman and Hall, 1992.

Heartney, Eleanor. "How Wide Is the Gender Gap?" *Art News* 86, no. 6 (summer 1987): 139–45.

Hendricks, Jon. *Fluxus Codex.* New York: Harry N. Abrams, 1988.

Herrera, Hayden. *Frida: A Biography of Frida Kahlo.* New York: Harper and Row, 1983.

Hernandez, Keith, and Mike Bryan. *If at First: A Season with the Mets.* New York: McGraw-Hill, 1986.

Hess, Elizabeth. "The Women." *Village Voice,* 8 November 1994, 91, 93.

Hills, Patricia. *Alice Neel.* New York: Harry N. Abrams, 1983.

An International Survey of Recent Painting and Sculpture. Exhibition catalogue. New York: Museum of Modern Art, 1984.

Irigaray, Luce. *Speculum of the Other Woman.* Ithaca: Cornell University Press, 1985.

———. *Le Corps à corps avec la mère.* Montreal: Les Editions de la Pleine Lune, 1981.

Joelson, Suzanne, and Andrea Scott, guest eds. "The Question of Gender in Art." *Tema Celeste,* no. 37–38 (autumn 1992) and no. 39 (winter 1993).

Jones, Amelia. "Absence of body: the fantasy of representation." *M/E/A/N/I/N/G,* no. 9 (May 1991): 9–23.

———. " 'Post-feminism,'—a remasculinization of culture?" *M/E/A/N/I/N/G,* no. 7 (May 1990): 29–40.

———. "Postfeminism, Feminist Pleasures, and Embodied Theories of Art." In *New Feminist Criticism: Art, Identity, Action,* ed. Joanna Frueh, Cassandra L. Langer, and Arlene Raven, 18–41. New York: HarperCollins, 1994.

———. *Postmodernism and the En-gendering of Marcel Duchamp.* Cambridge: Cambridge University Press, 1994.

———. "Return of the feminist body." *M/E/A/N/I/N/G,* no. 14 (November 1993): 3–12.

Jones, Amelia, ed. *Sexual Politics: Judy Chicago's "Dinner Party" in Feminist Art History.*

Berkeley, Los Angeles, and London: University of California Press in associa-
tion with UCLA at the Armand Hammer Museum of Art and Cultural Center,
1996.

Judd, Donald. *Donald Judd: Complete Writings 1959–1975.* Halifax, Nova Scotia: The Press
of the Nova Scotia College of Art and Design; New York: New York University
Press, 1975.

Juliet, Charles. *Giacometti.* New York: University Books, 1986.

Kabakov, Ilya. *Ten Characters.* Exhibition catalogue. London: Institute of Contempo-
rary Art, 1989.

Kaplan, Janet. *Unexpected Journeys: The Art and Life of Remedios Varo.* New York: Abbe-
ville Press, 1988.

Kaprow, Alan. *Essays on the Blurring of Art and Life.* Berkeley and Los Angeles: Uni-
versity of California Press, 1996.

Kardon, Janet. *David Salle.* Exhibition catalogue. Philadelphia: Institute of Contem-
porary Art, University of Pennsylvania, 1986.

Katz, Robert. *Naked by the Window: The Fatal Marriage of Carl Andre and Ana Mendieta.*
New York: Atlantic Monthly Press, 1990.

Mary Kelly INTERIM. Exhibition catalogue. New York: New Museum of Contem-
porary Art, 1990.

Kelly, Mary. *Post-Partum Document.* London: Routledge and Kegan Paul, 1983.

Kent, Sarah. "The Erotic Male Nude." In *Women's Images of Men,* ed. Sarah Kent and
Jacqueline Morreau, 75–105. London: Writers and Readers Publishing, 1985.

———. "Looking Back." In *Women's Images of Men,* ed. Sarah Kent and Jacqueline
Morreau, 55–74. London: Writers and Readers Publishing, 1985.

Kent, Sarah, and Jacqueline Morreau, eds. *Women's Images of Men.* London: Writers
and Readers Publishing, 1985.

Keuls, Eva C. *The Reign of the Phallus: Sexual Politics in Ancient Athens.* New York: Harper
and Row, 1985.

King, Elaine A. *David Humphrey: Paintings and Drawings 1987–1994.* Cincinnati: Con-
temporary Arts Center, 1995.

Kozloff, Joyce. "From the Other Side: Public Artists on Public Art." *Art Journal* 48,
no. 4 (winter 1989): 339.

———. *Patterns of Desire.* Introduction by Linda Nochlin. New York: Hudson Hills
Press, 1990.

Kozloff, Max. "Pygmalion Reversed." *ArtForum* 14, no. 3 (November 1975): 30–37.

Kristeva, Julia. *Powers of Horror: An Essay on Abjection.* New York: Columbia Univer-
sity Press, 1982.

Krüger, Michael. *David Salle.* Trans. Martin Scutt. Hamburg: Ascan Crone, 1983.

Kuspit, Donald. "Dorothea Tanning's Occult Drawings." *Art Criticism* 3, no. 2 (1987):
43–48.

———. "Reviews: Robert Morris." *ArtForum* 28, no. 1 (September 1989): 140.

———. "Reviews: David Salle." *Art in America* 20, no. 2 (summer 1982): 142.

Lawson, Thomas. "Last Exit: Painting." *ArtForum* 19, no. 1 (October 1981): 40–47.

———. "Reviews." *ArtForum* 19, no. 9 (May 1981): 71–72.

Lehman, Peter. "Penis-Sized Jokes and Their Relation to Hollywood's Unconscious." In *Running Scared: Masculinity and the Representation of the Male Body*, 105–29. Philadelphia: Temple University Press, 1993.

Lerner, Gerda. *The Creation of Patriarchy*. New York: Oxford University Press, 1986.

Levin, Kim. "The Masterpiece Mentality." *Village Voice*, 1 June 1993, 84.

Levine, Judith. *My Enemy, My Love: Man-Hating and Ambivalence in Women's Lives*. New York: Doubleday, 1992.

Levine, Sherrie. "David Salle." *Flash Art*, no. 103 (summer 1981): 34.

Linker, Kate. "Vito's Acconci's Address to the Viewer Or, How Do I Work This Chair?" In *Vito Acconci: The House and Furnishings as Social Metaphor*, exhibition catalogue. Tampa: University of South Florida, USF Art Galleries, 1986.

Lippard, Lucy R. *From the Center: Feminist Essays on Women's Art*. New York: E. P. Dutton, 1976.

———. *Overlay: Contemporary Art and the Art of Prehistory*. New York: Pantheon Books, 1983.

———. *The Pink Glass Swan: Selected Feminist Essays on Art*. New York: The New Press, 1995.

Lipton, Eunice. "Justify My Hate . . ." *Women's Review of Books* 9, no. 8 (May 1992): 16.

Lublin, Lea. "Painters' Wee Wees or the Confoundations of Painting." *Wedge*, no. 6 (winter 1984): 30–35.

Lynden, Patricia. "The Art of Protest." *New York Woman* (September 1987): 11.

Lyons, Christopher. "Kiki Smith: Body and Soul." *ArtForum* 28, no. 6 (February 1990): 102–6.

Marks, Elaine, and Isabelle de Courtivron, eds. *New French Feminism: An Anthology*. New York: Schocken Books, 1981.

Marsh, Georgia. "David Salle. An Interview by Georgia Marsh." *Bomb* 13 (fall 1985): 20–25.

Marzorati, Gerald. "I Will Not Think Bad Thoughts. An Interview with Eric Fischl." *Parkett*, no. 5 (1985): 8–30.

M/E/A/N/I/N/G, nos. 1–19/20 (November 1986–May 1996).

Ana Mendieta: A Retrospective. Exhibition catalogue. New York: New Museum of Contemporary Art, 1987.

Paula Modersohn-Becker: The Letters and Journals. Ed. Günter Busch and Liselotte von Reinken, ed. and trans. Arthur S. Wensinger and Carole Clew Hoey. New York: Taplinger, 1983.

Moi, Toril. *Sexual/Textual Politics: Feminist Literary Theory*. London and New York: Methuen, 1985.

Mondrian, Piet. *The New Art—The New Life: The Collected Writings of Piet Mondrian*. Ed. and trans. Harry Holtzman and Martin S. James. New York: Da Capo Press, 1993.

Motherwell, Robert. *The Collected Writings of Robert Motherwell*. Ed. Stephanie Terenzio. New York and Oxford: Oxford University Press, 1992.

Motherwell, Robert, ed. *Dada Painters and Poets: An Anthology*. 2d ed. Cambridge, Mass.: Harvard University Press, Belknap Press, 1989.

Muecke, D. C. *The Critical Idiom #13—Irony and the Ironic.* London and New York: Methuen, 1970.

Mulvey, Laura. *Visual and Other Pleasures.* Bloomington: Indiana University Press, 1989.

Nemser, Cindy. "Interview with Eva Hesse." *ArtForum* 8, no. 9 (May 1970): 59–63.

Nesbitt, Lois E. "Reviews: Judy Ledgerwood." *ArtForum* 28, no. 3 (November 1989): 151.

————. "Janine Antoni at Sandra Gering Gallery." *ArtForum* 30, no. 10 (summer 1992): 112.

Newman, Barnett. *Barnett Newman: Selected Writings and Interviews.* Ed. John P. O'Neill. New York: Alfred A. Knopf, 1990.

Nochlin, Linda. *The Body in Pieces: The Fragment as a Metaphor of Modernity.* New York: Thames and Hudson, 1995.

————. "Courbet's *L'Origine du monde:* The Origin without an Original." *October* 37 (summer 1986): 76–86.

————. "Eroticism and Female Imagery in Nineteenth-Century Art." In *Women as Sex Objects: Studies in Erotic Art 1730–1970,* ed. Thomas Hess and Linda Nochlin. New York: Newsweek, 1972.

————. "Why Have There Been No Great Women Artists?" In *Art and Sexual Politics,* ed. Thomas B. Hess and Elizabeth C. Baker, 1–44. New York: Collier, 1971. Originally published in *ARTnews* (January 1971): 22–39, 67–71.

————. *Women, Art and Power and Other Essays.* New York: Harper and Row, 1988.

O'Doherty, Brian. *Inside the White Cube: The Ideology of the Gallery Space.* Santa Monica, Calif.: Lapis Press, 1986.

Ozick, Cynthia. *Art & Ardor.* New York: E. P. Dutton, 1984.

Parker, Rozsika, and Griselda Pollock. *Old Mistresses: Women, Art and Ideology.* New York: Pantheon Books, 1981.

Parker, Rozsika, and Griselda Pollock, eds. *Framing Feminism: Art and the Women's Movement 1970–1985.* London and New York: Routledge and Kegan Paul, Pandora Press, 1987.

Penley, Constance. "Teaching in Your Sleep: Feminism and Psychoanalysis." In *The Future of an Illusion: Film, Feminism, and Psychoanalysis.* Minneapolis: University of Minnesota Press, 1989.

Perreault, John. *Bedrooms.* Exhibition pamphlet. New York: Newhouse Center for Contemporary Art, Snug Harbor Cultural Center, Staten Island, 1991.

Perry, Gillian. *Paula Modersohn-Becker: Her Life and Work.* New York: Harper and Row, 1979.

Petersen, Karen, and J. J. Wilson, eds. *Women Artists: Recognition and Reappraisal from the Early Middle Ages to the Twentieth Century.* New York: Harper and Row, Colophon Books, 1976.

Phelan, Peggy. *Unmarked: The Politics of Performance.* London and New York: Routledge, 1993.

Phillips, Patricia C. "Temporality and Public Art." *Art Journal* 48, no. 4 (winter 1989): 331–35.

Pincus-Witten, Robert. "Alien Nature or Art once esoteric and banal or Painting as mise-en-scène or WITHOUT MOVING YOUR LIPS, possible titles for an essay on Annette Lemieux." *Annette Lemieux.* New York: Josh Baer Gallery, 1989.

———. *Bourgeois Truth.* New York: Robert Miller Gallery, 1982.

———. "David Salle: Holiday Glassware." *Arts* (April 1982): 58–60.

———. "Entries: Big History, Little History." *Arts* (April 1980): 183.

———. "Pure Pinter: An Interview with David Salle." *Arts* (November 1985): 78–81.

Pollock, Griselda. *Vision & Difference: Femininity, Feminism and the Histories of Art.* New York: Routledge, 1988.

"Queen Kong." *Playboy,* July 1989, 15.

Ratcliff, Carter. "David Salle and the New York School." In *David Salle,* exhibition catalogue. Rotterdam: Museum Boymans-van Beuningen, 1983.

Raven, Arlene. "ABC No Lady." *Village Voice,* 19 June 1990, 116.

———. *Crossing Over: Feminism and Art of Social Concern.* Ann Arbor, Mich.: U.M.I. Research Press, 1988.

Raven, Arlene, ed. *Art in the Public Interest.* Ann Arbor, Mich.: U.M.I. Research Press, 1989.

Raven, Arlene, Cassandra L. Langer, and Joanna Frueh, eds. *Feminist Art Criticism: An Anthology.* Ann Arbor, Mich.: U.M.I. Research Press, 1988.

Ad Reinhardt. Exhibition catalogue. Los Angeles: Museum of Contemporary Art; New York: Museum of Modern Art, 1991.

Reinhardt, Ad. *Art as Art: The Selected Writings of Ad Reinhardt.* Ed. Barbara Rose. Berkeley and Los Angeles: University of California Press, 1991.

Riding, Alan. "Politics, This Is Art. Art, This Is Politics." *New York Times,* 10 August 1995, C11, C15.

Robinson, Hilary, ed. *Visibly Female—Feminism and Art Today: An Anthology.* New York: Universe Books, 1988.

Rosenberg, Harold. *Discovering the Present—Three Decades in Art, Culture and Politics.* Chicago and London: University of Chicago Press, 1973.

Rukeyser, Muriel. *The Collected Poems of Muriel Rukeyser.* New York: MacGraw-Hill, 1982.

Salaman, Naomi, ed. *What She Wants: Women Artists Look at Men.* Introduction by Linda Williams. London and New York: Verso, 1994.

Salle, David. "The Paintings are Dead." *Cover* 1, no. 1 (May 1979): n.p.

Salomon, Charlotte. *Charlotte: A Diary in Pictures.* Commentary by Paul Tillich with a biographical note by Emil Strauss. New York: Harcourt, Brace and World, a Helen and Kurt Wolff Book, 1963.

———. *Charlotte Salomon: Life or Theater? An Autobiographical Play.* Translated from the German by Leila Vennewitz with an introduction by Judith Herzberg. New York: Viking Press, a Studio Book, in association with Gary Schwartz, 1981.

Salvioni, Daniela. "Cady Noland: The Homespun Violence of the Hearth." *Flash Art,* no. 148 (October 1989): 129.

Schapiro, Meyer. "The Apples of Cézanne—An Essay on the Meaning of Still-Life." In *Modern Art—19th and 20th Centuries: Selected Papers,* 1–41. New York: Georges Braziller, 1978.

Schjeldahl, Peter. "Absent-Minded Female Nude on Bed, for David Salle." *ArtForum* 20, no. 4 (December 1981): 49.

———. *The Hydrogen Jukebox: Selected Writings of Peter Schjeldahl 1978–1990.* Ed. Malin Wilson. Berkeley: University of California Press, 1991.

———. "Introduction: The Oracle of Images." In *Cindy Sherman,* 7–11. New York: Pantheon Books, 1984.

———. "On Cindy Sherman." *7 Days,* 26 March 1990. Reprinted in *Village Voice,* 10 April 1990.

Schneemann, Carolee. "Carolee Schneemann." In *Angry Women Re/Search #13,* ed. Andrea Juno and V. Vale, 66–77. San Francisco: Re/Search Publications, 1991.

Schor, Mira. "Backlash and Appropriation." In *The Power of Feminist Art,* ed. Norma Broude and Mary D. Garrard, 248–63. New York: Harry N. Abrams, 1994.

Schor, Naomi. *Bad Objects: Essays Popular and Unpopular.* Durham and London: Duke University Press, 1995.

———. "This Essentialism Which Is Not One: Coming to Grips with Irigaray." *differences* 1 (summer 1989): 38–58. Reprinted in *The Essential Difference,* ed. Naomi Schor and Elizabeth Weed, 40–62. Bloomington: Indiana University Press, 1994.

Siegel, Jeanne. "The American Trip: Cady Noland's Investigations." *Arts* 64, no. 4 (December 1989): 45.

———. "Annette Lemieux: It's a Wonderful Life, or Is It?" *Arts* 61, no. 5 (January 1987): 78–81.

Smith, Roberta. "So Big and So Dressed Up, New Galleries Bloom in Soho." *New York Times,* 11 May 1990, C1.

———. "Some British Moderns Seeking to Shock." *New York Times,* 23 November 1995, C11, C14.

———. "Waging Guerrilla Warfare Against the Art World." *New York Times,* 17 June 1990, C1, C31.

———. "Women Artists Engage the 'Enemy.'" *New York Times,* Sunday, 16 August 1992, sec. 2, p. 1.

Steinberg, Janice. *Death of a Postmodernist.* New York: Berkley Prime Crime, 1995.

Steinberg, Leo. *The Sexuality of Christ in Renaissance Art and Modern Oblivion. October 25.* Cambridge, Mass.: MIT Press, 1983.

Stone, Allucquère Rosanne. *The War of Desire and Technology at the Close of the Mechanical Age.* Cambridge, Mass.: MIT Press, 1995.

Taylor, Paul. "Where the Girls Are." *Corporate Culture,* April 1987.

Theweleit, Klaus. *Male Fantasies.* Vol. 1, *Women, Floods, Bodies, History.* Trans. Stephen Conway. Minneapolis: University of Minnesota Press, 1987.

———. *Male Fantasies.* Vol. 2, *Male Bodies: Psychoanalyzing the White Terror.* Trans. Erica Carter and Chris Turner. Minneapolis: University of Minnesota Press, 1989.

Tworkov, Jack. "By Jack Tworkov." In *Jack Tworkov: Paintings, 1928–1982,* 127–145. Seattle and London: Pennsylvania Academy of Fine Arts in association with University of Washington Press, 1987.

WAC States—The Facts About Women. New York: WAC, The Women's Action Coalition, 1992.

Wallis, Brian, ed. *Art After Modernism: Rethinking Representation*. New York: New Museum of Contemporary Art; Boston: David R. Godine, 1984.

——. *Blasted Allegories: An Anthology of Writings by Contemporary Artists*. New York: New Museum of Contemporary Art; Cambridge, Mass.: MIT Press, 1987.

Wei, Lilly. "Feminists in the Art World." *Art in America* (January 1995): 35, 37.

Weisang, Myriam. "Guerrilla Girls Unmask Sexism in the Art World." *Mother Jones* (August–September 1987): 13.

Wilding, Faith. *By Our Own Hands*. Santa Monica, Calif.: Double X, 1977.

Witnesses: Against Our Vanishing. Exhibition catalogue. New York: Artists Space, 1989.

Wollen, Peter. *Raiding the Icebox: Reflections on Twentieth-Century Culture*. Bloomington: Indiana University Press, 1993.

Woodruff, Mark. "Artspeak: Monkey Business." *Taxi* (April 1989): 45.

Woolf, Virginia. *A Room of One's Own*. New York: Harcourt, Brace and World, 1957.

Wye, Deborah. *Committed to Print*. Exhibition catalogue. New York: Museum of Modern Art, 1988.

Acknowledgments

"Ana Mendieta" previously appeared in *Sulfur* 22 (spring 1988): 101–4.

"Appropriated Sexuality" first appeared in *M/E/A/N/I/N/G*, no. 1 (December 1986): 8–17, and has also appeared in Richard Hertz, ed., *Theories of Contemporary Art*, 2d ed. (Englewood Cliffs, N.J.: Prentice Hall, 1993), 69–77.

"Authority and Learning" previously appeared in *M/E/A/N/I/N/G*, no. 8 (November 1990): 29–35.

" 'The Bitter Tea of General Yen': Paintings by David Diao" previously appeared in *Provincetown Arts* 11 (July 1995): 96–97.

"Bonnard's Ants" previously appeared in *M/E/A/N/I/N/G*, no. 2 (November 1987): 22–26.

"Course Proposal" previously appeared in *M/E/A/N/I/N/G*, no. 13 (November 1993): 20–23.

"Figure/Ground" previously appeared in *M/E/A/N/I/N/G*, no. 6 (November 1989): 18–27.

"Forensics: The Part for the Hole" previously appeared in *Tema Celeste*, no. 35 (April–May 1992): 30–31.

"From Liberation to Lack" previously appeared in *Heresies 24: 12 Years* 6, no. 4, (1989): 15–21.

"Just the Facts, Ma'am" first appeared, under the title, "Girls Will Be Girls" in *ArtForum* (September 1990): 124–27; it was reprinted as "Just the Facts, Ma'am" in *Guerrilla Girls Talk Back,* exhibition catalogue Falkirk Cultural Center, San Rafael, Calif., 1991.

"Medusa Redux: Ida Applebroog and the Spaces of Postmodernity" first appeared

in *ArtForum* 28, no. 7 (March 1990): 116–22; a second version appeared in *Ida Applebroog,* exhibition catalogue (Derry, Northern Ireland: Orchard Gallery, 1993), 5–16.

"On Failure and Anonymity" appeared in *Heresies 25* (1990): 7–9.

"Painting as Manual" previously appeared in *M/E/A/N/I/N/G,* no. 18 (November 1995): 31–41.

"Patrilineage" first appeared in *Art Journal* 50, no. 2 (summer, 1991): 58–63; an updated version appeared in Joanna Frueh, Cassandra L. Langer, and Arlene Raven, eds., *New Feminist Criticism: Art/Identity/Action* (New York: HarperCollins, 1994), 42–59.

"Representations of the Penis" previously appeared in *M/E/A/N/I/N/G,* no. 4 (November 1988): 3–17.

"Researching Visual Pleasure" previously appeared in *M/E/A/N/I/N/G,* no. 10 (November 1991): 34–39.

"The Return of the Same" previously appeared under the title, "Mira Schor on the Return of the Same," in the "Troubleshooters" column, *ArtForum* 28, no. 10 (summer 1990): 17–18.

"You Can't Leave Home without It" previously appeared in *ArtForum* 30, no. 2 (October 1991): 114–19.

Photo credits

p.26, photo Zindman/Fremont; p.32, photo eeva-inkeri; p.64, photo Ana Mendieta; p.65, photo Mimmo Capone; p.77, 79, photo Jennifer Kotter; p.103, photo eeva-inkeri; p.198–99, photo Penlak/Noble; p.201, photo Wolfgang Hoyt [ESTO]; p.208, photo J.J. Breit; p.209, photo Sarah Wells; p.211, photo Pelka/Noble; p.213, photo Sarah Wells

Index

I

Mira Schor is a painter and writer living in New York
City. She was the coeditor of *M/E/A/N/I/N/G* from
1986 to 1996 and currently teaches at Parsons School of
Design.

Library of Congress Cataloging-in-Publication Data
Schor, Mira.
Wet : on painting, feminism, and art culture /
by Mira Schor.
Includes bibliographical references and index.
ISBN 0-8223-1910-1 (cloth : alk. paper). —
ISBN 0-8223-1915-2 (paper)
1. Feminism and art—United States. I. Title.
N72.F45S36 1997
704'.042'0973—dc20 96-29410 CIP